Palgrave Studies in Creativity and Culture

Series editors
Vlad Petre Glăveanu
Department of Psychology
Webster University
Geneva, Switzerland

Brady Wagoner
Communication and Psychology
Aalborg University
Aalborg, Denmark

Both creativity and culture are areas that have experienced a rapid growth in interest in recent years. Moreover, there is a growing interest today in understanding creativity as a socio-cultural phenomenon and culture as a transformative, dynamic process. Creativity has traditionally been considered an exceptional quality that only a few people (truly) possess, a cognitive or personality trait 'residing' inside the mind of the creative individual. Conversely, culture has often been seen as 'outside' the person and described as a set of 'things' such as norms, beliefs, values, objects, and so on. The current literature shows a trend towards a different understanding, which recognises the psycho-socio-cultural nature of creative expression and the creative quality of appropriating and participating in culture. Our new, interdisciplinary series Palgrave Studies in Creativity and Culture intends to advance our knowledge of both creativity and cultural studies from the forefront of theory and research within the emerging cultural psychology of creativity, and the intersection between psychology, anthropology, sociology, education, business, and cultural studies. Palgrave Studies in Creativity and Culture is accepting proposals for monographs, Palgrave Pivots and edited collections that bring together creativity and culture. The series has a broader focus than simply the cultural approach to creativity, and is unified by a basic set of premises about creativity and cultural phenomena.

More information about this series at
http://www.palgrave.com/gp/series/14640

Tony Gillam

Creativity, Wellbeing and Mental Health Practice

palgrave
macmillan

Tony Gillam
University of Wolverhampton
West Midlands, UK

Palgrave Studies in Creativity and Culture
ISBN 978-3-319-74883-2 ISBN 978-3-319-74884-9 (eBook)
https://doi.org/10.1007/978-3-319-74884-9

Library of Congress Control Number: 2018934463

Cover credit: Pattern adapted from an Indian cotton print produced in the 19th century

Printed on acid-free paper

This Palgrave Pivot imprint is published by Springer Nature
The registered company is Springer International Publishing AG
The registered company address is: Gewerbestrasse 11, 6330 Cham, Switzerland

For Sue, Katie and Dan

Permissions

Parts of this book have been previously published elsewhere in a somewhat different form. I would like to acknowledge and thank the following publishers for kind permission to re-use this material here.

Some sections of Chaps. 2, and 3 originally appeared in my article *Creativity and mental health care* in *Mental Health Practice* (June 2013, Vol. 16, No.9).

Other sections of Chap. 2 and sections of Chap. 6 originally appeared in my chapter *Creativity and the therapeutic use of the creative arts* (pp. 287–298) in the 2003 book *The handbook of community mental health nursing* (edited by Michael Coffey and Ben Hannigan) published by Routledge, with permission from Taylor & Francis.

Other sections of Chap. 6 originally appeared in my article *An isle full of noises: Enhancing mental health through the Music Workshop Project*, first published in *Groupwork* (Vol. 13, Issue 3) in 2003.

Some sections of Chap. 7 originally appeared in my article *The therapeutic value of writing* in the *British Journal of Wellbeing* (September 2010, Vol. 1, No.6).

Some sections of Chap. 8 originally appeared in my article *Learning to be a transformational leader* in *Mental Health Practice* (May 2016, Vol. 19, No.8).

ACKNOWLEDGMENTS

Laurent Daloz observed that no one ever reads acknowledgments except the people the author inadvertently leaves out. If you happen to be in that category, I would like to say a special thank you. I also want to thank my colleagues and students at the University of Wolverhampton and, in particular, Alison Geeson who has encouraged and supported the writing of this book. Thanks are due to all the wonderfully skilled, creative and compassionate mental health practitioners who have influenced, inspired and supported me in various ways throughout three decades of working in the NHS. Especial thanks to former colleagues at Worcestershire's Early Intervention Service and to Dr Gráinne Fadden and all the dedicated family work trainers and practitioners associated with the Meriden Family Programme. I am indebted to the teaching staff at the University of Worcester, in particular Dr Janice Clarke, the librarians at Worcestershire Health Libraries and at the University of Wolverhampton and to Phil Richards who conjured up a copy of the hard-to-find *Journey to the East*. Thanks to all the editors who, over the years, have encouraged me by publishing my writing and, of course, to the Palgrave Macmillan editorial team for helping to bringing this book to fruition. I am grateful to all those service users, carers, colleagues and students with whom I have had the privilege of working. Finally, I would like to acknowledge the love and support of my family and friends ... and, most of all, my wife Sue. If I manage to be in any way creative and to enjoy a reasonable level of wellbeing it is surely thanks to her.

CONTENTS

LIST OF FIGURE AND TABLES

LIST OF BOXES

CHAPTER 1

Introduction: Creativity, Wellbeing and Mental Health

Abstract This opening chapter provides an introduction, an overview and a rationale for the book. It suggests that, while both creativity and wellbeing have become arguably mere buzz-words, in reality they are both complex and useful, interconnected concepts which do have a relevance to contemporary mental health care. Reference is made to Elgar's association with Worcester asylum as an early example of the connection between creative arts and mental health care. Some autobiographical elements are introduced and creative nonfiction techniques are used to explain the motivations behind writing the book and to illustrate the use of creativity as a foretaste of the book's themes. The chapter touches on the fashion for creativity and on mental health practice as a creative activity. An outline describes each chapter's content.

Keywords Overview • Creativity • Wellbeing • Interconnected concepts • Relevance to mental health • Creative arts • Creativity as fashionable • Mental health practice as a creative activity

© The Author(s) 2018
T. Gillam, *Creativity, Wellbeing and Mental Health Practice*,
Palgrave Studies in Creativity and Culture,
https://doi.org/10.1007/978-3-319-74884-9_1

1

EDWARD ELGAR AND HIS DANCES FOR LUNATICS

There is a tradition of naming hospital wards after famous people associated with the local area. For example, Shelton Hospital in Shrewsbury, where I trained as a mental health nurse, had a Housman ward. Although the poet A E Housman was from Worcestershire, his best-known work is his collection of poems *A Shropshire Lad* so it was fitting that the former Shropshire and Montgomery County Asylum should commemorate the poet. Likewise, when the city of Worcester opened an impressive new psychiatric inpatient unit to replace its Victorian mental hospital, it named part of the building The Elgar Unit, after the celebrated composer.

The use of Elgar's name is more than simply decorative, however. Not only was Edward Elgar born in Worcestershire but he had a deep connection with the history of mental health care in the area (de Young, 2015). As a young violinist, the man who would later compose the *Enigma Variations* and the *Pomp and Circumstance Marches* played in concerts at Powick Hospital (or, as it was known then, the Worcester County and City Lunatic Asylum.)

The County Asylum Act of 1845 had required local authorities to construct and manage their own accommodation for 'pauper lunatics'. By the late 19th century, towns and cities throughout England and Wales had, on their outskirts, asylums staffed not by nurses but by attendants. Hospitals like Powick and Shelton were self-contained institutions, almost self-sufficient communities, producing their own food, having kitchens, laundries, chapels, dance halls and cricket pavilions on site. They often boasted their own orchestral bands and sports teams made up of patients and attendants and it was seen as an advantage, when recruiting staff, that they should be able to play a musical instrument or be good at sports.

Worcester's asylum was particularly fortunate to have young Mr Elgar as a neighbour. Lacking the funds to travel abroad to study music at a conservatoire he, instead, chose to serve his musical apprenticeship in the asylum band. By the age of 22 he had taken up the post of bandmaster and was composing polkas and minuets to be performed every Friday evening at dances organised for the entertainment of the patients. This, of course, was not *music therapy*, in the modern meaning of the term, nor was it *dance therapy*, but Elgar's specially-composed *Dances for Worcester City and County Pauper Lunatic Asylum*, performed by patients and attendants, show a connection which is central to this book. Music and dance in a mental hospital – a connection between creativity, wellbeing and mental health.

About This Book

This book is all about connections. As the title makes obvious, it is about the connections between creativity, wellbeing and mental health practice, but it is also about the connections between mental health and the creative arts, between patients and poets, between asylum attendants and mental health nurses. It is about the connections between the wellbeing of service users and the wellbeing of service providers, between artistic temperament and madness, between me the writer and you the reader.

In *Creativity, wellbeing and mental health practice,* creativity and mental health are examined from several perspectives, considering the notion of creativity and its interaction with the creative arts and caring interventions. In this book I invite mental health nurses and other practitioners to reflect on how creativity can be applied in practice and how mental health care might be considered a creative activity in itself.

Along with providing a new model for creative mental health care this book also clarifies what is understood by the term wellbeing. It provides a framework for readers to make sense of this concept and makes recommendations about how it can influence practice. It argues that a clearer understanding of both creativity and wellbeing can help transform mental health services – for service users, for carers and for the providers of care themselves.

Portrait of the Artist as a Young Nurse

I mentioned earlier that, as a mental health nursing student, I worked on Housman ward at Shelton Hospital. I was born and brought up in Shrewsbury and so, unlike Housman, I really *was* a Shropshire lad. While I enjoyed my time on the inpatient wards, and learnt a great deal, I felt more at home in the day hospital where I discovered there were art therapists and occupational therapists (OTs). There, I was encouraged to share my interest in music with service users and was allowed to experiment with running improvisational music-making sessions in the art therapy room. These provided a prototype for the Music Workshop Project that I developed later, (and which is discussed in detail in Chap. 6).

Alongside my longstanding interest in music – playing guitar, songwriting, improvising – my other passion was for writing and literature. I found an outlet for this by helping to facilitate therapeutic creative writing groups (see Chap. 7) and by writing about mental health. In some ways, I have

led a kind of double-life as, throughout three decades of working as a nurse, I was also a writer, contributing to nursing journals and other publications. This parallel career began when my wife and I lived in a house in the grounds of Powick Hospital, just a few years before it closed ... and a hundred years after Elgar had conducted its asylum orchestra.

Why This Book and Why Now?

Not far from the site of Powick Hospital (now a housing estate) is a large field that is frequently used for car boot sales. My mother-in-law is a car boot sale addict and so, one Sunday, I found myself browsing through the bric-a-brac and old books haphazardly covering the trestle tables. Here I came across a book called *Reflections on Community Psychiatric Nursing* which I had written several years ago (Gillam, 2002). For any author, finding one's own book in a charity shop or at a car boot sale provokes a mixture of feelings. First, the shock of recognition, then a sadness that it has come to this, and a forlorn resignation that the book is no longer considered useful, relevant or valuable to the original owner.

I picked up the well-worn paperback. "Any good?" I asked the woman behind the table, who looked hopeful of a sale.

"Oh, that? Well, I found it really useful when I was doing my nurse training," she said.

Well, that was some consolation. What I realised, though, was that this was nature's way of telling me it was about time I wrote a new book.

For years, I had been having conversations, writing articles, running conference workshops promoting the benefits of using creative approaches in mental health, facilitating music groups and writing groups, supporting other staff to run arts and crafts projects, encouraging colleagues to write and reflect ... but why had I not found the time or energy to write another book? Partly, because the 'day job' – managing a busy, specialist mental health service in what often seemed like a hostile organisational culture – was sapping my strength, diminishing any sense of wellbeing. Despite all our best efforts, I and many of many colleagues, I am sure, would have identified with the mental health social worker (quoted in a discussion paper) who felt deskilled and demotivated by current ways of working:

> The ability to be creative is gone (...) Relationship is no longer possible in any therapeutic sense. I am prevented by the way the service works from

using my skills to actively engage and to sustain engagement over time. This is what I was called to do and trained to do.... (Duggan, Cooper, & Foster, 2002, p. 4)

It is interesting to note that the author of this quote chose to leave mental health social work to do a Master's degree in creative writing, as if intuitively knowing a creative activity could be the antidote to the deadening effect of working in what might be called the opposite of a creative climate (Berg & Hallberg, 1999).

Another reason it took me so long to write this 'follow-up' book is that I, too, was studying part-time for a Master's degree (alongside my full-time job) and, happily, the resulting research – on creativity and wellbeing – has provided some of the material for this new book. My research helped me recognise the close interconnection between creativity and wellbeing. The importance of creativity to mental health and wellbeing, the survival of the reflective, creative practitioner and the problem of occupational stress and satisfying professional practice – these, then, are recurring themes in *Creativity, wellbeing and mental health practice*.

THE ROAD TO CREATIVITY

I still live in Worcestershire but now spend part of my time working in Staffordshire, commuting back and forth to Wolverhampton. On the A449 between Kidderminster and Wolverhampton lies the county boundary separating Worcestershire and Staffordshire. This is marked by a sign saying "*Welcome to Staffordshire – The Creative County.*"

Creativity has, it seems, become a highly fashionable, highly desirable attribute. As advertising and media types might say, creativity is 'sexy'. This would appear at times to be literally the case; according to one study, creative people have, on average, twice the number of sexual partners as the wider population (Nettle & Clegg, 2006).

If creativity is associated with excitement and attractiveness, it is also linked – even in times of economic downturns – with prosperity. In 2016, the Department for Culture, Media and Sport reported there were 1.9 million jobs in the creative industries – an increase of 19.5 per cent since 2011, compared with a mere 6.3 per cent increase in the total number of jobs in the wider UK economy during the same period (Department for Culture, Media and Sport, 2016.)

The allure of the creative industries may seem a far cry from the unglamorous world of mental health care. While some of the jobs classified by the Department for Culture, Media and Sport may not attract thrill-seekers (working in museums, galleries and libraries, for example,) careers in film, TV, photography, designer fashion, music and performing arts all sound much more likely to involve fame and fortune, jet-setting and mixing with celebrities, even if the reality is more mundane. People choose to work in mental health because they are caring and compassionate and not because they hope to become rich and famous. Nurses probably do not, on the whole, consider themselves to be 'creatives' – but this does not mean they are unimaginative people, nor does it mean that mental health care is inevitably an uninspired or uninspiring activity. On the contrary, this book argues that mental health practice can and should be creative. Modern mental health nursing is not only about treating and managing mental illness – it is about *creating* positive health and wellbeing.

Nursing: Art, Science or Craft?

The idea of nursing as a creative activity has similarities with the work of Phil Barker (a former professor of psychiatric nursing) and Poppy Buchanan-Barker (a former therapist, counsellor and social worker.) In their book *The Tidal Model* (Barker & Buchanan-Barker, 2005) the old debate about whether nursing is an art or a science is subverted. Nursing, it is suggested, is neither – rather, nursing is a *craft*. The craftsperson combines skill (art) and knowledge (science) but "the success or value of any crafted object is defined by the unknown gift of appreciation that the owner bestows on the object" (p. 36). The 'owner' of the craft of nursing is the person cared for. In this model "the professional aims to develop the *craft* of caring – using professional skills and knowledge together to meet the discrete needs of the person, so that a unique experience of being *cared with* can develop" (p. 36).

One of the core assumptions of the Tidal Model is that "therapeutic nursing is an interactive, developmental, human activity, more concerned with the future development of the person than with the origins or causes of their present distress" (p. 37). If we accept this, it becomes possible to use creativity as part of our craft, to interact, develop and *create* health and wellbeing. While the Department for Culture, Media and Sport may not count nursing, OT or social work among the creative industries, they do include those who work in the field of crafts. If nursing is a craft, then it is a creative activity.

MORE ABOUT THIS BOOK

One of my aims in writing *Creativity, wellbeing and mental health practice* is to share insights gained from practising as a mental health nurse over many years. Throughout my nursing career, I have – sometimes spontaneously, sometimes very purposefully – deployed creative approaches to mental health care. Through this book I want to share some of the excitement and satisfaction of this way of working, to inspire nurses and other practitioners to consider being more creative in their day-to-day work with service users, carers and colleagues.

I also want readers to gain a much clearer understanding of what is meant by the terms creativity and wellbeing. It is hard to argue that creativity promotes wellbeing if no one can agree exactly what creativity or wellbeing represent. Leckey (2011), in a systematic review of the literature, identified this very problem. Despite a long tradition of creative activities in mental health and impressive claims for the benefits of creative arts in improving wellbeing, she found the evidence weak, partly because of the lack of clarity over the meanings of the terms wellbeing, mental health and creative arts. If creativity is a nebulous concept the whole area of wellbeing has similarly been described as "a complex, confusing and contested field (with) competing and contradictory definitions" (McNaught, 2011, pp. 7–8). So, in this book, I go to some lengths to unravel and explain meanings as well as to provide examples from the literature and from 'real-life' practice.

Over three decades, in various roles – nurse, manager, supervisor, therapist, trainer, mentor and educator – I have tried to apply creativity to my work, whether with service users, families and carers, students or colleagues. I have also tried to focus less on illness, symptoms and performance targets and more on wellbeing. Within the positive psychology movement, the concept of wellbeing has become increasingly better-defined and better-understood (Seligman & Csikszentmihalyi, 2000; Seligman, 2011) and, in Chaps. 4 and 9, I argue that wellbeing is a meaningful and essential aspect of our work.

If you are reading this book you probably already value creativity and wellbeing, even if their precise meaning is hazy. You may think they are abstract, highfaluting ideas that cannot be applied to the real world of mental health care. You may even think they are luxuries we cannot afford to implement in financially-straitened healthcare economies. This book asserts that, on the contrary, creativity and wellbeing are essential ingredients that can empower and sustain both service users and those providing care.

I make no apologies for writing from the perspective of a mental health nurse, though you will find that my approach, in writing and in practice, is inter-disciplinary and inter-agency. You may be a nurse, OT or social worker, or perhaps a psychologist, psychiatrist, counsellor or wellbeing worker. Alternatively, you may be a peer support worker, a service user or a carer or possibly a community artist, an artist-in-residence or a creative arts therapist. Whatever your particular perspective, I welcome you all and hope you will find something here to intrigue or inspire you.

This book is published as part of the series *Palgrave Studies in Creativity and Culture* which reflects the rapid growth in interest in both creativity and culture in recent years. It is the first book in this series to focus on an area of healthcare and reflects the concerns of the series to understand creativity as a psycho-socio-cultural phenomenon. With a better under-standing of the interdisciplinary theory and research of creativity (and of wellbeing), we can see culture as a transformative, dynamic process. This book seeks to encourage practitioners to understand and transform the culture of mental health care, harnessing creativity to promote greater wellbeing.

Creativity, wellbeing and mental health practice offers a detailed, evidence-based background to the subject, along with examples of how theory can been applied to practice. It aims to empower practitioners to make mental health care a creative enterprise and to encourage readers to adopt fresh perspectives and new roles that can enrich mental health prac-tice and society's wellbeing. Whether we are the cared-for or those who care, the conditions for creativity and wellbeing are the same for all of us.

STYLE AND FORMAT

As one of my goals is to inspire and enthuse practitioners, as well as to bring together research evidence and examples from practice, I have tried to use accessible language and to strike a balance between the require-ments of academic rigour and readability. Readers will notice there are sections where the style is that of *creative nonfiction*[1] and this is in keeping with the theme of creativity. In other words, this is not only a book *about* creativity but a book that deploys and models creative techniques.

Storytelling is important in mental health nursing. Treloar, McMillan and Stone (2016) have investigated how mental health nurses and others working in mental health tell stories in educational settings and in the workplace. They observe how clinical anecdotes can capture important

professional knowledge and attitudes that may be missing from textbooks but that are essential to help practitioners deal with the unpredictable real world of mental health care. This book includes a certain amount of this kind of storytelling, to provide some practice-based evidence for, as Ryan and Morgan (2004) suggest, practice-based evidence "contributes to enriching our knowledge of what works by combining the experience of daily practice with the experience of the research message" (p. 250).

KEY FEATURES

Creativity, wellbeing and mental health practice explains and clarifies creativity and wellbeing for mental health practitioners, students and researchers. It shows how these concepts are interrelated and demonstrates how they can be applied to contemporary mental health practice, including helping practitioners to be more mindful of their own wellbeing. In doing so, it seeks to provide inspiration for innovative practice, critical thinking and a more positive approach to mental health care. Key features include:

- a new model of creative mental health care to inspire more creative practice
- a framework for a clearer understanding of both creativity and wellbeing and how they can help transform mental health services
- practical recommendations for promoting the wellbeing of service users and service providers
- an accessible, readable style written by an experienced practitioner, drawing on both the research evidence and examples from practice.

Supplementary content, further exploring and discussing the themes of the book, can be found at the associated blog: https://tonygillam.blogspot.co.uk/

STRUCTURE OF THE BOOK: FINDING YOUR WAY AROUND

This opening chapter has provided an introduction, an overview and a rationale for the book. It has suggested that, while both creativity and wellbeing have become arguably mere buzz-words, in reality they are both complex and useful, interconnected concepts which do have a relevance to contemporary mental health care. Reference was made to Elgar's association with Worcester asylum as an early example of the connection between

creative arts and mental health care. Some autobiographical elements were introduced and creative nonfiction techniques were used to explain the motivations behind writing the book and to illustrate the use of creativity as a foretaste of the book's themes. The chapter touched on the fashion for creativity and on mental health practice as a creative activity.

Chapter 2 investigates what is understood by creativity. It explores different meanings of the concept, drawing on the development of creativity research including individualist and sociocultural approaches. So called 'Big-C' and 'little-c' creativity are considered and key aspects (novelty, effectiveness and ethicality, discipline and playfulness, as well as creativity as a healing, life-affirming activity.) The creative state of mind, everyday creativity and radical creativity are examined alongside the question of whether creativity is a readily learnable skill and why the subject has not always been taken completely seriously by the scientific community. Finally, creativity's link with wellbeing is discussed and the chapter concludes by proposing that creativity is applicable in mental health practice and is not merely desirable but necessary.

Chapter 3 examines the relationship between creativity and mental health and the historical link between 'madness' and creativity. Dispelling persistent myths surrounding psychosis, mood disorder, artistic temperament and 'strong imagination', it asserts that people are more likely to be creative when they are mentally well-balanced. The mental health benefits of arts and creativity are considered, including arts as social inclusion and as a protective factor. The use of creative arts and humanities in healthcare are explored as are ways of promoting and sustaining creativity, including clinical supervision. Organisational creativity is discussed, and the chapter concludes by suggesting a creative climate, rather than a risk-averse one, helps reduce work-related stress in mental health nursing, leading to greater autonomy and empowerment for the workforce and service users.

Chapter 4 begins by introducing wellbeing theory and ranges from Aristotle's ideas about eudaimonia, through the positive psychology conceptions of Seligman and colleagues, to contemporary preoccupations with happiness, wellbeing and flourishing. It then outlines the findings of my systematic literature review, exploring the question: *what is wellbeing and how is it relevant to mental health nursing?* The findings are presented under five main thematic headings: wellbeing as a nebulous, multifaceted notion, physical wellbeing as a legitimate concern, psychosocial wellbeing *for* mental health nurses (MHNs), the psychosocial wellbeing *of* MHNs and finally spiritual wellbeing (MHNs as spiritual allies.) These findings

are revisited and discussed in depth in Chap. 9, which also makes recommendations based upon this discussion.

Building on the understanding of creativity and wellbeing developed in preceding chapters, Chap. 5 clarifies how creativity can be applied to mental health practice. It addresses two aspects of the question: how to apply concepts of creativity to one's own discipline and how to incorporate creative arts within practice. Themes of evidence-based practice, patient-centred care, collaboration and caring lead towards a concept of creative mental health care. The meaning and role of creativity is explored along with risk-taking, improvisation, the characteristics of creative mental health practitioners and barriers to creative practice. Incorporating creative arts within practice is examined, the benefits for practitioners and the role of improvisation in individual work, groupwork and teamwork. Finally, a new model of creative mental health care is outlined.

Following on from the presentation of a model of creative mental health care in Chap. 5, Chap. 6 adopts a more personal, reflective approach, exploring my own experiences of using music in mental health settings. It begins by tracing the development of music therapy, the role of evidence-based practice in arts activities and value for money versus the so-called 'wow factor'. It then outlines the Music Workshop Project as an example of practice-based evidence, discussing the project's organic shift from a 'therapy' model towards a 'community music' model. It compares the community music movement with community mental health care and considers how to get creative projects started. A typical session is described in detail and the chapter concludes by reviewing how the project ended, linking this to the sigmoid curve as a model of the natural rise and decline of projects.

Having explored music in mental health in Chap. 6, Chap. 7 provides an overview of therapeutic uses of creative writing, including the concept of expressive writing. It reviews evidence for the use of literature, creative writing and poetry in mental health care, exploring bibliotherapy, therapeutic writing and poetry therapy as well as narrative biography. Creative writing is examined as a tool for promoting both the recovery of service users and the professional development of mental health practitioners, including a discussion of the value of storytelling in mental health nursing. The chapter also considers the role of journaling and blogging and the blurring between therapeutic writing, literary writing, autobiography and writing for publication.

Learning and leadership are closely related so Chap. 8 considers how creativity might be applied to these two important areas of mental health practice. Beginning with a series of reflections, the chapter examines the nature of leadership, which is seen as a complex interaction between the leader and the social and organisational environment. It examines resilient leadership and the unhelpful confusion between management development and leadership development. Different leadership styles are considered with a particular focus on transformational leadership. The concept of servant leadership is explored as well as Beghetto's description of creative leadership. The chapter concludes by suggesting transformational and servant leadership have much in common with creative leadership, which involves both role-modelling everyday creativity and establishing a creative organisational climate.

Chapter 9 revisits the themes of the systematic review, introduced in Chap. 4, which explores the question: *what is wellbeing and how is it relevant to mental health nursing?* The five main themes identified are discussed: wellbeing as a nebulous, multifaceted notion, physical wellbeing as a legitimate concern for nurses, psychosocial wellbeing *for* nurses, psychosocial wellbeing *of* nurses, and nurses as spiritual allies. The chapter examines how we can facilitate flourishing, the centrality of relatives, carers and family life, the connections between general health and psychological wellbeing, occupational stress and satisfying professional practice and the interaction between individual and organisational wellbeing. I make links and draw conclusions from the findings which lead to a series of eight recommendations for translating these findings into practice.

Finally, Chap. 10 summarises the book's main arguments. It asserts that some aspects of contemporary mental health practice have become mechanical, joyless and uninspiring, leading to a loss of creativity and wellbeing; enjoying a high level of wellbeing is essential to mental health and the practice of mental health care, and creativity is at the heart of this. Key areas are revisited and both the model of creative mental health care (from Chap. 5) and the eight wellbeing recommendations (from Chap. 9) are reviewed. The chapter concludes with the hope that all those associated with mental health practice will support and implement the proposed wellbeing recommendations and make use of the model of creative mental health care in order to promote greater creativity and wellbeing.

NOTE

1. Gutkind (1997) explains creative nonfiction is a genre that can include memoirs or autobiographical writing and much of what is referred to as literary journalism. Creative nonfiction uses literary devices normally associated with fiction, poetry or drama in the writing of nonfiction stories which strive to be as true, accurate and informative as reportage.

REFERENCES

Barker, P., & Buchanan-Barker, P. (2005). *The tidal model: A guide for mental health professionals.* Hove: Brunner-Routledge.
Berg, A., & Hallberg, I. R. (1999). Effects of systematic clinical supervision on psychiatric nurses' sense of coherence, creativity, work-related strain, job satisfaction and view of the effects from clinical supervision: A pre-post test design. *Journal of Psychiatric and Mental Health Nursing, 6*(5), 371–381.
de Young, M. (2015). *Encyclopedia of asylum therapeutics, 1750–1950s.* Jefferson: McFarland.
Department for Culture, Media and Sport. (2016). *Creative industries: Focus on employment, June 2016.* London: Department for Culture, Media and Sport. Retrieved from: https://www.gov.uk/government/uploads/system/uploads/attachment_data/file/53435/Focus_on_Employment_revised_040716.pdf
Duggan, M., Cooper, A., & Foster, J. (2002). *Modernising the social model in mental health: A discussion paper.* London: Social Perspectives Network for Modern Mental Health.
Gillam, T. (2002). *Reflections on community psychiatric nursing.* London: Routledge.
Gutkind, L. (1997). *The art of creative nonfiction: Writing and selling the literature of reality.* New York: Wiley.
Leckey, J. (2011). The therapeutic effectiveness of creative activities on mental well-being: A systematic review of the literature. *Journal of Psychiatric and Mental Health Nursing, 18*(6), 501–509.
McNaught, A. (2011). *Defining wellbeing.* In A. Knight & A. McNaught (Eds.), *Understanding wellbeing: An introduction for students and practitioners of health and social care.* Banbury: Lantern Publishing Limited.
Nettle, D., & Clegg, H. (2006). Schizotypy, creativity and mating success in humans. *Proceedings of the Royal Society of London B: Biological Sciences, 273,* 611–615.
Ryan, P., & Morgan, S. (2004). *Assertive outreach: A strengths approach to policy and practice.* Edinburgh: Churchill Livingstone.
Seligman, M. E. P. (2011). *Flourish: A new understanding of happiness and wellbeing – and how to achieve them.* London: Nicholas Brealey Publishing.

Seligman, M. E. P., & Csikszentmihalyi, M. (2000). Positive psychology: An introduction. *American Psychologist, 55*(1), 5–14.

Treloar, A., McMillan, M., & Stone, T. (2016). Nursing in an imperfect world: Storytelling as preparation for mental health nursing practice. *International Journal of Mental Health Nursing, 26*(3), 293–300.

CHAPTER 2

Understanding Creativity

Abstract This chapter investigates what is understood by creativity. It explores different meanings of the concept, drawing on the development of creativity research including individualist and sociocultural approaches. So called 'Big-C' and 'little-c' creativity are considered along with key aspects (novelty, effectiveness and ethicality, discipline and playfulness, as well as creativity as a healing, life-affirming activity.) The creative state of mind, everyday creativity and radical creativity are examined alongside the question of whether creativity is a readily learnable skill and why the subject has not always been taken completely seriously by the scientific community. Finally, creativity's link with wellbeing is discussed and the chapter concludes by proposing that creativity is applicable in mental health practice and is not merely desirable but necessary.

Keywords Development of creativity research • Individualist and sociocultural approaches • 'Big-C' and 'little-c' creativity • Novelty, effectiveness and ethicality • Discipline and playfulness • Creativity as healing and life-affirming • Creative state of mind • Everyday creativity • Radical creativity • Creativity as readily-learnable • Scientific community • Creativity's link with wellbeing

© The Author(s) 2018
T. Gillam, *Creativity, Wellbeing and Mental Health Practice*,
Palgrave Studies in Creativity and Culture,
https://doi.org/10.1007/978-3-319-74884-9_2

What Is Creativity?

Defining creativity is a complex enterprise. Sawyer (2012) suggests that "defining creativity may be one of the most difficult tasks facing the social sciences" (p. 7) while Bohm (2004) suggested it was not just difficult but "impossible to define in words" (p. 1). Creativity can indeed seem to be a "fuzzy, soft construct" (Plucker, Beghetto, & Dow, 2004, p. 86), prone to myth-making and confusion.

Individualist Approaches and Sociocultural Approaches

How we define creativity depends on our approach. Sawyer (2012) has charted the development of creativity research and has identified two broad traditions: the individualist and the sociocultural (see Table 2.1). What Sawyer calls the *first wave* of creativity research – which began in the 1950s and 1960s – focused on the personalities of exceptional creative people. In the *second wave* – during the 1970s and 1980s – the focus remained individualist but, rather than examining personality traits, attention shifted to cognition. Influenced by cognitive psychology, researchers became more concerned with the internal mental processes of people engaged in creative activity. In the *third wave* of creativity research – the 1980s and 1990s – there was a shift from the preceding individualist approaches towards a sociocultural approach in which different disciplines (for example, sociology, anthropology and history) studied creativity by focusing on social groups and cultural contexts. Sawyer goes on to propose an integrated framework, incorporating aspects of all three models.

Table 2.1 Development of creativity research

First wave	1950s–1960s	Personalities approach	Focused on the personalities of exceptional creators	INDIVIDUALIST
Second wave	1970s–1980s	Cognitive approach	Based on cognitive psychology; focused on internal mental processes	
Third wave	1980s–1990s	Sociocultural approach	Interdisciplinary; focused on creative social systems; groups of people in social and cultural contexts	SOCIOCULTURAL

Adapted from Sawyer (2012)

Focusing on the person engaged in creative thought or behaviour, the individualist approach defines creativity as "a new mental combination that is expressed in the world" (Sawyer, 2012, p. 7). This definition includes three important aspects:

- the *new* (novel or original) thought or action
- *combination* (two or more thoughts or actions being combined)
- creativity is *expressed in the world* (rather than remaining as an unexpressed idea in the mind of the would-be creator.)

By contrast, the sociocultural approach, (concerned with people working creatively together in social, cultural and organisational systems) defines creativity somewhat differently as "the generation of a product that is judged to be novel and also to be appropriate, useful or valuable by a suitably knowledgeable social group" (p. 8).

Plucker et al. (2004), anxious about the "fuzziness" and "softness" (p. 86) of the concept, propose a definition that views creativity as "the interaction among aptitude, process, and environment by which an individual or group produces a perceptible product that is both novel and useful as defined within a social context" (p. 90). This is a clear example of a sociocultural definition of creativity, with its inclusion not only of the individual but of the group and the way in which the creative product is to be judged within a social context.

Sternberg and Lubart (1999) define creativity as "the ability to produce work that is both novel and appropriate" (p. 3). Thus, it is linked with productivity, originality and usefulness. Similarly, Weston (2007) emphasises its innovative, practical, problem-solving character.

A more elaborate definition of the creative process is put forward by Glăveanu (2015) who regards it as:

a form of action by which actors, materially and symbolically, alone and in collaboration with others, move between different positions and, in the process, imaginatively construct new perspectives on their course of action which afford greater reflexivity and the emergence of novelty. (p. 165)

This conceptualisation is, like Plucker et al.'s (2004), emphatically sociocultural but seems to focus more on the process than on the product. Yet, all of the above definitions share common themes of novelty, originality, productivity, action, expression, usefulness and appropriateness.

BIG-C AND LITTLE-C CREATIVITY

Sawyer (2012) points out that sociocultural definitions of creativity demand the generation of a socially valuable product in order for the act of the person to be judged creative. The product may be a major work of genius or a solution to a particularly challenging problem. The term Big-C creativity is sometimes used in this context. Kaufman and Sternberg (2007) explain that Big-C creativity often involves eminent people and give, as examples, Toni Morrison's novels and the scientific theories of Charles Darwin. Little-c creativity, on the other hand, concerns "the thinking and work of ordinary people, such as problem-solving, storytelling, or uttering witticisms" (p. 57). Andreasen and Ramchandran (2012, p. 50) describe the Big-C type as "genius-like creativity possessed by only a few" and the little-c type as "ordinary creativity that all human beings possess" and suggest there might be a continuum between the two types.

Indeed, if the individualist cognitive approach, rather than the sociocultural one, is applied to both types then Big-C and little-c creativity may not be so far apart. Weisberg (2006) asserts that we are all capable of creative thought and, even if the products of our creativity may not be remembered for generations to come, he argues that the thinking processes used when being creative are the same, whether we are an average person or a genius.

NEW, GOOD AND RELEVANT: NOVELTY, EFFECTIVENESS AND ETHICALITY

Earlier, reference was made to Sawyer's (2012) individualist definition and the fact it comprises three aspects; in this case, the three elements are *newness*, the use of *combinations* and the principle that creativity is *expressed in the world*. This triad of elements is in keeping with Kaufman and Sternberg's (2007) observation that most definitions of creativity are made up of three components. Although the three components may vary they are often variations on a theme. Kaufman and Sternberg suggest the first principle is that ideas must represent something new, different or innovative. Secondly, creative ideas must be of high quality. Thirdly, they need to be appropriate to the task. This can be summarised in the form that "a creative response to a problem is new, good, and relevant" (p. 55).

When Kaufman and Sternberg refer to "good" in their summation of "new, good, and relevant" they are referring to quality. An alternative

meaning of "good" is invoked in the slightly different triad offered by the Cropley (2001) (see Box 2.1). For Cropley, the three key aspects of creativity are:

- novelty
- effectiveness
- ethicality.

First, whether we are considering a creative product, a course of action or an idea, Cropley suggests that which is creative is inherently *novel* (i.e. it necessarily departs from the familiar). In this, Cropley is in agreement with the majority of commentators on the subject (Plucker et al., 2004; Kaufman & Sternberg, 2007; Sawyer, 2012). Second, a creative product, course of action or idea must be *effective* (i.e. it must work, in the sense that it achieves some end). This, again, links with ideas of quality and of being appropriate, useful or valuable. Third, according to Cropley, it must be *ethical*, arguing that the term creative is not usually used to describe selfish or destructive behaviour (although, in his later work – on what he terms *the dark side of creativity* – he acknowledges that creativity does not always necessarily serve positive ends) (Cropley, Kaufman, & Runco, 2010). So, whereas a "good" thing in Kaufman and Sternberg's conception of creativity means fit for purpose, Cropley's formulation carries a meaning not only of good in the sense of high quality, effective, workmanlike, but also conveys a *moral* sense of good in the ethical domain.

Box 2.1 Cropley's Three Key Aspects of Creativity

- **novelty** – a departure from the familiar
- **effectiveness** – achieves some end
- **ethicality** – not usually applied to selfish or destructive behaviour. (Adapted from Cropley, 2001)

We shall see, in Chap. 5, why this ethical dimension of creativity is so important in developing a model of creative mental health care that is acceptable to nurses and other mental health professionals. Although, here we are discussing creativity in general, ultimately this book is seeking to

apply the concept to mental health practice and Cropley's conception of creativity, with its emphasis on ethicality, seems especially relevant to mental health care.

DISCIPLINE AND PLAYFULNESS

As described earlier, the first wave of creativity research, adopting an individualistic approach, focused on the personalities of exceptional creative people and defined creativity in terms of their characteristics, which would seem to imply that there are those who are creative and those who are not. However, Weston (2007) argues that anyone can *learn* to be creative – a view associated with the second (cognitive) wave of creativity research. Though still focusing on individual characteristics rather than the sociocultural, like Weisberg (2006), Weston believes we are all capable of creative thought. He observes that creative people – presumably irrespective of whether they are geniuses or average people – are characterised by:

- critical thinking
- imagination
- inventiveness
- discipline
- persistence.

Weston observes that creativity demands a certain kind of playfulness but also takes work. The oxymoronic combination of discipline, persistence and work with playfulness is characteristic of much of the writing on creativity and is, of course, another example of the principle of combination – two or more things being brought together in a novel way. Indeed, one of Weston's suggested methods for promoting creative thinking (for Weston believes the capacity for creative thinking can be developed) is what he calls *mix-and-match* – this combining of two things not normally associated. The idea of combinations, we have seen, is one of Sawyer's (2012) three elements of creativity and is emphasised in his definition of the concept as "a new mental combination that is expressed in the world" (p. 7). It could also be argued that the premise of this book – the combining of creativity and wellbeing with mental health practice – is another example of this.

CREATIVITY AS A HEALING, LIFE-AFFIRMING ACTIVITY

Notwithstanding Cropley et al.'s (2010) acknowledgment that creativity may, at times, have its dark side, the concept is almost invariably viewed as a valuable, positive force in society. Sawyer (2012) identifies the fact that most people in the Western world share a set of implicit assumptions about creativity which constitute what anthropologists would call a cultural model of creativity. This cultural model includes beliefs such as that creativity and mental illness are connected (see Chap. 3) and that "creativity is a healing, life-affirming activity" (p. 14.) One example of this last belief is Weston's (2007) assertion that "by showing us the world, or some part of the world, as it *could* be creativity gives us a whole new view of the world as it *is*" (p. vii). This may seem a rather romantic expression of the belief in creativity as a life-affirming force, but Sawyer (2012) finds substantial evidence that creative people are healthier than average and cites research from humanistic psychology, personality studies and more recent studies of *flow*[1] and intrinsic motivation to support this. One example is Rothenberg's (1994) findings that, although they begin with the same level of psychological health as others, creative people enjoy greater health and psychological freedom than the average population as a result of engaging in creative activities.

Some writers have expressed this notion of creativity as life-affirming in more mystical or spiritual language. For example, Lane (2006) extols the virtues of the creative life thus:

> To live creatively is to touch *everything* with joyful unexpected magic. It is to nourish the children's bedtime stories with fresh invention; to delight visitors with an astonishing dish served on the carefully laid table; to enrich the garden with unheard of combinations of plants; to enchant a room with decoration and colour; to paint pictures, make music, write poems, to play with life. The playful life is one intoxicated by spirit, at once unselfconscious and spontaneous, yet disciplined. (p. 75)

For all its exuberance, this extract neatly illustrates the aspects of novelty and combination with its example of enriching the garden with *unheard of combinations* of plants. Moreover, we see again, here, the juxtaposition of *the playful life* with *discipline*.

A CREATIVE STATE OF MIND

Though placing a similarly high value on the role of creativity, Bohm (2004) expresses himself in rather less mystical language. Writing of the compensatory function of creativity in society, he argues:

> the artist, the musical composer, the architect, the scientist all feel a fundamental need to discover and create something new that is whole and total, harmonious and beautiful. Few ever get a chance to try to do this, and even fewer actually manage to do it. Yet deep down, it is probably what very large numbers of people in all walks of life are seeking when they attempt to escape the daily humdrum routine by engaging in every kind of entertainment, excitement, stimulation, change of occupation (…) through which they effectively try to compensate for the unsatisfying narrowness and mechanicalness of their lives. (p. 3)

Bohm (2004) is quoted at length here because what he has to say about creativity is highly relevant to this book's subject: not only creativity – but also wellbeing – and mental health practice. The deskilled, demotivated mental health social worker described in Chap. 1, who gave up her vocation to study creative writing (Duggan, Cooper, & Foster, 2002), is one victim of this dissatisfaction. Yet, what if mental health practice could provide workers with satisfying opportunities to be creative, so they were no longer overwhelmed by narrowness and mechanicalness and forced to satisfy their need for creativity elsewhere?

Far from it being the preserve of specially-gifted creatives, Bohm (2004) suggests it might be possible for any of us to achieve "a generally creative quality of living in all areas of human activity" (p. 27). This sounds very much like a plea for more little-c creativity. Bohm reflects on how we might break out of our "conditioning to mediocrity and mechanicalness (to) *discover* what it means to be original and creative" (p. 27) and calls for a *creative state of mind*, something which he believes needs to be cultivated in order to promote creativity in wider society. He describes this creative state of mind as one in which the individual "is open to learning what is new, to perceiving new differences and new similarities, leading to new orders and structures, rather than always tending to improve familiar orders and structures in the field of what is seen" (p. 21).

This is not too far removed from Weston's (2007) description of the characteristics of *creative people*. Where Bohm disagrees with Weston (2007) and other commentators on creativity, though, is in his belief that

exercises to teach or promote creativity are ineffective. Instead, Bohm argues creativity emerges as a by-product of cultivating the creative state of mind. This view, then, is something of an anomaly. With his interest in *the creative state of mind* Bohm ought to be identifiable with the cognitive approach to creativity research but he seems not to believe that people can learn to think creatively. Yet, there is a suggestion that, given the right conditions, creativity can be *discovered*.

A READILY LEARNABLE SKILL

In stark contrast to Bohm, Weston (2007) is a proponent of achieving creativity through applied techniques, asserting that it is "a readily learnable skill" (p. vi). According to Weston creative thinking calls for "an exploratory attitude, a willingness to unsettle things a bit in search of new ideas and angles – and first and foremost, *methods*" (p. 21). (See Box 2.2).

Box 2.2 Some Methods for Promoting Creativity

- **exotic association** – using random words, images or other prompts or associations as provocations
- **going public** – diversifying and developing ideas simply by talking to other people and getting their views
- **comparing and contrasting** – using historical and cross-cultural comparisons
- **exaggeration** – taking a feature of the problem and pushing it as far as possible
- **mixing and matching** – combining things not originally combined. (Adapted from Weston, 2007)

Schmid (2005) describes how several disciplines (such as sociology, economics, organisational management and education) embrace the idea that creativity can be learnt by all rather than being the preserve of special individuals such as creative geniuses or those in top management. In these fields, training employees to be more creative and innovative is seen as important to productivity, but Schmid believes that public education programmes diminish the value of creative thinking and the creative process by making these implicit rather than explicit in the curriculum and by relegating the study of creativity to optional arts subjects:

If its connection is made only with the arts, then it depletes the significance of the role that creativity can play in everyday activities and occupations. Once creativity is demystified, students understand that there is a deep human need for creativity and that it has strong connections with health and well-being through self-esteem. (p. 4)

The relationship between creativity, productivity, self-esteem and well-being are explored further in Chap. 9. However, Schmid's point here is to demystify the creative process so that it can be applied in everyday activities and occupations, (such as mental health care, for example.) This argument contains two key points. First, that creativity is *learnable* – whether this be through techniques (Weston, 2007) or the nurturing of a creative state of mind (Bohm, 2004). Second, that it can be *everyday* (rather than exceptional.)

EVERYDAY CREATIVITY AND RADICAL CREATIVITY

Weston (2007) describes creative thinking as "a way of life" (p. 65) and, in so doing, comes close to the mystical, spiritual tone of Lane (2006). Weston describes what he calls *creative good citizenship*: "Creativity is also a social contribution (…) Creative thinking along these lines can improve life for all of us (…) Practice creativity as visibly, explicitly, and invitingly as you can. Teach it to your children. Talk to people" (p. 67).

Weston goes on to recommend, in a more evangelical tone, *going public* with the best of one's ideas, suggesting that "radical creativity can also *change the world*. It can be as practical as everyday creativity but thinks on a vastly larger scale – and does not shrink from even the wildest and most utopian hopes" (p. 69). Here, in Weston's view, creativity seems to have become a living entity in its own right, capable of cognition: radical creativity *thinks* (sic) on a larger scale. The contrast between the apparent simplicity of applying easily-learnt techniques – everyday creativity – and the somewhat grandiose rhetoric of radical creativity as a world-changing force is striking and may be one reason why the concept of creativity is not always given the credence it might deserve.

PSYCHOLOGY'S ORPHAN

In 1999, Sternberg and Lubart lamented the low status given to creativity in the field of psychological research. In a striking phrase they asserted that, despite creativity's importance to society, it has traditionally been

regarded as "one of psychology's orphans" (p. 4). As evidence for creativity remaining a relatively marginal topic in the field of psychology they highlighted the dearth of journal articles, psychology textbooks, academic positions or research journals dedicated to creativity. While much of the more recent research cited in this book might suggest this has changed, there is still a view that it remains a "fuzzy, soft construct" (Plucker et al., 2004, p. 86) and, as Sawyer (2012) notes, while books about creativity are not in short supply, few of them report scientific findings, tending instead to simply "present the Western cultural model of creativity (...) with catchy new terms and engaging anecdotes" (p. 14).

In their considered and systematic analysis, Sternberg and Lubart (1999) identified six approaches or paradigms that have been used to understand creativity:

- mystical
- psychoanalytic
- pragmatic
- psychometric
- cognitive
- social-personality.

Moreover, they suggest there may be a seventh approach that uses multidisciplinary approaches and combines elements from one or more of the six approaches. This last paradigm would seem to be a sophisticated example of Weston's *mix and match* method (Weston, 2007).

Sternberg and Lubart (1999) argue that the study of creativity has historically faced a number of "roadblocks" in terms of being taken seriously in the field of psychology. These roadblocks (see Table 2.2) provide a helpful and comprehensive guide to understanding creativity's credibility problem and, within this framework, different writers on creativity could be seen as more or less culpable of blocking creativity's acceptance in the scientific community. Lane's writing (2006) for instance, is a clear if endearing example of the first of these roadblocks, in the tradition of mysticism and spirituality:

> To create presupposes delight – and exhilaration – in *making* as the expression of our deepest nature, the part of us with the most intrinsic value. To live the self-expressive life, the creative life, is to tread a path towards the deepest personal fulfilment. It is to realise dreams, to be alert to the imagination. It is to partake of the healing power unknown by those who do not have the courage to create. (pp. 74–75)

Table 2.2 Sternberg and Lubart's six roadblocks to the serious study of creativity

Roadblock	Difficulties
1 The tradition of mysticism and spirituality	This tradition of creativity studies seems indifferent or even possibly counter to the scientific spirit
2 Pragmatic, commercial approaches	These approaches to creativity convey the impression that its study lacks a basis in psychological theory or verification through psychological research
3 Being outside the mainstream	Early work on creativity that was theoretically and methodologically apart from the mainstream of theoretical and empirical psychology, resulting in creativity sometimes being seen as peripheral to psychology as a whole
4 Definitional problems	Problems with the definition of and criteria for creativity that seemed to render the phenomenon either elusive or trivial
5 The view that the separate study of creativity is unnecessary	Approaches that viewed creativity as an extraordinary result of ordinary structures or processes made it seem it was not always necessary to have any separate study of creativity
6 Unidisciplinary approaches that viewed a part of creativity as the whole	Approaches focusing on one aspect (e.g. cognitive processes, personality traits,) often resulted in a narrow vision of creativity

Adapted from Sternberg and Lubart (1999)

This could certainly be criticised for being "indifferent or even possibly counter to the scientific spirit" (Sternberg & Lubart, 1999, p. 4). If Lane epitomises the mystical, counter-scientific approach, Weston's (2007) interpretation of creativity would seem to match with several of Sternberg and Lubart's other roadblocks – a fusion of allegedly easy-to-learn techniques and grandiose claims, a "pragmatic commercial approach" (p. 4) that is hard to verify and that runs the risk of rendering the concept "elusive or trivial" (p. 4), all in the context of a view of creativity as an "extraordinary result of ordinary structures or processes" (p. 4).

CREATIVITY FOR ALL

Bohm's work (2004) could equally be said to have fallen victim to many of Sternberg and Lubart's (1999) roadblocks. The polymath Bohm – a quantum physicist who contributed to the fields of theoretical physics, philosophy and neuropsychology – was, though, well-placed to address

the problem of unidisciplinary approaches which Sternberg and Lubart felt might lead to a narrow vision of creativity. It is Bohm's work that points the way to the possibility of mental health practitioners being creative in their work:

> no matter what his occupation may be, anyone can, in principle, approach life in this way (i.e. with wholehearted interest in what one is doing, just as great scientists and artists do) (...) with an ability to learn something new (originality) and not impose preconceptions on the fact as he sees it. (p. 6)

In Chap. 1 it was acknowledged that, while mental health care professions might not naturally be counted among the creative industries if, for example, nursing is regarded as a craft then it is a creative activity. As Bohm (2004) explains:

> Such an opportunity arises in many fields which may at first show little promise, especially because (...) society is not in the habit of *recognising* them to be potentially creative (...) creativity of some kind may be possible in almost any conceivable field, and (...) is always founded on the sensitive perception of what is new and different from what is inferred from previous knowledge. (p. 7)

Thus, irrespective of profession, creativity is possible for all.

CREATIVITY FOR WELLBEING

The idea of creativity for all is endorsed by Schmid (2005) who is keen to encourage the promotion of public health and wellbeing through creativity, starting from the standpoint that all people are or have the potential to be creative. Because it is connected to everyday activities creativity can be expressed through any kind of everyday activity, be this in our working life or our leisure time. Schmid draws on evolutionary psychology to argue that the global increase in mental and neurological disorders may be linked to a growing estrangement from creativity. The converse of this is that, if everyday creativity is understood as a survival capacity enabling humans to adapt to changing environments, then reconnecting with creative processes increases health and wellbeing (Schmid, 2005; Sawyer, 2012; Rothenberg, 1994).

Lane (2006) reminds us of the link between satisfying work and wellbeing when he warns:

to work at something in which one has little or no belief, no commitment, no delight (…) is to bring about an incorrigible paralysis of one's personal well-being, an inner death, a throttling of life's most vivid aspirations. In the powerful words of Charles Dickens, it is to make 'a coffin of the heart'. (p. 75)

While society may not instinctively view mental health care as a potentially creative field both Bohm (2004) and Schmid (2005) open up this possibility. If it is possible for mental health workers to be creative then, by extension, it is possible for mental health care to become a creative activity. By this I am not merely suggesting the incorporation of creative arts activities into mental health care (although in the following chapters we will see the importance of this aspect too.) As Schmid (2005) reminds us, if creativity is only associated with the arts then we risk underestimating its important role in everyday activities and in the less obviously artistic occupations.

An occupation devoid of creativity is deadening for the worker but, if that worker is a nurse – a practitioner of the craft of nursing – then it is the service user who may suffer ultimately. Barker and Buchanan-Barker (2005) were quoted in Chap. 1, reminding us that "the success or value of any crafted object is defined by the unknown gift of appreciation that the owner bestows on the object" (p. 36) and, since the 'owner' of the craft of nursing is the person cared for, the therapeutic relationship will be damaged if the craftsperson's heart is not in the work.

If a nurse has "no belief, no commitment, no delight" in their work (Lane, 2006, p. 75) it is likely they also have little compassion left either. In nursing, a lack of compassion can be unsatisfactory for the service user (Leiter, Harvie, & Frizzell, 1998) if not catastrophic (Mid-Staffordshire NHS Foundation Trust, 2013). To quote Bohm (2004) once more:

In (…) emphasising the need for each individual to realise the creative potentialities of the human mind, I do not wish to suggest that this is merely what I (or other people) happen to want, or what I think would be useful to society or to the individual himself. Rather, it seems to me that just as the health of the body demands that we breathe properly, so, whether you like it or not, the health of the mind requires that we be creative. (p. 29)

In Chap. 1, we heard about the mental health social worker who left practice to study creative writing (Duggan et al., 2002). The pressures of the work had perhaps made a coffin of her heart. Evolutionary psychology argues that creativity is essential for our survival (Schmid, 2005). We cannot afford

to be estranged from our creative impulses. If we are to avoid burnout and that incorrigible paralysis of personal wellbeing (Lane, 2006) then creativity is not merely desirable but necessary for mental health and wellbeing.

CHAPTER SUMMARY

This chapter has investigated what is understood by creativity. It explored different meanings of the concept, drawing on the development of creativity research including individualist and sociocultural approaches. So called 'Big-C' and 'little-c' creativity were considered along with key aspects (novelty, effectiveness and ethicality, discipline and playfulness, as well as creativity as a healing, life-affirming activity.) The creative state of mind, everyday creativity and radical creativity were examined alongside the question of whether creativity is a readily learnable skill and why the subject has not always been taken completely seriously by the scientific community. Finally, creativity's link with wellbeing was discussed and the chapter concluded by proposing that creativity is applicable in mental health practice and is not merely desirable but necessary.

NOTE

1. Flow – a concept closely linked to creativity and associated with the psychologist Mihaly Csikszentmihalyi (1990) – describes a peak, positive experience of total absorption in a given activity. When in flow, the challenges of the task are perfectly matched to the ability of the person, the focus narrows to the intrinsically rewarding activity itself and the person becoming oblivious to the environment and the passage of time.

REFERENCES

Andreasen, N. C., & Ramchandran, K. (2012). Creativity in art and science: Are there two cultures? *Dialogues in Clinical Neuroscience, 14*(1), 49–54.
Barker, P., & Buchanan-Barker, P. (2005). *The tidal model: A guide for mental health professionals.* Hove: Brunner-Routledge.
Bohm, D. (2004). *On creativity.* London: Routledge.
Cropley, A. J. (2001). *Creativity in education and learning: A guide for teachers.* London: Kogan Page.
Cropley, A. J., Kaufman, J. C., & Runco, M. A. (Eds.). (2010). *The dark side of creativity.* Cambridge: Cambridge University Press.
Csikszentmihalyi, M. (1990). *Flow: The psychology of optimal experience.* New York: HarperCollins.

Duggan, M., Cooper, A., & Foster, J. (2002). *Modernising the social model in mental health: A discussion paper.* London: Social Perspectives Network for Modern Mental Health.

Glăveanu, V. P. (2015). Creativity as a sociocultural act. *The Journal of Creative Behavior, 49*(3), 165–180.

Kaufman, J. C., & Sternberg, R. J. (2007). Resource review: Creativity. *Change, 39*, 55–58.

Lane, J. (2006). *The spirit of silence: Making space for creativity.* Totnes: Green Books.

Leiter, M., Harvie, P., & Frizzell, C. (1998). The correspondence of patient satisfaction and nurse burnout. *Social Science Medicine, 47*(10), 1611–1617.

Mid-Staffordshire NHS Foundation Trust Public Inquiry. (2013). *Report of the Mid-Staffordshire NHS Foundation Trust Public Inquiry.* Retrieved from: https://www.gov.uk/government/uploads/system/uploads/attachment_data/file/27912/0947.pdf

Plucker, J. A., Beghetto, R. A., & Dow, G. T. (2004). Why isn't creativity more important to educational psychologists? Potentials, pitfalls, and future directions in creativity research. *Educational Psychologist, 39*(2), 83–96.

Rothenberg, A. (1994). *Creativity and madness – New findings and old stereotypes.* Baltimore: The John Hopkins University Press.

Sawyer, R. K. (2012). *Explaining creativity: The science of human innovation* (2nd ed.). Oxford: Oxford University Press.

Schmid, T. (Ed.). (2005). *Promoting health through creativity: For professionals in health, arts and education.* London: Whurr Publishers Ltd.

Sternberg, R. J., & Lubart, T. I. (1999). *The concept of creativity: Prospects and paradigms.* In R. J. Sternberg (Ed.), *Handbook of creativity.* New York: Cambridge University Press.

Weisberg, R. W. (2006). *Creativity: Understanding innovation in problem solving, science, invention, and the arts.* Hoboken, NJ: Wiley.

Weston, A. (2007). *Creativity for critical thinkers.* New York: Oxford University Press.

Creativity and Mental Health

Abstract This chapter examines the relationship between creativity and mental health and the historical link between 'madness' and creativity. Dispelling persistent myths surrounding psychosis, mood disorder, artistic temperament and 'strong imagination', it argues that people are more likely to be creative when they are mentally well-balanced. The mental health benefits of arts and creativity are considered, including arts as social inclusion and as a protective factor. The use of creative arts and humanities in healthcare is explored as are ways of promoting and sustaining creativity, including clinical supervision. Organisational creativity is discussed, and the chapter concludes by suggesting a creative climate, rather than a risk-averse one, helps reduce work-related stress in mental health nursing, leading to greater autonomy and empowerment for the workforce and service users.

Keywords 'Madness' and creativity • Psychosis • Mood disorder • Artistic temperament and 'strong imagination' • Social inclusion • Arts as a protective factor • Arts and humanities in healthcare • Clinical supervision • Organisational creativity • Creative climate • Risk-aversion • Work-related stress • Mental health nursing • Autonomy • Empowerment

© The Author(s) 2018
T. Gillam, *Creativity, Wellbeing and Mental Health Practice*,
Palgrave Studies in Creativity and Culture,
https://doi.org/10.1007/978-3-319-74884-9_3

LUNATICS, LOVERS AND POETS

The relationship between creativity and mental health has a long history, from the old stereotype of the creative genius who is close to madness to the growing contemporary interest in participation in the arts to promote positive mental health. On the one hand, there is the view of the creative process as pathological; on the other, the idea that artistic activity can heal the mind. The link between madness and creativity goes back to antiquity. Plato remarked:

> For the poet is a light and winged and holy thing, and there is no invention in him until he has been inspired and is out of his senses and the mind is no longer in him (...) God takes away the minds of poets, and uses them as his ministers, as he also uses diviners and holy prophets. (Plato, 5th Century BC)

Artistic creation has historically been seen as mystical, divine and closely allied to madness. In *A Midsummer Night's Dream*, Shakespeare has Theseus say: "The lunatic, the lover and the poet/Are of imagination all compact" (5.1.7–8). Alongside the idea of the creative process as something pathological is, however, the idea that artistic activity can heal the mind. Creativity, like love and madness, is seen as both a powerful, potentially destabilising influence and a vehicle for positive change.

DISPELLING MYTHS

Jung (1984) claimed "the divine frenzy of the artist comes perilously close to a pathological state" (p. 78) but others have sought to dispel some of the mythology surrounding drunken poets, mad scientists and debauched artists. Refuting the link between the creative, artistic genius and mental illness, Rothenberg (1994) argues that creative people need to be supremely 'normal' and that, despite superficial resemblances between psychosis and high level creativity, creative thinking generally occurs in a rational and conscious frame of mind rather than a pathological, mystically-altered or transformed state.

Despite Rothenberg's rigorous rebuttal of the association, the belief in the connection between creativity and mental illness is so persistent that Sawyer (2012) lists it as one of his ten commonly-found beliefs within the Western cultural model of creativity. Having reviewed the research, Sawyer concurs that:

There's no solid evidence that mental illness is more common among creative people than the general population. There continue to be a small number of people who argue for a connection, but the consensus among creativity researchers is that those few studies that initially seemed to find a connection are methodologically flawed and don't prove that there's an association between creativity and clinical levels of mental illness. (p. 409)

As with many unfounded beliefs there is, however, a grain of truth in it. Sawyer concedes that, in a few areas of creative activity – notably fiction writing and fine art painting – there is some evidence that more creative people show slightly higher scores of psychological pathology, although even these do not fully meet diagnostic criteria for mental illness, leading Sawyer to support Rothenberg in concluding that, generally, people are more likely to make creative contributions if they are well-balanced.

Mood Disorder and 'Artistic Temperament'

One noted proponent of the mental illness/creativity connection is Kay Redfield Jamison. Like Rothenberg (and a number of other commentators in this area), Jamison is a professor of psychiatry. However, Jamison also has a diagnosis of bipolar disorder and thus has lived experience of mental health difficulties. Her research (Jamison, 1989) focuses on mood disorders and patterns of creativity in a selection of writers and artists as well as the links between manic-depressive illness and the artistic temperament. Her book *Touched with Fire* (Jamison, 1996) explores artistic temperament – historically thought to be a symptom of genius or eccentricity peculiar to artists, writers and musicians – and suggests that the highs and lows of many creative artists were evidence of affective disorders.

Schlesinger (2004a) is scathing about the literature linking psychopathology to creativity, describing it as "shot through with badly designed studies and dramatic overstatement" (p. 184). She is bemused by the fact that, despite her own and Rothenberg's critique of the flawed "mad creative" research, as she terms it, "the public appetite for the doomed artist is too great" (p. 184) and this myth persists. She criticises Jamison's work for blurring the distinction between serious bipolar disorder and the less severe mood disorder of cyclothymia, and for relying too much on the anguish of the Romantic poets and not enough on the scientific method (Schlesinger, 2004b).

More Interdisciplinary Mixing and Matching

It is notable how many researchers in the area of creativity have a background in more than one discipline and thus embody, as it were, the cross-cultural, mixing-and-matching, interdisciplinary approach described in Chap. 2 (to which Sawyer (2012), Weston (2007), and Sternberg and Lubart (1999) all refer in different ways.) For example, David Bohm was a quantum physicist versed in philosophy and neuropsychology; Kay Redfield Jamison has been both a mental health service provider (a psychiatrist) and a service user; Judith Schlesinger combines psychology with music and writing while Keith Sawyer, a professor of education, is also a jazz pianist who spent several years playing piano with improvisational theatre groups.

In this same spirit of mixing-and-matching Daniel Nettle is both a psychologist and anthropologist. This background would seem to clearly identify him with the third wave, sociocultural approach to creativity research (interdisciplinary and focused on creative social systems and groups of people in social and cultural contexts). Nettle (2001) builds upon Jamison's (1996) work to explore the links between mental illness and creativity. Unlike Schlesinger (2004a), Nettle seems untroubled by any concerns over flawed methodology or dramatic overstatement in Jamison's research.

Strong Imagination

Alongside affective disorders, Nettle (2001) also considers psychosis – from both a genetic and evolutionary perspective – and finds evidence supporting the belief that "the traits that underlie psychosis also underlie the vision of the poet" (p. 141). He identifies the essence of these traits as *strong imagination* (a phrase taken from Theseus's already-cited *Midsummer Night's Dream* speech.) Nettle uses the term strong imagination to denote the "common imaginative capacity which, directed one way, can lead to madness, and, directed another, can lead to creativity" (p. 2).

Earlier, we saw how Sawyer (2012), having reviewed the evidence, found the consensus among creativity researchers was this: the few studies that initially described an association between mental illness and creativity were methodologically flawed and therefore provided no proof of an association between creativity and clinical levels of mental illness. Schlesinger (2004a) objected to the dramatic, overblown, Romantic language used by Jamison (1996), but Nettle (2001) falls into this same trap – or deploys this same strategy, (depending on whether you view this as a weakness or a rhetorical device) – by using the familiar term 'madness' rather than more scientific terms such as serious mental illness.[1]

Nettle claims that the dimension of personality called *psychoticism* aids creativity. He divides psychoticism into two subdimensions: *thymotypy* and *schizotypy*. Thymotypy relates to mood while schizotypy relates to divergent thought. According to Nettle, these two subdimensions help creativity in different ways and he suggests that "perhaps the most potent force is some combination of the two, providing the drive and energy of hypomania and the original thought of schizotypy" (p. 157). The suggestion seems to be that the sustained high mood associated with hypomania gives the energy necessary to go on producing creative work while the tendency to divergent thinking provides the requisite inventiveness and originality to spark off creative activity. Of course, however much they may be said to derive from the same gene pool, a tendency to divergent thinking and hypomania – strong imagination – is not the same as the experience of an illness like schizophrenia or bipolar disorder which, as Rothenberg (1994) and Nettle (2001) agree, can be so debilitating as to work *against* the creative impulse.

POSITIVE AFFECT AND CREATIVITY: BEING OF GOOD CHEER

As highlighted earlier, people are more likely to make creative contributions if they are well-balanced; psychotic illnesses and mood disorders work against creativity (Sawyer, 2012). This is further underlined by Amabile, Barsade, Mueller and Staw (2005) in their study of affect[2] and creativity at work, which found that positive affect relates positively to creativity: it is both a *consequence* of creative thought events and a *concomitant* of the creative process.

Amabile et al. (2005) suggest that, for every account of a troubled genius – Vincent Van Gogh or Sylvia Plath, for example, where affective dysfunction is claimed to be an active ingredient of the artist's creativity – there are many, less publicised (perhaps less romantic) accounts of positive affect acting as a catalyst to creative activity. They cite reports of individuals who experienced creative breakthroughs while relaxing on holiday, and Mozart's remarks (Vernon, 1970) about optimal creativity and positive affect:

> When I am, as it were, completely myself, entirely alone, and of good cheer – say, travelling in a carriage, or walking after a good meal, or during the night when I cannot sleep; it is on such occasions that my ideas flow best and most abundantly. (p. 55)

MENTAL HEALTH BENEFITS OF ARTS AND CREATIVITY

If the connection between mental illness and creativity is a myth, albeit a persistent myth, by contrast there is growing evidence that participation in artistic and creative activity may be beneficial for mental health. We should remind ourselves here that creative activity may include but is not limited to artistic activity. As we saw in Chap. 2, to connect creativity solely with the arts risks diminishing its significance in other activities, including mental health practice (Schmid, 2005). With this in mind, let us first, though, explore artistic activity.

Griffiths (2003) gives a useful overview of the role of arts in health. She identified three key themes in the literature:

- The place of arts and creativity in promoting community health
- The use of artworks in clinical settings such as hospitals
- The therapeutic value of participation in the arts, particularly for those considered to be socially excluded.

ARTS AND SOCIAL INCLUSION

In 2004, the UK's New Labour government's Social Inclusion Programme identified access to recreational activities, including participation in the arts, as essential to promoting the social inclusion of people with mental health needs (ODPM, 2004). The report on mental health and social exclusion argued that arts, leisure and sports activities could have a positive impact on mental health. This is something that the attendants in the Victorian asylums described in Chap. 1, with their cricket matches and Friday night dances, seemed to have understood perfectly well. New Labour's Social Inclusion Programme described how "Arts are believed to have a therapeutic role as well as helping people reintegrate into wider society by increasing self-esteem, confidence and social networks" (p. 83). The same report cites one survey in which approximately half of participants reported feeling better or healthier since involvement in the arts (Matarasso, 1997) and another which showed people had fewer readmissions to hospital if they worked with artists post-discharge (Colgan, Bridges, & Faragher, 1991).

The Social Inclusion Programme highlighted the need for a better evidence base for arts and mental health and Leckey (2011) describes the same problem in her systematic review of the literature relating to the therapeutic effectiveness of creative activities on mental wellbeing. Leckey concludes that, while the scope of creative arts and their effects on mental

CREATIVITY AND MENTAL HEALTH 37

well-being was impressive – judged in terms of the number of clients participating in activities – there was no clear evidence that such participation resulted in social benefits. She acknowledges that this is partly due to the lack of clarity over the terminology and calls for further research into the effects of creative arts as well as a clarification of the precise meaning of mental wellbeing. (Chapters 4 and 9 of this book will, I hope, go some way towards meeting this need.)

Leckey (2011) identified eleven studies which showed a direct link between creative arts, mental health and mental wellbeing. These interventions ranged from visual arts, crafts and writing to photography and the performing arts. Despite the need for greater clarity and more systematic reviews, the recognition that creative arts activities could be beneficial meant that some health and care services had already begun to establish projects (one such initiative being the Music Workshop Project described in detail in Chap. 6.) In some areas, primary care practitioners were sufficiently convinced of the evidence that they had started 'prescribing' participation in the arts for depression and anxiety (Cassandra, 2004).

Participation and Self-Expression: Arts as a Protective Factor

Griffiths (2003) suggested that the mental health benefits of arts and creativity are three-fold. They strengthen psychosocial, life and coping skills of the individual, increase social support as a buffer against adverse life events and increase access to resources and services that protect mental well-being.

Box 3.1 The Mental Health Benefits of Participation in Arts and Creative Activity

- Strengthens psychosocial, life and coping skills of the individual (e.g. through self-expression, self-efficacy, building self-esteem, learning new skills, stress or anger management and relaxation)
- Increases social support as a buffer against adverse life events (e.g. building social contacts, as part of a self-help group, networking and new friendships)
- Increases access to resources and services that protect mental wellbeing (e.g. benefit uptake, supported employment, access to mainstream services). (Adapted from Griffiths, 2003)

From this analysis it might be thought that the benefits of arts participation are linked to simply taking part, making new friends and learning new skills, (in other words social and recreational aspects, rather than any specific artistic or creative element.) However, the unique opportunity for self-expression also seems to be important. In the words of one service user:

> Dance, photography, music and painting offer new routes to creating meaning and telling a particular story, perhaps above all for those on the margins. Art has long been of special significance within the user/survivor movement. The achievements of great artists who experienced mental health problems have been used to counter negative images and to create a sense of meaning and pride in madness. (Cassandra, 2004, p. 37)

If arts participation can promote self-esteem then this could be significant given that low self-esteem is a risk factor for depression, suicidal behaviour, eating disorders and being bullied (Emler, 2002). As Griffiths (2003) points out, "the role of the arts in creating opportunities for participation and in building social networks may be of particular importance because both are protective factors for mental health" (p. 28).

CREATIVE ARTS AND HUMANITIES IN HEALTHCARE

While service-user participation in arts activity is one aspect of this trend, there is also an interest in creativity from the perspective of the mental health service provider. In 2002, The Nuffield Trust (an independent health policy charitable trust) produced a report on the creative arts and humanities in health care (Philipp, 2002). This included recommendations on professional education, arts therapies and creative environments. It emphasised the importance of the arts in community development and health and advocated further development of the humanities in healthcare.

In the same year, the Royal College of Nursing Institute (RCNi) participated in a collaborative inquiry examining the concept of nurturing creativity in health, social care and education (Arts Council England, 2005). The work of Coats et al. (2004) and Coats, Dewing and Titchen (2006) identified the need for healthcare practitioners "to be encouraged and facilitated to use their creative imagination in finding ways of developing and sustaining humanistic caring practices (and) to develop expertise through gaining knowledge and experience in working with the arts in healthcare" (Coats et al., 2004, p. 9). Throughout the first decade of the 21st century there seemed to be a growing appreciation that health care professionals could harness creativity as a force to enhance mental health care.

Promoting and Sustaining Creativity in Healthcare

At this point it would helpful to take stock of some of our findings so far. This book poses a few questions. One of these is: *What would happen if those working in the field of mental health care were to develop their own awareness of creativity?* Another is: *What if mental health practice was considered a creative activity in itself?* The mental health care system can seem a joyless and uninspiring place to those who are on the receiving end of it. Equally, for those trying to provide high quality care, this can often seem to be within the context of an unimaginative or even hostile world of bureaucracy and frustrating limitations. So, how do we promote and sustain creativity in healthcare settings?

First, reflecting back to Chap. 2, we have Bohm's (2004) idea that, regardless of occupation, anyone can, in principle, approach life in a creative way; that "creativity of some kind may be possible in almost any conceivable field" (p. 7). Second, we have Schmid's (2005) assertion that "opportunities to be creative may be found in every kind of day-to-day activity, whether at work, home or in leisure" (p. 5). Third, understanding the difference between so called 'Big-C' and 'little-c' creativity helps us appreciate that mental health professionals are perfectly capable of everyday, little-c creativity (Kaufman & Sternberg, 2007; Andreasen & Ramchandran, 2012). Thus, we can conclude that practitioners can be creative in their everyday work and we would expect this to be of value to healthcare provider organisations. Amabile et al. (2005) note that creativity is highly valued as a key to enduring advantage in organisations keen to generate fresh ideas for products, services and processes to better achieve their goals. Since creativity is beneficial to organisations *and* increases the health and wellbeing of the mental health workforce (Schmid, 2005; Sawyer, 2012; Rothenberg, 1994) a central consideration for practitioners – and their managers and leaders – ought to be how to promote and sustain creativity in the workplace.

Clinical Supervision for Creativity and Wellbeing

Part of the solution to this problem of how to promote and sustain creativity might lie in clinical supervision, defined by the Nursing and Midwifery Council (2002) as "a practice-focused professional relationship, involving a practitioner reflecting on practice guided by a skilled supervisor" (p. 7). Berg and Hallberg (1999) considered the effects of systematic clinical supervision on nurses' sense of

- coherence
- creativity
- work-related strain
- job satisfaction.

These are aspects of organisational wellbeing that will be explored more fully in Chaps. 4 and 9. Berg and Hallberg, using a Creative Climate Questionnaire, found that clinical supervision led to a significantly more creative and innovative climate in the dimensions of trust, idea time and reduced conflicts. However, the organisational climate remained unchanged suggesting that increases in the *perceived* creativity of nurses may not be enough to produce organisational creativity.

ORGANISATIONAL CREATIVITY: A CREATIVE CLIMATE OR A RISK-AVERSE CLIMATE?

Ekvall's (1996) work on organisational climate and factors affecting organisational creativity identified ten dimensions which can usefully be applied to mental health care settings (see Box 3.2). It is easy to see how these ten dimensions relate to the concepts of creativity described in Chap. 2. For example, *playfulness/humour* links with Weston's (2007) balancing of discipline with playfulness, and with the uttering of witticisms that is seen as part of little-c creativity (Kaufman & Sternberg, 2007). However, it is the ninth of Ekvall's factors – *risk-taking* – which is perhaps most controversial when applying creativity to mental health care, and this needs closer examination.

Box 3.2 Ekvall's Ten Factors Affecting Organisational Creativity

1.	Challenge:	How challenged, emotionally involved and committed are employees to the work?
2.	Freedom:	How free are staff to decide how to do their job?
3.	Idea support:	Are there resources to give new ideas a try?
4.	Trust/Openness:	Do people feel safe speaking their minds and offering different points of view?
5.	Dynamism/ Liveliness:	How eventful is life in the organisation?

(*continued*)

Box 3.2 (continued)

6.	Playfulness/ Humour:	How relaxed is the workplace? Is it acceptable to have fun?
7.	Debates:	To what degree do people engage in lively debates about issues?
8.	Conflicts:	To what degree do people engage in interpersonal conflict?
9.	Risk-taking:	Is it acceptable to fail?
10.	Idea time:	Do employees have time to think things through before having to act?

Adapted from Ekvall (1996)

In 2006, the then incumbent Chief Nursing Officer (CNO) published a review of mental health nursing, *From values to action* (DoH, 2006). It placed an emphasis on a number of areas including:

- innovation
- the recovery approach
- positive therapeutic relationships
- a widening of skills
- more direct clinical contact time for inpatient nurses
- minimising the time nurses spend on administrative tasks

All of these areas could be interpreted as being favourable to promoting a more creative climate for mental health nurses (MHNs). However, alongside these priorities, the review stressed nurses must be able to assess comprehensively and respond to needs and identified risks. Few, if any, would question the importance of assessing and responding to service users' needs, but the issue of risk is more contentious. Some argue that mental health care is too preoccupied with risk assessment and risk management. As Stickley and Felton (2006) point out:

> Community care has increased the focus on risk management, and mental health nurses increasingly find themselves being pulled in two directions. Can they manage to promote a service user's liberty, whilst simultaneously endeavouring to protect the individual and society from danger? (p. 26).

This tension highlights a potential conflict, or at least a mixed message, at the heart of contemporary mental health care. Can professionals be

expected to promote recovery whilst remaining preoccupied with risk? As Stickley and Felton conclude, "promoting recovery will inevitably mean promoting autonomy. For as long as MHNs err on the side of protectionism people with mental health problems will remain confined behind the invisible walls of the asylum through coercion and stigma...." (p. 30).

We shall see in Chaps. 4 and 9 how erring on the side of protectionism impacts on the psychosocial wellbeing of MHNs. MacCulloch (2009) identified the triple stress of carrying the burden of complex risk, patient and family distress and potential criticism from wider society. Nurses are also sometimes constrained by "the invisible walls of the asylum" (Stickley & Felton, 2006, p. 30). Perhaps practitioners themselves need to enjoy a degree of freedom and autonomy if they are to be able to promote freedom and autonomy in service users.

Maintaining a Balance: Work-Related Stress in Mental Health Nursing

It could be argued that mental health practitioners want to promote recovery and autonomy but are under enormous pressure from their employing organisations to put safety first, to favour the side of caution, protectionism and defensive practice. As a result, workers, service users and carers experience a system in which recovery and autonomy are frustrated ... but at least people are supposed to be safe. This is unsatisfactory for everyone and may explain the problems, also acknowledged in the CNO's review, of work-related stress in mental health nursing and difficulties with recruitment and retention (DoH, 2006). The review highlighted 54 studies that compared mental health nursing to other branches of nursing as well as comparing mental health nursing to other mental health professions. It found evidence that MHNs experienced higher levels of stress and lower levels of job satisfaction compared with other nurses, as well as lower job satisfaction compared with mental health professionals of other disciplines and the highest rate of burn-out (DoH, 2006).

It is unlikely that this situation will have improved in the years since this 2006 review. The Royal College of Nursing's (2013) survey on the health, wellbeing and stress of nurses found that, despite some improvements in employers' awareness of staff health and wellbeing, "efficiency measures in the private and public sectors mean there are fewer people in the workplace doing more work, working longer hours, feeling less secure and

under tighter management" (p. 11). One MHN quoted in the report complained of unrealistic targets: "it appears stats are more important than quality time with clients" (p. 25).

If nursing and other mental health disciplines were to be considered creative activities in themselves this might provide an antidote to the more stultifying aspects of the work. This could be facilitated through both clinical supervision (Berg & Hallberg, 1999; MacCulloch, 2009) and the positive focusing on factors that affect organisational creativity (Ekvall, 1996). Such an approach may well have a positive impact on mental health workers' stress levels, job satisfaction and risk of burn-out. These might be the benefits for workers themselves. Implicit in this, though, is the suggestion that a less stressed, more satisfied, more autonomous, more empowered mental health workforce is likely to lead to greater autonomy and empowerment in service users and carers, to a fuller recovery from illness and more positive mental health. Indeed the result might be a higher level of wellbeing for the community and for society.

CHAPTER SUMMARY

This chapter has examined the relationship between creativity and mental health and the historical link between 'madness' and creativity. Dispelling persistent myths surrounding psychosis, mood disorder, artistic temperament and 'strong imagination', it argued that people are more likely to be creative when they are mentally well-balanced. The mental health benefits of arts and creativity were considered, including arts as social inclusion and as a protective factor. The use of creative arts and humanities in healthcare were explored as were ways of promoting and sustaining creativity, including clinical supervision. Organisational creativity was discussed, and the chapter concluded by suggesting a creative climate, rather than a risk-averse one, helps reduce work-related stress in mental health nursing, leading to greater autonomy and empowerment for the workforce and service users.

NOTES

1. To be fair to Nettle, even Rothenberg (1994) – making the case for an objective, scientific analysis of the area – called his book *Creativity and Madness.*

2. The precise meaning of *affect* is sometimes hard to define. The Royal Children's Hospital, Melbourne (2017) helpfully explain the relationship between emotional affect and mood as being comparable to that between the weather (affect) and the season (mood). Mood refers to emotional experience over a more prolonged period while affect refers to more immediate expressions of emotion.

REFERENCES

Amabile, T. M., Barsade, S. G., Mueller, J. S., & Staw, B. M. (2005). Affect and creativity at work. *Administrative Science Quarterly, 50*(3), 367–403.

Andreasen, N. C., & Ramchandran, K. (2012). Creativity in art and science: Are there two cultures? *Dialogues in Clinical Neuroscience, 14*(1), 49–54.

Arts Council England. (2005). *Arts, creativity and health in the South East.* Brighton: Arts Council England.

Berg, A., & Hallberg, I. R. (1999). Effects of systematic clinical supervision on psychiatric nurses' sense of coherence, creativity, work-related strain, job satisfaction and view of the effects from clinical supervision: A pre-post test design. *Journal of Psychiatric and Mental Health Nursing., 6*(5), 371–381.

Bohm, D. (2004). *On creativity.* London: Routledge.

Cassandra. (2004, November). Cassandra column. *Mental Health Today, 37.*

Coats, E., Dewing, J., & Titchen, A. (2006). *Opening doors on creativity: Resources to awaken creative working. A learning resource.* London: Royal College of Nursing.

Coats, E., Stephens, G., Titchen, A., McCormack, B., Odell-Miller, H., Sarginson, A., et al. (2004). *Creative arts and humanities in healthcare: Swallows to other continents.* London: The Nuffield Trust.

Colgan, S., Bridges, K., & Faragher, B. (1991). A tentative START to community care. *Psychiatric Bulletin, 15,* 596–598.

Department of Health. (2006). *From values to action: The Chief Nursing Officer's review of mental health nursing.* London: Department of Health.

Ekvall, G. (1996). Organizational climate for creativity and innovation. *European Journal of Work and Organizational Psychology, 5*(1), 105–123.

Emler, N. (2002). *Self esteem: The costs and causes of low self-worth.* London: Joseph Rowntree Foundation.

Griffiths, S. (2003). Arts and creativity: A mental health promotion tool for young African and Caribbean men. *Mental Health Review, 8*(3), 26–30.

Jamison, K. R. (1989). Mood disorders and patterns of creativity in British writers and artists. *Psychiatry, 52,* 125–134.

Jamison, K. R. (1996). *Touched with fire* (2nd ed.). New York: Simon & Schuster.

Jung, C. G. (1984). *The spirit in man, art and literature.* London: Routledge.

Kaufman, J. C., & Sternberg, R. J. (2007). Resource review: Creativity. *Change*, *39*, 55–58.

Leckey, J. (2011). The therapeutic effectiveness of creative activities on mental well-being: A systematic review of the literature. *Journal of Psychiatric and Mental Health Nursing, 18*(6), 501–509.

MacCulloch, T. (2009). Clinical supervision and the well-being of the psychiatric nurse. *Issues in Mental Health Nursing, 30*, 589–590.

Matarasso, F. (1997). *Use or ornament? The social impact of the arts.* Stroud: Comedia.

Nettle, D. (2001). *Strong imagination – Madness, creativity and human nature.* Oxford: Oxford University Press.

Nursing and Midwifery Council. (2002). *Supporting nurses and midwives through lifelong learning.* London: NMC.

Office of the Deputy Prime Minister. (2004). *Mental health and social exclusion – Social Exclusion Unit report.* London: HMSO.

Philipp, R. (2002). *Arts, health and well-being.* London: The Nuffield Trust.

Plato. (5th Century BC). *Ion.* Retrieved from http://www.sacred-texts.com/cla/plato/ion.htm

Rothenberg, A. (1994). *Creativity and madness – New findings and old stereotypes.* Baltimore: The John Hopkins University Press.

Royal Children's Hospital Melbourne. (2017). *Clinical practice guidelines: Mental state examination.* Retrieved from http://www.rch.org.au/clinicalguide/guideline_index/Mental_state_examination/

Royal College of Nursing. (2013). *Beyond breaking point? A survey report of RCN members on health, wellbeing and stress.* London: Royal College of Nursing.

Sawyer, R. K. (2012). *Explaining creativity: The science of human innovation* (2nd ed.). Oxford: Oxford University Press.

Schlesinger, J. (2004a). Creativity and mental health. *British Journal of Psychiatry, 184*(2), 184.

Schlesinger, J. (2004b). Heroic, not disordered: Creativity and mental illness revisited. *British Journal of Psychiatry, 184*(4), 363–364.

Schmid, T. (Ed.). (2005). *Promoting health through creativity: For professionals in health, arts and education.* London: Whurr Publishers Ltd..

Shakespeare, W. (1978). *A midsummer night's dream.* In P. Alexander (Ed.), *William Shakespeare: The complete works.* London: Collins.

Sternberg, R. J., & Lubart, T. I. (1999). *The concept of creativity: Prospects and paradigms.* In R. J. Sternberg (Ed.), *Handbook of creativity.* New York: Cambridge University Press.

Stickley, T., & Felton, A. (2006). Promoting recovery through therapeutic risk taking. *Mental Health Practice, 9*(8), 26–30.

Vernon, P. E. (1970). *Creativity.* Middlesex: Penguin Books.

Weston, A. (2007). *Creativity for critical thinkers.* New York: Oxford University Press.

Understanding Wellbeing and Mental Health Nursing

Abstract This chapter begins by introducing wellbeing theory and ranges from Aristotle's ideas about eudaimonia, through the positive psychology conceptions of Seligman and colleagues, to contemporary preoccupations with happiness, wellbeing and flourishing. It then outlines the findings of a systematic literature review conducted by the author, exploring the question: *what is wellbeing and how is it relevant to mental health nursing?* The findings are presented under five main thematic headings: wellbeing as a nebulous, multifaceted notion, physical wellbeing as a legitimate concern, psychosocial wellbeing *for* mental health nurses (MHNs), the psychosocial wellbeing *of* MHNs and finally spiritual wellbeing (MHNs as spiritual allies.) These findings are revisited and discussed in depth in Chap. 9, which also makes recommendations based upon this discussion.

Keyword Wellbeing theory • Aristotle and eudaimonia • Seligman and positive psychology • Happiness, wellbeing and flourishing • Mental health nursing • Physical wellbeing • Psychosocial wellbeing • Spiritual wellbeing

© The Author(s) 2018
T. Gillam, *Creativity, Wellbeing and Mental Health Practice*,
Palgrave Studies in Creativity and Culture,
https://doi.org/10.1007/978-3-319-74884-9_4

WHAT IS WELLBEING?

The two preceding chapters have considered the concept of creativity and how it might be applied to mental health. This book, however, is concerned not only with creativity but also with wellbeing so, just as Chap. 2 critically evaluated what is understood by creativity, this chapter will explore possible interpretations of the concept of wellbeing and its relevance for mental health practice.

This book has some of its roots in my own systematic review of the literature. My research began by asking the question: what is wellbeing and how is it relevant to mental health nursing? The aim was to explore possible interpretations of the concept and to consider the ways in which wellbeing is *currently* applied to mental health nursing, as well as how it *could be applied* in the future.

WELLBEING: UBIQUITOUS, MEANINGLESS?

Wellbeing has been described as "a complex, confusing and contested field (with) competing and contradictory definitions" (McNaught, 2011, pp. 7–8). The term is used imprecisely in various contexts (for example in the phrases *physical and emotional wellbeing, mental wellbeing, health and wellbeing,*) and often used in conjunction with, or as a synonym for, health and/or happiness. In its ubiquity it risks meaninglessness. Universities now boast Faculties of Health and Wellbeing, Student Counselling and Wellbeing Services, Sport and Wellbeing Services and policies on Health, Safety and Wellbeing. Local authorities have Health and Wellbeing Boards – statutory bodies charged with assessing the local population's needs and agreeing Health and Wellbeing Strategies. When I began my research in 2014, I typed the word wellbeing into online retailer Amazon's website. It yielded 20,000 results, ranging from books on mindfulness and child-rearing and CDs of relaxing music to aromatherapy oils, orthotic insoles and jars of honey. Repeating this experiment at the time of writing this book, nearly 76,687 results presented themselves, suggesting that the market for wellbeing-related goods has grown even larger in recent years.

Within the positive psychology movement, the concept of wellbeing has become increasingly better-defined and better-understood (Seligman & Csikszentmihalyi, 2000; Seligman, 2011). The term has also gained increasing currency in nursing circles. By 2008, it had found its way into the nurses' code of conduct, which stated no less than that the Nursing and Midwifery

Council (NMC) "exist to safeguard the health and wellbeing of the public (and nurses must work) to protect and promote the health and wellbeing of those in (their) care, their families and carers, and the wider community" (pp. 1–2). Nurses were thus given responsibility not only for health but for wellbeing, and the wellbeing not only of their own patients but of the wider community. In 2015, the NMC published a revised code which made four references to wellbeing, encouraging nurses to "pay special attention to promoting wellbeing" (p. 5) but also acknowledging that people can make their own contribution to their wellbeing. This would seem to represent a move towards seeing the promotion of wellbeing as a responsibility to be more equally shared between patients, the public and nurses.

Alongside the growing use of the term wellbeing there has been a shift in mental health nursing from an era when the specialism was called psychiatric nursing (primarily concerned with *mental illness*) to an era in which it is referred to as mental health nursing (ostensibly concerned with *mental health*.) With wellbeing, not merely health, now being regarded as the proper concern of nurses, the question arises whether there might, in the future, be a further development from mental *health* nursing towards mental *wellbeing* nursing.

It may be that the word wellbeing has become devalued, a mere buzzword. So, we first need to clarify what is understood by wellbeing and secondly if it has a relevance and applicability to mental health nursing. My research examined whether there could be a genuine synergy between contemporary mental health nursing and wellbeing. This involved exploring how a meaningful understanding of the concept can inform mental health nursing practice. Moreover, if promoting wellbeing is the proper concern of nurses, then consideration should also be given to the wellbeing of the nursing workforce itself since it seems logical that, just as unhealthy nurses may be less able to promote the health of others, nurses with low levels of personal wellbeing may struggle to enhance the wellbeing of their patients.

WELLBEING THEORY: FROM ARISTOTLE TO SELIGMAN

Despite the contemporary (probably overly inclusive) popular usage of the term, wellbeing is hardly a new idea. The ancient Greek philosopher Aristotle wrote about his concept of *eudaimonia* (in his *Nicomachean Ethics*). Ryff and Singer (2008) suggest eudaimonia is closely linked to the modern concept of wellbeing. More than the pursuit of happiness, Aristotle

believed that true wellbeing – eudaimonia – is attained by leading a virtuous life and doing what is worthwhile. Life's aim is to achieve happiness; eudaimonia involves the feeling not only that life is going well but that it accords with our full potential.

Just as, for Aristotle, there is more to eudaimonia than feeling cheerful or contented, modern concepts of wellbeing involve more than being happy. It may be tempting to denigrate the modern popularity of wellbeing as part of an unscientific, 'touchy-feely', 'New Age', 'self-help' form of 'pop psychology'. Martin Seligman (2011) has used the pejorative term *happiology* to distinguish his own work (which seeks to establish a scientific evidence base for wellbeing) from less valid approaches to happiness.[1]

Seligman can be seen as a kind of founding father of the positive psychology movement; a research scientist holding multiple professorships and a former President of the American Psychological Association, he is a respected member of the academically-rigorous, evidence-based psychological establishment. Seligman grew disillusioned with the limitations of psychological therapies which, he considered, merely minimise misery or, at best, relieve suffering. He began developing a theory of positive psychology with the goal of promoting what he initially called *authentic happiness*. In his writings, Seligman acknowledges his debt to Aristotle. Authentic happiness theory suggests happiness comprises of three elements:

- Positive emotion
- Engagement
- Meaning.

Seligman expanded this into a wellbeing theory wherein the goal (and measure) was not merely increased life satisfaction but an increase in *flourishing* (more of which later.) He criticised his own earlier work because of its overemphasis on life satisfaction which, he believed, only measures cheerful mood, hence being no more than "happiology" (p. 14.) In other words, one could be cheerful but still not experience wellbeing if one feels disengaged or that life is essentially meaningless. Ferkany (2012), writing from a philosophical rather than psychological perspective, puts this slightly differently when he succinctly describes two distinct aspects to wellbeing: "... doing well and life's going well ..." (p. 489). He suggests, while subjective feelings of happiness and satisfaction are part of wellbeing, objectively observable factors like positive relationships and accomplishments may be more important. This concurs with Seligman's (2011) developed view of wellbeing as comprising five elements (see Box 4.1) summarised by the mnemonic 'PERMA':

- Positive emotion
- Engagement
- Relationships
- Meaning
- Accomplishment.

Box 4.1 Seligman's Five Elements of Wellbeing (summarised by the mnemonic 'PERMA')

- **Positive emotion**
 - 'the pleasant life' (of which happiness and life satisfaction are aspects)
- **Engagement**
 - feeling completely absorbed in something
- **(Positive) Relationships**
 - other people
- **Meaning**
 - belonging to and serving something that you believe is bigger than the self
- **Accomplishment**
 - the pursuit of success, achievement and mastery for its own sake.

– Adapted from Seligman (2011)

EVIDENCE INTO POLICY

In 2008, the New Economics Foundation's (NEF) Centre for Well-being reviewed existing evidence and developed a set of evidence-based actions to improve personal wellbeing (Aked, Marks, Cordon, & Thompson, 2008). Their report *Five ways to well-being* brings together evidence and translates its key findings into five actions that the public could easily implement, (in a way that echoes the well-known five-a-day campaign to encourage healthy eating.)

Like Ferkany's (2012) dualistic "doing well and life's going well", Aked et al. (2008) identify two main elements that make up wellbeing: "feeling good and functioning well" (p. 1). *Feeling good* (which equates with Seligman's Positive emotion) includes feelings of happiness, contentment, enjoyment, curiosity and engagement. (Engagement is included as an aspect of feeling good, rather than a separate element in itself.) As for *functioning well*, this encompasses: positive relationships, having control

over one's life and a sense of purpose, corresponding approximately with Relationships, Meaning and Accomplishment – the 'RMA' of Seligman's 'PERMA'.

Drawing on the various elements of "feeling good and functioning well" (Aked et al., 2008, p. 1), the NEF produced their wellbeing 'five-a-day', recommending five actions to be incorporated into day-to-day lives to promote wellbeing:

- Connect
- Be active
- Take notice
- Keep learning
- Give

Aked et al. (2008) provide an evidence-based rationale for each action. For example, connecting with others is important because social relationships are critical for promoting wellbeing and act as a buffer against mental ill health while giving to others (say, in random acts of kindness) is associated with neuronal stimulation in the brain's reward areas, leading to enhanced self-worth and positive emotion as well as greater social cooperation.

FROM WELLBEING TO FLOURISHING

Five ways to well-being draws substantially upon the work of Felicia Huppert and colleagues at the University of Cambridge Wellbeing Institute. Huppert and So's (2009) concept of *flourishing* can be viewed as an extension or elaboration of Seligman's PERMA model. Flourishing equates to a high level of wellbeing. According to Huppert and So (2009) flourishing requires three core features plus six additional features (See Box 4.2).

Using these measures, in 2006–7, the prevalence of flourishing was assessed across the (then) 22 countries of the European Union, by means of a European Social Survey (Huppert & So, 2009). Data from 43,000 adults was surveyed to ascertain the percentage of Europeans who could be said to be flourishing. It was found Eastern European countries tended to have lower levels of wellbeing while Scandinavian countries enjoyed the highest. According to Huppert (2008) only 14 per cent of the UK's population (ranked tenth in the survey) was flourishing. A further 14 per cent had very low wellbeing; (this excluded those with diagnosed mental health conditions.)

Box 4.2 Features of Flourishing
Three core features:

- Positive emotions
- Engagement, interest
- Meaning, purpose

and six additional features of:

- Self-esteem
- Optimism
- Resilience
- Vitality
- Self-determination
- Positive relationships

– adapted from Huppert and So (2009)

In this context it is understandable that governments are beginning to consider wellbeing as a subject worthy of study, not only from a health but a socio-economic perspective.[2] Thus, the NEF sought to promote it "as a legitimate and useful aim of policy and to provide people with the understanding and tools to redefine wealth in terms of well-being" (Aked et al., 2008, p. 1). Similarly, a UK government report sees mental wellbeing as "a state, in which the individual is able to develop their potential, work productively and creatively, build strong and positive relationships with others, and contribute to their community" (Foresight Mental Capital and Wellbeing Project, 2008, p. 10). Viewed this way, wellbeing is valuable to governments, particularly in times of austerity, because it increases productivity, employability and social cohesion. The Foresight report suggests, while the needs of those with learning difficulties and mental disorders are important, policies should nurture the wellbeing of the wider population, "so that everyone can flourish throughout their lives" (p. 10). By this token, the wellbeing of the whole population matters and it becomes a goal of government policy for citizens to achieve no less than the highest level of wellbeing – flourishing.

The Care Act 2014 (governing adult social care in England) came into effect in England in 2015, making the promotion of wellbeing a statutory duty for local authorities (Care Act, 2014). A new principle of individual wellbeing underpins the Act, seeking to make physical, mental and emotional wellbeing the driving force behind care and support.

RELEVANCE TO MENTAL HEALTH NURSING

My own research examined literature of especial relevance to mental health nursing in order to explore more deeply the relationship between wellbeing and the branch of nursing specialising in mental healthcare. The language used in policy documents relating to mental health is telling. For example, a report by the CentreForum Mental Health Commission (2014) was called *The pursuit of happiness: a new ambition for our mental health*. While advocating effective, timely interventions to promote recovery in mental healthcare it also emphasised the promotion of wellbeing for all. Canada's Mental Health Commission called its 2009 national mental health strategy *Toward recovery and well-being*. As one might expect, this set goals for effective programmes and treatments for mental illness, integrating people with mental health problems and prevention of mental health problems, but went further in aiming to be "a strategy for achieving the best possible mental health and well-being for everyone" (Mental Health Commission of Canada, 2009, p. 13), just as the Foresight Project (2008) concerned itself, not only with the care of those with mental health conditions, but with the wellbeing of the whole population.

MENTAL HEALTH NURSING'S ROLE

It would appear, then, that national and local government agencies, think tanks and researchers are urging healthcare systems to go beyond the traditional provision of treatment and care of mentally ill people. Certainly, promoting recovery is advocated but also prevention of mental ill health in the general population. Moreover, there is a drive to extend this further so that systems cater for the promotion of wellbeing across the whole of society, preferably to the point where everyone can flourish. Notwithstanding the duty now placed on social care to promote wellbeing in England (Care Act, 2014) it seems the nursing profession conspicuously has been charged with protecting and promoting wellbeing, not only in those under their care but in the wider community (NMC, 2015). Since there is clearly a

connection between wellbeing and mental health, mental health nurses (MHNs) would seem to be especially well-placed to spearhead what sounds like something amounting to a social revolution. But, if MHNs are to play a pivotal role in helping society flourish, we need to scrutinise what they currently do, whether they have the skills and capacity for this new role and whether they themselves enjoy high levels of wellbeing.

Ironically, there is some evidence that nurses' own wellbeing may be compromised by working in mental healthcare (Leka, Hassard, & Yanagida, 2012). There is also evidence that positive psychology's approach to wellbeing has not yet been adopted by practicing MHNs. Blakeman and Ford (2012) found MHNs are indeed well-placed to promote the wellbeing of service users but the profession is still predominated by an 'ill-well' continuum. Embracing wellbeing, they suggest, would lead to different ways of working (a key theme of this book.) Wellbeing promises to transform the profession and wider society but first possible interpretations of the concept need exploring and consideration given to how it is, and could be, applied.

FIVE EMERGING THEMES

My research involved a critical appraisal of the literature and the use of thematic analysis. The findings were organised into five main emerging themes:

1. Wellbeing as a nebulous, multifaceted notion
2. Physical wellbeing as a legitimate concern
3. Psychosocial wellbeing *for* MHNs
4. The psychosocial wellbeing *of* MHNs
5. Spiritual wellbeing – MHNs as spiritual allies.

Within the themes of Psychosocial wellbeing *for* MHNs and the Psychosocial wellbeing *of* MHNs are a number of subthemes:

- Facilitating flourishing
- Relatives, carers and family life
- General health and psychological wellbeing
- Recovery
- Occupational stress and satisfying professional practice
- Individual and organisational wellbeing
- Traumatised by concern – the wellbeing of student MHNs.

In this chapter, the aim is simply to outline the findings. Chapter 9 will revisit these, discussing them in depth and making recommendations based upon this discussion.

Wellbeing as a Nebulous, Multifaceted Notion

Rose and Glass (2006) describe how the Australian community MHNs in their qualitative study had difficulty defining wellbeing. One of those interviewed spoke of its nebulous nature and the researchers identified this as a defining characteristic. Part of wellbeing's nebulousness is its multifaceted nature. The literature refers to various types of wellbeing including:

- physical (Jones, 2004)
- mental (Saarijarvi et al., 1998)
- psychological (Morrissette, 2004; Ruddick, 2013)
- social (Blakeman & Ford, 2012)
- emotional (Rose & Glass, 2006; Morrissette & Doty-Sweetnam, 2010)
- psychosocial (McCauley, Hacker Hughes, & Liebling-Kalifani, 2010)
- spiritual (both religious and existential) (Hood Morris, 1996; Dunn, Handley, & Shelton, 2007)
- individual and organisational wellbeing (Thomsen, Arnetz, Nolan, Soares, & Dallender, 1999).

Apart from this profusion of wellbeings, the concept is also linked to a wide range of areas including socio-economics, positive psychology, nursing, occupational stress, isolation, burnout, health promotion, family life, children, older people, military personnel, stigma, marginalisation, resilience, stress management, recovery, trauma, gender, sexuality, holism and feminism.

Physical Wellbeing as a Legitimate Concern

It is a commonplace that nursing should be holistic because of the inseparability of physical and mental health. For example, Ruddick (2013) describes the two aspects as inextricably linked and highlights the expectation on nurses to promote both, citing examples such as incorporating exercise and dietary management into treatment plans for anxiety and depression. Alongside a growing awareness of physical wellbeing in common mental health conditions there is an increasing emphasis on monitoring and promoting physical

health, especially in patients with serious mental illness (SMI).[3] Jones (2004) emphasises the significant body of evidence and policy guidelines linking schizophrenia with increased diabetes and cardiovascular risk while Younger (2011) underlines the increased risk of HIV and some cancers in people with SMI.

Jones (2004) offers examples of MHNs attending to the physical health of SMI patients by providing wellbeing support programmes, lifestyle assessment and advice, physical health checks and healthy lifestyle groups. Younger (2011) argues for nurses in all fields to be aware of the links between mental and physical wellbeing to ensure holistic treatment. One New Zealand account (Stodart, 2014) describes the work of a MHN who provided wellness checks in the Maori community monitoring diabetes risk, cardiovascular, eye and dental health, sexual health, diet, drug and alcohol issues, and measuring heart rate, blood pressure, weight, body mass index, blood sugar and oxygen saturation levels. According to Stodart such a holistic approach incorporates the four cornerstones of Maori health (physical, mental, family and spiritual.)

Psychosocial Wellbeing for Mental Health Nurses

Most of the literature reviewed concerned not physical but psychosocial wellbeing (including mental, psychological, social, emotional, individual and organisational wellbeing.) The psychosocial wellbeing of service users (as a service delivery issue) will be considered first before moving on to the psychosocial wellbeing of MHNs themselves. A distinction is thus made between psychosocial wellbeing *for* MHNs and the psychosocial wellbeing *of* MHNs.

Facilitating Flourishing

In a review of sociological concepts related to mental health nursing, Blakeman and Ford (2012) discuss links between individual health and the socio-economic context, finding poverty and social exclusion correlate with poorer health and lower levels of wellbeing. Ruddick (2013) similarly acknowledges the impact of loneliness and poverty and discusses the concepts of *psychological wealth* (an individual's global sense of wellbeing and life satisfaction) and *resilience* (the ability to use coping skills to withstand life's challenges.) Rather than viewing mental health in terms of its absence, Ruddick maintains public mental health would be better served by positively promoting resilience and wellbeing and, while government has a

role, there is a role for nurses (which involves supporting the welfare of children and families and greater use of solution-focused approaches and self-management resources like the Wellness Recovery Action Plan (WRAP) (Copeland, 2000).)

Blakeman and Ford (2012) also discuss resilience, noting that growing up in poverty hinders its development, thus nurses need to be aware of the impact of social exclusion and inequality, able to identify and mobilise strengths in the community to bolster resilience and attend to strengths rather than focusing on symptom reduction or amelioration. Several definitions of wellbeing are cited including one from the policy document *No Health Without Mental Health* (DoH, 2011) which defines wellbeing as: "a positive state of mind and body, feeling safe and able to cope, with a sense of connection with people, communities and the wider environment" (p. 90). Another definition, mentioned by Blakeman and Ford (2012), views wellbeing as a continuum, with *flourishing* at one extreme and *languishing* at the other (Keyes, 2002). To be flourishing is to enjoy positive emotion and good psychological and social functioning while languishing is associated with emptiness, stagnation and despair. Languishing is seen as not, in itself, pathological but as a risk factor for mental illness while, conversely, flourishing is a protective factor. Therefore, Blakeman and Ford (2012) conclude, MHNs need appropriate training and interventions to facilitate flourishing and they question whether current interventions (like cognitive behavioural therapy and medication) achieve this. Like Ruddick (2013), they see value in Aked et al.'s (2008) *Five Ways to Wellbeing* as a framework MHNs could use to promote resilience, emotional intelligence and self-esteem. Blakeman and Ford also encourage MHNs to reflect on how their current practice promotes wellbeing, to engender greater social inclusion through interventions and to engage politically through public health campaigns, writing for publication and sharing knowledge through support, supervision and educational groups.

Relatives, Carers and Family Life
Jormfeldt (2014) concurs that MHNs need to go beyond symptom reduction to support and empower patients to make health and situational choices. She sees MHNs' role as facilitating transitions through emotionally supportive, trusting relationships that enhance patients' – and their relatives' – self-understanding and wellbeing. A number of authors discuss the importance of relatives, carers and family life to psychosocial wellbeing.

In a Finnish double-blind placebo-controlled parallel group study involving relatives of patients with schizophrenia, Saarijarvi et al. (1998) found relatives' psychological wellbeing increased when given access to a community MHN (CMHN). Minardi, Heath and Neno (2007) considered the future wellbeing of older people and suggest MHNs will have an important role supporting carers while initiatives focusing on social inclusion and dealing with loss could improve carers' wellbeing. Weber (2008) explores parenting, family life and wellbeing among sexual minorities in the US, and argues stigma and marginalisation negatively impact on the psychosocial wellbeing of lesbian and gay parents and their children, urging nurses to be mindful of this. McGuinness and McGuinness (2014) review the wellbeing of children in military families, and the impact of their parents' military deployment, recommending MHNs screen children in this situation for anxiety, depression, effects on academic performance, relationships, suicidal ideation and risk behaviours.

General Health and Psychological Wellbeing
A correlational cohort study of Jordanian university students considered the relationship between general health and perceived psychological wellbeing (Hamdan-Mansour & Marmash, 2007) using Ryff and Keyes' (1995) Psychological Well-Being Scale, which measures six dimensions:

- purpose in life
- self-acceptance
- positive relationships
- personal growth
- environmental mastery
- autonomy.

While previous studies report poor psychological status among university students, this study found respondents reported positive perceptions of their psychological wellbeing which, the researchers hypothesised, may be due to differing social and cultural norms among Arab people and the fact that, in Jordan, students tend to remain in the family home. Higher perception of psychological wellbeing correlated with better general health, leading Hamdan-Mansour and Marmash (2007) to recommend MHNs screen for physical symptoms as well as assessing psychological wellbeing.

Recovery

Papadopoulos, Fox and Herriott (2013) take the concept of recovery (increasingly prevalent in UK mental health policy and practice) and propose its integration within a wider framework of wellbeing. They suggest recovery could lead beyond absence of symptoms and greater social inclusion towards wellbeing. Their wellbeing framework has six features:

- integrity of self
- integrity of other
- belonging
- agency
- enrichment
- security.

Like Ruddick (2013) they favour the use of WRAP and outline implications for services generally and MHNs specifically.[4] They suggest their framework provides a context within which nurses could strike a balance between technical expertise and recovery values, helps change the culture for all mental health professions and supports people to maximise their wellbeing.

The Psychosocial Wellbeing of Mental Health Nurses

For the avoidance of confusion, it is worth reiterating here that a distinction is made between psychosocial wellbeing *for* MHNs and the psychosocial wellbeing *of* MHNs. The former concerns the psychosocial wellbeing of service users (as a service delivery issue) and the implications of this for nurses (as outlined above). Thus, MHNs are encouraged to consider those four sub-themes of:

- Facilitating flourishing
- Relatives, carers and family life
- General health and psychological wellbeing
- Recovery.

All of these, as we shall see in Chap. 9, have important implications for clinical practice. No less important, though, is the theme of the psychosocial wellbeing *of* MHNs, put forward below. This includes the three sub-themes of:

- Occupational stress and satisfying professional practice
- Individual and organisational wellbeing
- Traumatised by concern – the wellbeing of student MHNs.

Occupational Stress and Satisfying Professional Practice
A Japanese cohort study investigated the impact of psychosocial risks and occupational stress on inpatient MHNs' wellbeing (Leka et al., 2012). Two dimensions of wellbeing were measured: *feeling uptight* and *emotional exhaustion*. The study used the General Well-Being Questionnaire, a reliable, validated measure of general malaise (which corresponds with poor wellbeing) (Cox & Gotts, 1987). Leka et al. rehearse evidence that stress and burnout are widespread in nursing, that MHNs experience higher levels compared with other mental health professionals and that burnout is significantly higher in CMHNs compared with public health nurses. Furthermore, those most at risk of poor physical and mental health are those experiencing job strain (high psychological demand with low job control) paired with low support in the workplace.[5] Leka et al. found high levels of work-related stress in their sample (361 MHNs across six Japanese hospitals). Poor wellbeing was predicted by high psychological job-demands, low levels of support at work and occupational stress coupled with low social support. They therefore recommend organisations adopt strategies to minimise psychological demand and occupational stress and provide support networks and resources to build resilience. Stress management techniques (including relaxation and behavioural techniques, stress management workshops and training in therapeutic skills) were found to be effective. The supportive benefits of clinical supervision are emphasised, alongside mentoring for younger nurses (who were found to be more prone to emotional exhaustion than older MHNs.)

An Australian study (Tyson, Lambert, & Beattie, 2002) explored the impact of inpatient ward design on MHNs' occupational satisfaction and wellbeing. Using the Maslach Burnout Inventory (Maslach & Jackson, 1986) and a job satisfaction measure (Warr, Cook, & Wall, 1979) Tyson et al. found improvements in the inpatient environment were better for patients but worse for MHNs. This appeared to be due to increased burn-out and stress linked with feeling more isolated from colleagues.

Cole, Scott and Skelton-Robinson (2000) examined the psychological wellbeing of MHNs caring for older adults in UK residential settings. This two-group comparison study used the General Health Questionnaire (GHQ-28), a highly reliable measure of emotional distress in medical

settings which screens for risk of psychiatric disorder (Goldberg, 1978). Cole et al. found the significant factors causing occupational stress were organisational (role definition, support mechanisms, knowledge of procedures), rather than related to residents' challenging behaviour.

Using a critical feminist theoretical framework, oral narrative/storytelling and reflective journaling methods, Rose and Glass (2006) explored the relationship between emotional wellbeing and satisfying professional practice in Australian CMHNs. Asserting that radical, rapid change in healthcare and economic pressures have resulted in the wellbeing of nurses being considered less important than that of their service users, they identified four components of emotional wellbeing:

- the nebulous notion
- the stress relationship
- the mind/body/spirit connection
- inner sense of balance.

Levels of autonomy, satisfaction and perceived ability to speak out all impacted on professional practice. CMHNs' work is characterised by greater autonomy than that of inpatient MHNs and Rose and Glass found, to maintain emotional wellbeing and satisfying professional practice, organisational support to practice autonomously and to participate in clinical supervision was necessary.

MacCulloch (2009) further endorses the benefits of clinical supervision, seeing it as not only concerned with the safety and wellbeing of clients and families but also of the clinician. Like Rose and Glass (2006), he highlights the context of diminishing resources, increasing acuity and higher levels of individual responsibility and accountability. CMHNs, especially, he contends, experience greater isolation and carry a burden of complex risk, patient and family distress and potential criticism from wider society. MacCulloch sees supervision as a safe, trusting, respectful and empathic relationship which can help MHNs retain a sense of meaning and attend to their own wellbeing. Just as Jormfeldt (2014) regards the MHN's role as building trusting relationships to enhance patient and carer wellbeing, so MacCulloch sees the trusting relationship of supervision as supporting MHNs' wellbeing.

In a cohort study that complements McGuinness and McGuinness's (2014) review of the wellbeing of children in military families, McCauley et al. (2010) investigated the wellbeing of military MHNs and psychiatrists.

They reviewed evidence that military health professionals are prone to trauma, stress and burnout (which affect patient care) but taking part in life-threatening situations can, conversely, improve psychological wellbeing and resilience – a process termed *post-traumatic growth* (Joseph, 2004). McCauley et al. found psychological ill health and post-traumatic stress disorder were prevalent in military MHNs but most participants also reported growth and personal development linked to their deployment, with some reporting improvements in their clinical work and their outlook generally. The findings were consistent with earlier research but were not replicated in the quantitative data, leading McCauley et al. to suggest qualitative methods were better at eliciting information about relationships.

Individual and Organisational Wellbeing
One cross-cultural study (Thomsen et al., 1999) explored individual and organisational wellbeing, comparing MHNs in Sweden and England. Both these types of wellbeing appear to be different aspects of psychosocial wellbeing – individual wellbeing is defined as health and work satisfaction (measured by professional fulfilment, work-related exhaustion, mental energy, personality and background variables); organisational wellbeing is the perceived work environment (the subjective experience of organisational characteristics like autonomy, workload and leadership.)

Thomsen et al. (1999) review evidence that English MHNs are at increased risk of poor mental health, working with SMI patients is highly stressful and political and organisational factors, including management style, impact most on job satisfaction. Personality factors also play a part, especially self-esteem and hardiness (a concept similar to resilience). The paradoxical nature of psychiatric nursing is explored, wherein MHNs experience multiple areas of conflict:

- between ethical values and systemic limitations
- between patient empowerment and the benign authoritarianism of the biomedical model
- in applying a clinical approach to social problems.

The study found Swedish MHNs reported higher individual wellbeing while English MHNs experienced higher organisational wellbeing. Thomsen et al. (1999) found self-esteem was an important predictor of mental energy and conclude that, if English MHNs' self-esteem were as high as that of Swedish MHNs, they would enjoy equally good individual

wellbeing. Another important factor was autonomy – rated higher by the English MHNs. This suggests autonomy may not always contribute to wellbeing if nurses feel they lack the knowledge, skills or status to exercise it. Autonomy is one dimension of psychological wellbeing (Ryff & Keyes, 1995) but, as Rose and Glass (2006) found, to maintain emotional wellbeing, MHNs need organisational support to practice autonomously.

Traumatised by Concern: The Wellbeing of Student Mental Health Nurses

While McCauley et al. (2010) discussed trauma in the context of military deployment, Morrissette (2004) explores trauma as an aspect of student MHNs' experience. He asserts that students often suffer vicarious trauma or secondary traumatic stress when witnessing patient behaviour. Reviewing the evidence in terms of burnout, stress, counter-transference and wellbeing in MHNs, Morrissette (2004) laments a lack of research on student MHNs' wellbeing. He cites Figley's (1995) work on *compassion fatigue* which observes that attention is usually focused on the cared-for, rather than on those who care – a point echoed by Rose and Glass (2006).

Morrissette (2004) states that, historically, work-related problems have been neglected within mental health because professionals are not supposed to experience emotional depletion or burnout (and discussing this openly may dissuade new recruits.) Students may deny personal struggles because they are supposed to be providers rather than recipients of care unaware that, as caregivers, they may be "traumatised by concern" (p. 535.) Just as Leka et al. (2012) found younger nurses more prone to emotional exhaustion, Morrissette (2004) found student MHNs became emotionally depleted by their perceived inability to alleviate patient distress. They reported emotional numbness – a protective mechanism rather than a sign of disinterest – during intense clinical situation. They may experience changes, associated with compassion fatigue or secondary traumatic stress, in their own mood or behaviour in reaction to hearing painful stories or witnessing disturbing behaviour. Morrissette (2004) recommends strategies for student nurse wellbeing which include:

- anticipating the impact of caregiving
- maintaining personal awareness through feedback and clinical supervision
- providing a safe, respectful atmosphere
- protective strategies such as those suggested by Yassen (1995) (e.g. nutrition, exercise, sleep, relaxation and creative expression).

Morrissette also favours support networks, participation in professional organisations, realistic, achievable clinical goal-setting and, if required, mental health consultation in one's own right.

Building on this earlier work, Morrissette and Doty-Sweetnam (2010) examined how to safeguard students' emotional wellbeing by establishing respectful learning environments in MHN education. They emphasise the importance of the syllabus, personal boundaries and the educator-student relationship as a safe space. Just as feeling safe is an important element in wellbeing (DoH, 2011) and central both to the therapeutic relationship (Jormfeldt, 2014) and the clinical supervision relationship (MacCulloch, 2009), so Morrissette and Doty-Sweetnam emphasise the importance of a safe, boundaried, trusting, respectful learning environment to the emotional wellbeing of emerging MHNs.

Spiritual Wellbeing: Mental Health Nurses as Spiritual Allies

A small proportion of the literature reviewed dealt with spiritual wellbeing (SWB). Dunn et al. (2007) refer to Paloutzian and Ellison's (1982) conceptualisation of this as having two dimensions: *existential* and *religious*. The existential dimension is visualised as horizontal and includes a sense of meaning and purpose in life; the religious dimension is seen as vertical in that it refers to a relationship with God or a higher power. Dunn et al. considered SWB, anxiety and depression in antepartal women on bedrest and found that those with the lowest levels of SWB had the highest levels of anxiety and depression. Dunn et al. argue these findings support the use of a holistic framework involving body, mind and spirit – one of Rose and Glass's (2006) key components of emotional wellbeing – and suggest collaboration with MHNs and for nurse education to include physical, mental and spiritual assessment skills.

Coleman (2004) also uses the two-dimensional model of SWB in his study exploring its contribution to depression among African American heterosexuals with HIV. Like Dunn et al. (2007) Coleman found an inverse association between both aspects of SWB and depression – higher scores in existential and religious wellbeing correlated with lower depression scores. He also recommends MHNs adopt a holistic and multidisciplinary approach.

Pre-dating these two US studies, in Canada a somewhat different model of SWB had been developed by Hood Morris (1996), which she applied to older women experiencing depression. Within her model, Hood Morris identifies:

- enablers (pivotal life events, love, trust, meditation, prayer and contemplation)
- outcomes (such as a sense of purpose and meaning, guiding values and the ability to transcend current reality)
- virtues (that enkindle connection, enlightenment and empowerment.)

Key attributes are harmonious interconnectedness, creative energy and faith in a power greater than self. Parallels are drawn between depression and spiritual distress (characterised by cynicism, sense of loss and lack of conviction or enthusiasm) but, Hood Morris suggests, spiritual distress can either inhibit SWB or promote spiritual growth.

There are parallels here with the way in which trauma can lead to both stress and growth (Joseph, 2004) as seen in McCauley et al. (2010). As older women often struggle to maintain SWB (which may manifest as depression), the recommendation is MHNs act as "spiritual allies" (Hood Morris, 1996, p. 451),[6] using warmth, respect and empathy to help patients resolve their pain and despair. Alongside individual interventions for depression, groupwork is strongly advocated to support SWB because it provides opportunities for:

- connection
- creativity
- care
- contemplation
- transcendence of the limited experience of self
- drawing meaning from – and helping – others (thus instilling usefulness, hope and mutual reciprocity.)

CHAPTER SUMMARY

This chapter began by introducing wellbeing theory and ranged from Aristotle's ideas about eudaimonia, through the positive psychology conceptions of Seligman and colleagues, to contemporary preoccupations with happiness, wellbeing and flourishing. It then outlined the findings of my systematic literature review, exploring the question: *what is wellbeing and how is it relevant to mental health nursing?* The findings were presented under five main thematic headings: wellbeing as a nebulous, multi-faceted notion, physical wellbeing as a legitimate concern, psychosocial wellbeing *for* mental health nurses (MHNs), the psychosocial wellbeing *of* MHNs and finally spiritual wellbeing. These findings will be revisited and

discussed in depth in Chap. 9, which also makes recommendations based upon this discussion.

Through the course of these first four chapters, we have undertaken a detailed analysis of both creativity and wellbeing and how they relate to mental health. In the next chapter, we examine how we can begin to apply creativity in practice and to develop a model of creative mental health care.

NOTES

1. Seligman uses the hyphenated term 'well-being' rather than the single word 'wellbeing'. The older hyphenated form is used in North America and, while this is still used throughout the English-speaking world, the single word 'wellbeing' is now more widely used outside the US and Canada. For the purposes of this book, the single word form will be used, except when directly citing an author (such as Seligman) who used the hyphenated form in their original work.
2. In 1972, Bhutan's former King Jigme Singye Wangchuck made a half-joking remark suggesting Gross National Happiness (GNH) was as important as Gross Domestic Product (GDP). The idea was subsequently taken up by the Centre for Bhutan Studies who developed policy screening tools which measure the impact of different policies on the population's wellbeing level (McNaught, 2011).
3. While depression and anxiety can certainly be, in some cases, severe and debilitating, in mental health practice, because of their prevalence they are described as common mental health disorders and contrasted with relatively rarer disorders such as schizophrenia and bipolar disorder, which are denoted as serious (or severe) mental illness (sometimes abbreviated to SMI).
4. Papadopoulos et al. (2013) erroneously refer to the Wellness Recovery Action Plan (WRAP) as a Wellbeing Recovery Action Plan.
5. Job strain (high psychological demand with low job control) paired with low support in the workplace – a phenomenon that has been termed iso-strain (van der Doef & Maes, 1999).
6. Hood Morris (1996) provides a reference for an earlier use of the phrase "spiritual ally" (Colliton, 1981).

REFERENCES

Aked, J., Marks, N., Cordon, C., & Thompson, S. (2008). *Five ways to wellbeing: The evidence*. London: New Economics Foundation.

Blakeman, P., & Ford, L. (2012). Working in the real world: A review of sociological concepts of health and well-being and their relation to modern mental health nursing. *Journal of Psychiatric and Mental Health Nursing, 19*(6), 482–491.

Care Act. (2014). Retrieved from http://www.legislation.gov.uk/ukpga/2014/23/pdfs/ukpga_20140023_en.pdf

CentreForum Mental Health Commission. (2014). *The pursuit of happiness: A new ambition for our mental health*. London: CentreForum Mental Health Commission.

Cole, R. P., Scott, S., & Skelton-Robinson, M. (2000). The effect of challenging behaviour, and staff support, on the psychological wellbeing of staff working with older adults. *Aging & Mental Health, 4*(4), 359–365.

Coleman, C. L. (2004). The contribution of religious and existential well-being to depression among African American heterosexuals with HIV infection. *Issues in Mental Health Nursing, 25*(1), 103–104.

Colliton, M. A. (1981). *The spiritual dimension of nursing*. In V. Carson (Ed.), *Spiritual dimensions of nursing practice*. Toronto: W.B. Saunders.

Copeland, M. E. (2000). *Wellness recovery action plan*. Dummerston, VT: Peach Press.

Cox, T., & Gotts, G. (1987). *The general well-being questionnaire manual*. Nottingham: Department of Psychology, University of Nottingham.

Department of Health. (2011). *No health without mental health: A cross-government mental health outcomes strategy for people of all ages*. London: Department of Health.

Dunn, L. L., Handley, M. C., & Shelton, M. M. (2007). Spiritual well-being, anxiety, and depression in antepartal women on bedrest. *Issues in Mental Health Nursing, 28*, 1235–1246.

Ferkany, M. (2012). The objectivity of wellbeing. *Pacific Philosophical Quarterly., 93*, 472–492.

Figley, C. (Ed.). (1995). *Compassion fatigue: Coping with secondary traumatic stress disorder in those who treat the traumatized*. New York: Brunner/Mazel.

Foresight Mental Capital and Wellbeing Project. (2008). *Final project report – Executive summary*. London: The Government Office for Science.

Goldberg, D. (1978). *Manual of the general health questionnaire*. Windsor: NFER Nelson.

Hamdan-Mansour, A. M., & Marmash, L. R. (2007). Psychological well-being and general health of Jordanian university students. *Journal of Psychosocial Nursing, 45*(10), 31–39.

Hood Morris, L. E. (1996). A spiritual well-being model: Use with older women who experience depression. *Issues in Mental Health Nursing, 17*, 439–455.

Huppert, F. (2008). *Psychological well-being: Evidence regarding its causes and its consequences*. London: Foresight Mental Capital and Wellbeing Project.

Huppert, F., & So, T. (2009). *What percentage of people in Europe are flourishing and what characterizes them?* Cambridge: The Wellbeing Institute, Cambridge University.

Jones, A. (2004). Matter over mind: Physical wellbeing for people with severe mental illness. *Mental Health Practice, 7*(10), 36–38.

Jormfeldt, H. (2014). Perspectives on health and well-being in nursing. *International Journal of Qualitative Studies on Health and Well-Being, 9*, 10.

Joseph, S. (2004). Client-centred therapy, post-traumatic stress disorder and post-traumatic growth: Theoretical perspectives and practical implications. *Psychology and Psychotherapy Theory, Research and Practice, 77*(1), 101–119.

Keyes, C. L. M. (2002). The mental health continuum: From languishing to flourishing in life. *Journal of Health and Social Behavior, 43*, 207–222.

Leka, S., Hassard, J., & Yanagida, A. (2012). Investigating the impact of psychosocial risks and occupational stress on psychiatric hospital nurses' mental wellbeing in Japan. *Journal of Psychiatric and Mental Health Nursing, 19*(2), 123–131.

MacCulloch, T. (2009). Clinical supervision and the well-being of the psychiatric nurse. *Issues in Mental Health Nursing, 30*, 589–590.

Maslach, C., & Jackson, S. E. (1986). *Maslach burnout inventory. Research edition manual.* Palo Alto, CA: Consulting Psychologist Press.

McCauley, M., Hacker Hughes, J., & Liebling-Kalifani, H. (2010). Wellbeing of military mental health staff. *Mental Health Practice, 14*(4), 14–19.

McGuinness, T. M., & McGuinness, J. P. (2014). The well-being of children from military families. *Journal of Psychosocial Nursing, 52*(4), 27–30.

McNaught, A. (2011). Defining wellbeing. In A. Knight & A. McNaught (Eds.), *Understanding wellbeing: An introduction for students and practitioners of health and social care.* Banbury: Lantern Publishing Limited.

Mental Health Commission of Canada. (2009). *Toward recovery and well-being.* Alberta: Mental Health Commission of Canada.

Minardi, H., Heath, H., & Neno, R. (2007). *Mental health and well-being for older people in the future: The nursing contribution.* In R. Neno, B. Aveyard, & H. Heath (Eds.), *Older people and mental health nursing: A handbook of care.* Oxford: Wiley-Blackwell.

Morrissette, P. J. (2004). Promoting psychiatric student nurse well-being. *Journal of Psychiatric and Mental Health Nursing, 11*(5), 534–540.

Morrissette, P. J., & Doty-Sweetnam, K. (2010). Safeguarding student well-being: Establishing a respectful learning environment in undergraduate psychiatric/mental health education. *Journal of Psychiatric and Mental Health Nursing, 17*(6), 519–527.

Nursing & Midwifery Council. (2008). *The Code: Standards of conduct, performance and ethics for nurses and midwives.* London: NMC.

Nursing & Midwifery Council. (2015). *The Code: Professional standards of practice and behaviour for nurses and midwives.* London: NMC.

Paloutzian, R. D., & Ellison, C. W. (1982). Loneliness, spiritual well-being and the quality of life. In L. A. Peplau & D. Perlman (Eds.), *Loneliness: A sourcebook of current theory, research and therapy.* New York: Wiley.

Papadopoulos, A., Fox, A., & Herriott, M. (2013). Recovering wellbeing: An integrative framework. *British Journal of Mental Health Nursing, 2*(3), 145–154.

Rose, J., & Glass, N. (2006). Community mental health nurses speak out: The critical relationship between emotional wellbeing and satisfying professional practice. *Collegian, 13*(4), 27–32.

Ruddick, F. (2013). Promoting mental health and wellbeing. *Nursing Standard, 27*(24), 35–39.

Ryff, C. D., & Keyes, C. L. (1995). The structure of psychological well-being revisited. *Journal of Personality and Social Psychology, 69*, 719–727.

Ryff, C. D., & Singer, B. H. (2008). Know thyself and become what you are: A eudaimonic approach to psychological wellbeing. *Journal of Happiness Studies, 9*, 13–39.

Saarijarvi, S., Taiminen, T., Syvalahti, E., Niemi, H., Ahola, V., Lehto, H., & Salokangas, R. K. R. (1998). Relatives' participation in a clinical drug trial of schizophrenic outpatients improves their psychologic well-being. *Nordic Journal of Psychiatry, 52*(5), 389–393. Saarijarvi and colleagues use the rare word 'psychologic' (sic) rather than the usual 'psychological'.

Seligman, M. E. P. (2011). *Flourish: A new understanding of happiness and well-being – and how to achieve them.* London: Nicholas Brealey Publishing.

Seligman, M. E. P., & Csikszentmihalyi, M. (2000). Positive psychology: An introduction. *American Psychologist, 55*(1), 5–14.

Stodart, K. (2014). Breaking through the barriers to well-being. *Kai Tiaki Nursing New Zealand, 20*(3), 16–17.

Thomsen, S., Arnetz, B., Nolan, P., Soares, J., & Dallender, J. (1999). Individual and organizational well-being in psychiatric nursing: A cross-cultural study. *Journal of Advanced Nursing, 30*(3), 749–757.

Tyson, G. A., Lambert, G., & Beattie, L. (2002). The impact of ward design on the behaviour, occupational satisfaction and well-being of psychiatric nurses. *International Journal of Mental Health Nursing, 11*(2), 94–102.

van der Doef, M., & Maes, S. (1999). The job demand-control (-support) model and psychological well-being: A review of 20 years of empirical research. *Work and Stress, 13*, 87–114.

Warr, P., Cook, J., & Wall, T. (1979). Scales for the measurement of some work attitudes and aspects of psychological well-being. *Journal of Occupational Psychology, 52*, 129–148.

Weber, S. (2008). Parenting, family life, and well-being among sexual minorities: Nursing policy and practice implications. *Issues in Mental Health Nursing, 29*(6), 601–618.

Yassen, J. (1995). Preventing secondary traumatic stress disorder. In C. Figley (Ed.), *Compassion fatigue: Coping with secondary traumatic stress disorder in those who treat the traumatized.* New York: Brunner/Mazel.

Younger, C. (2011). The relationship between physical wellbeing and mental health care. *Mental Health Practice, 15*(1), 34–36.

Applying Creativity in Practice

Abstract Building on the understanding of creativity and wellbeing developed in preceding chapters, this chapter clarifies how creativity can be applied to mental health practice. It addresses two aspects of the question: how to apply concepts of creativity to one's own discipline and how to incorporate creative arts within practice. Themes of evidence-based practice, person- centred care, collaboration and caring lead towards a concept of creative mental health care. The meaning and role of creativity are explored along with risk-taking, improvisation, characteristics of creative mental health practitioners and barriers to creative practice. Incorporating creative arts within practice is examined, the benefits for practitioners and the role of improvisation in individual work, groupwork and team work. Finally, a new model of creative mental health care is outlined.

Keywords Creativity applied to mental health practice • Creative arts • Evidence-based practice • Person-centred care • Collaboration and caring • Risk-taking • Improvisation • Characteristics of creative mental health practitioners • Barriers to creative practice • Individual work • Groupwork • Teamwork • Model of creative mental health care

© The Author(s) 2018
T. Gillam, *Creativity, Wellbeing and Mental Health Practice*,
Palgrave Studies in Creativity and Culture,
https://doi.org/10.1007/978-3-319-74884-9_5

The Application of Creativity: Two Questions in One

In Chaps. 2 and 3 we examined the concept of creativity and its relationship to mental health. Chapter 4 then explored possible interpretations of the concept of wellbeing and its relevance for mental health practice. We should now have a deeper understanding of both concepts – creativity and wellbeing – but it may still be unclear *how* they can be applied. So, in this chapter we return to the theme of creativity to consider the application of creativity to practice.

As outlined in Chap. 2, regardless of occupation, anyone can approach life in a creative way and some kind of creativity may be possible in any field (Bohm, 2004). Moreover, every kind of day-to-day activity can provide opportunities to be creative (Schmid, 2005) and mental health nurses (MHNs) and others in the field are perfectly capable of everyday creativity (Kaufman & Sternberg, 2007; Andreasen & Ramchandran, 2012). So mental health care can, in theory, be a creative activity. How, though, can MHNs and other practitioners apply concepts of creativity and creative arts in their practice? There are really two separate questions embedded in this question. The first of these is about *applying concepts of creativity* to one's own discipline; the second is about *incorporating creative arts* within one's practice. These two separate questions will be considered in turn here.

Applying Concepts of Creativity

In an attempt to refine the concept, Fasnacht (2003) explores how creativity could be applied to nursing. She starts from the premise that creativity is an essential component of nursing practice and that it occurs daily in interactions between nurses, clients and families. This would suggest Fasnacht is thinking in terms of everyday, little-c creativity rather than genius-like big-C creativity (see Chap. 2)

Fasnacht's work is born out of a concern that a failure to acknowledge and encourage creativity in nurses at the start of their careers might hinder future developments and innovations in nursing practice and nursing science. She goes on to explore various conceptualisations of creativity, comparing its meaning in the fields of nursing, business and psychology. Her argument seems, however, to become more and more convoluted and circular, ending only in the conclusion that methods and techniques for developing creativity in nursing require further investigation.

EVIDENCE-BASED PRACTICE, PATIENT-CENTRED CARE AND CREATIVITY

Fasnacht's failure to reach any decisive conclusion might be seen as evidence in support of Bohm's (2004) argument, presented in Chap. 2, that creativity is not accessible through the use of "techniques and formulae" (p. 32). Acknowledging this, though, is perhaps tantamount to allowing our investigatory progress to be halted by one of Sternberg and Lubart's (1999) roadblocks (see Table 2.2), namely being indifferent to, or even against, the scientific spirit. To be counter-scientific would seem perverse when discussing nursing, in an era where evidence-based practice dominates healthcare. On this point, Finfgeld-Connett (2007) is helpful. In an editorial entitled *Mental health nursing is not fine art* she gently mocks other commentators (going back as far as Florence Nightingale) who have described nursing as a fine art. In modern times, Finfgeld-Connett suggests:

> given the growth of knowledge in nursing since Nightingale's era, it seems important for nurses to possess an updated understanding of the art of nursing that accounts for all aspects of the discipline: knowledge based, patient centred, and creative. In doing so, nurses may be able to realize the full potential of the discipline. (p. 9)

In this conceptualisation of nursing, creative aspects are not at odds with evidence-based practice but simply represent another aspect of the art of nursing. Finfgeld-Connett's suggestion – that the creative aspects of nursing are not in opposition to evidence-based practice – is a useful one, pointing to the idea that creativity can be understood as part of a group of interrelated concepts:

- evidence-based practice
- patient-centred (or person-centred) care
- creativity.

This triadic structure echoes the observation, made in Chap. 2, that most definitions of creativity are comprised of three components (Kaufman & Sternberg, 2007).

CREATIVITY, COLLABORATION AND CARING

Similarly, Le Navenec and Bridges (2005), in seeking to create connections between nursing care and the creative arts therapies, did so using the device of three interrelated concepts:

- creativity
- collaboration
- caring.

With its elegant alliteration it is evident how these three concepts translate very readily to contemporary mental health nursing with its emphasis on care and compassion and multi-disciplinary, multi-agency collaboration. Once again, seen in this context, creativity is just one element in a triad of aspects of nursing.

TOWARDS A CONCEPT OF CREATIVE MENTAL HEALTH CARE

A clearer picture is now emerging of how creativity can be applied to mental health practice. In Chap. 2, we saw how *combination* was one of Sawyer's (2012) three elements of creativity and formed part of his definition of the concept as "a new mental combination that is expressed in the world" (p. 7). We also highlighted Cropley's (2001) three key aspects of creativity: novelty, effectiveness and ethicality (see Box 2.1). In order to work towards a concept of creative mental health care, I make conscious use of the principle of combination in blending together different ideas about both creativity and mental health practice.

One reason Cropley's (2001) definition was singled out in Chap. 2 as particularly useful when applying creativity to health care was the third of its key aspects – *ethicality*. This is a crucial aspect for practitioners. While effectiveness is obviously important in mental health care, novelty might be considered more dispensable, perhaps even frivolous and unnecessary. That said, if we accept creativity is desirable then we have to accept novelty as a key component. Ethical practice, however, is paramount to the serious application of creativity in mental health practice and this is clear from the emphasis placed on ethicality in the codes of professional standards which govern nursing, occupational therapy (OT), social work and other disciplines (NMC, 2015; RCOT, 2015; BASW, 2014; HCPC, 2016).

So, given all that has been said so far, it is possible to begin to imagine what *creative* mental health care might look like in practice. It would be a *new combination* that is *expressed in the world* of everyday mental health care (rather than remaining as an unexpressed idea in the minds of practitioners) (Sawyer, 2012). It would involve a combination of *novelty, effectiveness and ethicality* (Cropley, 2001). It would *produce work* – crafted, person-centred, therapeutic relationships and interventions – (Barker & Buchanan-Barker, 2005) and this work would be both *novel and appropriate* (Sternberg & Lubart, 1999). Moreover, creative mental health care would be at once both *disciplined and playful* (Weston, 2007; Lane, 2006) (See Box 5.1).

Box 5.1 Characteristics of Creative Mental Health Care in Practice

- A new combination
- Expressed in the world of everyday mental health care (rather than remaining as an unexpressed idea in the minds of practitioners)
- Combining novelty, effectiveness and ethicality
- Producing work – crafted, person-centred, therapeutic relationships and interventions
- With outcomes that are both novel and appropriate
- Delivered in a way that is both disciplined and playful

Going further, we could add more detail to how creative mental health care might look in practice. Drawing on Bohm (2004), one might extend an understanding of creative mental health care to suggest that its aim would be to avoid "mediocrity and mechanicalness" in practice (p. 27) so that greater creativity could render the work more meaningful for the practitioner. Bohm argues for the cultivation of a creative state of mind which he suggests ought to be achievable for all, (although he disputes the idea that creativity can be readily learnt through techniques and methods.) A culture in which good quality, systematic clinical supervision is available would seem to be one that promotes creativity. However, clinical supervision, while necessary, is not sufficient in itself to ensure a more generally creative climate (Berg & Hallberg, 1999). Finally, risk-aversion appears to be a threat to a creative climate (Stickley & Felton, 2006) and it seems likely that a culture that promotes positive risk-taking in both its service users and service providers would be a more creative environment for all (Ekvall, 1996).

Creative mental health care is not antithetical to evidence-based practice but, rather, creative and evidence-based approaches are complimentary (Finfgeld-Connett, 2007). It is helpful to view mental health nursing as being made up of a group of interrelated concepts. For Finfgeld-Connett nursing comprises a triad of evidence-based practice, patient-centred care and creativity while, for Le Navenec and Bridges (2005) the triad is made up of creativity, collaboration and caring.

Lessons from Family Therapy and Couples Therapy

Carson, Becker, Vance and Forth (2003) carried out a study into therapists' perceptions of the role of creativity in family therapy and couples therapy. They surveyed 142 marriage (or couples) therapists and family therapists in 36 states in the US. While these therapists may represent a somewhat different group to MHNs, Carson et al.'s findings provide another rich perspective that is highly relevant to our understanding of creative mental health practice. They argue that creative thinking in couples and family work often leads to real and lasting breakthroughs and that creative energy promotes families' own problem-solving efforts, imagination, flexibility and playfulness. The study explored:

- the meaning and role of creativity in couples and family work
- the characteristics of a creative family therapist
- interventions believed to yield the most novel and helpful experiences
- barriers to creative practice.[1]

The Meaning and Role of Creativity: Risk-Taking and Improvisation

Carson et al. (2003) found an important part of creativity in family therapy was "the ability to apply traditional treatment modalities in novel ways" (p. 102). The respondents in their study mentioned the centrality of taking risks with clients and of improvising. Chapter 3 explored the impact that risk-aversion has in mental health nursing. Risk-taking is one of Ekvall's (1996) factors affecting organisational creativity (see Box 3.2). Stickley and Felton (2006) were concerned that a risk-averse climate inhibits recovery and autonomy, and MacCulloch (2009) identified the burden of complex risk as a major stress for community MHNs. Carson et al. are quick to

clarify that risk-taking in family therapy does not mean engaging in dangerous activities but responding intuitively to a client in a session.

Further examples of creative work in Carson et al.'s (2003) study were the ideas of being "in the moment", of "thinking on one's feet" and of "connecting with the intuitive and creative parts of our clients and ourselves as therapists" (pp. 102–103). "Thinking on one's feet" seems to link with improvisation (which, in itself, involves risk-taking on the part of the practitioner.) We will explore improvisation further below, when we consider how we incorporate creative arts within practice.

CHARACTERISTICS OR QUALITIES OF CREATIVE FAMILY THERAPISTS

The respondents in Carson et al.'s (2003) study identified three qualities of a creative family therapist, which could perhaps equally serve, more generally, as characteristics of a creative mental health practitioner:

- flexibility
- risk-taking
- humour.

While few would argue with the value of flexibility in clinical practice, we have already acknowledged that a willingness to take risks can be challenging in a risk-averse climate. The use of humour is also potentially controversial. Many might recognise that a sense of humour can be a valuable asset to any mental health practitioner, helping them to maintain a sense of balance and perspective in the face of often difficult situations and painful emotions. (Chap. 9 discusses vicarious trauma and how MHNs might deal with this.) Yet, using humour in clinical practice is a more contentious area, since, as Carson et al. recognise, the concerns and difficulties of service users are hardly something of which to make light. Using humour as a therapeutic tool, then, is risky but we cannot be creative without being playful. It may be helpful to keep in mind Weston's (2007) observation that "creativity can require a certain kind of playfulness (...) but it does not mean just letting go" (p. 3). Playfulness is part of creativity but, as identified in Chap. 2, it must be combined with discipline; to qualify as part of creative mental health care, the use of humour must be ethical and effective (Cropley, 2001) (See Box 5.2).

Box 5.2 **Characteristics of a Creative Mental Health Practitioner**

- **flexibility** – of thought and action; being able to "go with the flow"; a willingness to try new approaches; learning and growing alongside one's clients;
- **a willingness to take risks** – whilst observing ethical guidelines; taking risks in the best interests of the client; rewriting the rules of therapeutic engagement to find the best approach;
- **the importance of humour** – using humour appropriately and strategically as part of the healing process; to reduce tension and help clients see things from a less serious (potentially more optimistic) perspective.

– Adapted from Carson et al. (2003)

CREATIVE INTERVENTIONS

The list of creative techniques and interventions generated by respondents in Carson et al.'s (2003) study is interesting because many of them involve attempts to use techniques derived from the creative arts. These include role play, role reversal and psychodrama, drawing, collages, art therapy, stories, poems, films, songs, letter writing and narrative therapy. This suggests that the therapists surveyed strongly associated creativity with the arts. Andreasen and Ramchandran (2012) highlight the general tendency among lay people to associate creativity more with the arts than with the sciences. In Chap. 2, we introduced Schmid's (2005) argument that connecting creativity solely with the arts may diminish its significant role in other activities. I would argue the association limits the possible meaning of creative mental health practice, hence I have dealt with applying concepts of creativity and incorporating creative arts as two distinct areas.

BARRIERS TO CREATIVE PRACTICE

The fourth aspect Carson et al. (2003) investigated was perceived barriers to creative family therapy. As suggested above, these barriers – if they apply to family therapists or marital therapists – are likely to apply just as much to mental health practitioners in general. The obstacles identified by the respondents were:

- time constraints – finding time to contemplate, learn and implement creative techniques and interventions;
- client resistance – a reluctance to take part in more creative tasks;
- managed care – duration and methods of therapy prescribed or mandated;
- personal limitations of the therapist – lack of confidence, inhibition.

Commenting on this, Carson et al. point out that if the therapist is inhibited about trying out a more creative approach, whether due to time or other constraints or their own self-doubt, then this is likely to lead to reluctance on the part of the client. The moral seems to be that, if we are convinced of the benefits of a more creative approach to mental health care, as practitioners we have to act as positive role models and offer creativity in such a way that it is likely to be embraced.

All of the above helps us to answer the first question posed at the beginning of this chapter: *how can mental health professionals apply concepts of creativity to their discipline?* We can now begin to conceptualise a model of creative mental health care. First, though, in order to make our model more complete, we need to consider the second question posed at the start of the chapter: *how can MHNs and other practitioners incorporate creative arts within their practice?*

INCORPORATING CREATIVE ARTS WITHIN PRACTICE

In addressing the question of incorporating creative arts within one's practice it is important to distinguish between the *creative arts therapies* and *arts in health.* Griffiths (2005) explains that creative arts therapies (such as art therapy and music therapy) are professional disciplines with a long tradition of use, for example, in the treatment of severe and enduring mental illness and in situations of trauma and political conflict. In contrast, the arts in health movement "has a wider range of goals which are more closely linked to community health development and regeneration" (and is) "seen as an important element of mental health promotion, which aims to strengthen the mental and emotional well-being of individuals and communities" (pp. 27–28).

Jones (2005) similarly clarifies that arts therapies are used in direct therapeutic work as part of the clinical provision in health settings whereas arts in health activities either create access to the arts for the disenfranchised (whether as producers or consumers of art) or complement health practice (e.g. the commissioning of art in hospitals or as part of health promotion activities). Roberts and Bund (1993) suggest

that arts in health activities, such as art workshops run by practicing artists, are *not* intended to be used in a clinical context and are not to be confused with the work of professional arts therapists, nor that of OTs involved in diversional therapy. Roberts and Bund (1993) do concede, however, that arts in health activities can "bring fun, enjoyment, involvement and an opportunity to find a means of self-expression and discovery" (that) "may contribute to a beneficial, therapeutic effect" but they stress that it is *not* "therapy in the clinically defined sense of the word" (p. 58).

Since only professionally-accredited creative arts therapists can practice art therapy, music therapy, drama therapy and dance movement therapy, it would seem mental health professionals of other disciplines (e.g. nursing, social work and OT) have two ways open to them of incorporating creative arts within their practice. First, they can collaborate with professional arts therapists as co-workers in arts therapy groups; second, they can collaborate with professional artists in arts in health activities. Le Navenec and Bridges (2005) advocated a triad made up of creativity, *collaboration* and caring. It is logical to think about such collaborations being with creative arts therapists or artists in arts in health settings and, if the latter involved other health and social care professionals, one could expect them to be as caring as they would be creative and collaborative. (Chaps. 6, 7 and 8 provide examples of creative collaborations with OT and social work colleagues, as well as with artistically-talented service users, in music, creative writing and wellbeing-based activities.)

Smyth (1996) noted that, despite the arts being influential in people's lives, they are rarely discussed in nursing literature. One example from a mental health inpatient unit, however, is McGarry and Prince (1998) who found that MHNs were able to lead groups for creative expression, that no specific training in the arts was required for these and that patients benefited from group participation through expression. Lane (2005) claims that many nurses have responded to the evidence-base for the therapeutic effects of music "by working with artists and musicians to heal people of all ages" (p. 123) and suggests nurses can help service users in a variety of ways to use music, drawing, dance and journal-keeping. Some of her suggestions involve collaboration with professional artists; others sound similar to the activities described above by McGarry and Prince (1998).

Benefits for Practitioners

Smyth (1996) suggests that using musical interventions may promote optimism in nurses and thus help prevent burnout while Roberts (2010) describes the use of poetry in the education of MHNs as a means of developing both emotional intelligence and empathy. In a study of the effects of arts activities in children and adolescents, Goldstein and Winner (2012) examined the impact of arts training on the development of empathy (mirroring the emotions of others) and theory of mind (the ability to reflect on what others are thinking or feeling.)

Clearly, both empathy and theory of mind are essential social cognitive skills for mental health professionals. Goldstein and Winner (2012) found that those young people who received training in acting showed significant gains in empathy scores, while training in visual arts and music did not seem to have this effect. They concluded that training in acting may lead to a growth in empathy and theory of mind. While the study centred on children and adolescents, it has useful implications for the professional development of mental health practitioners. Role-playing, the study suggests, may be the key component that leads to enhanced empathy. The acting training in Goldstein and Winner's study involved practice in improvisation. Carson et al.'s (2003) research cited earlier also emphasised the importance of improvisation and the ability to "think on one's feet" as a hallmark of creative practice.

Improvisation: Individual Work, Groupwork and Teamwork

Earlier, we conjured up an image of a creative mental health practitioner as a craftsperson (Barker & Buchanan-Barker, 2005) producing carefully-crafted, person-centred, therapeutic relationships and interventions. However, this is not to suggest that workers would be practising their craft in splendid isolation. As we also saw, Le Navenec and Bridges (2005) stress collaboration – central to contemporary mental health care with its emphasis on interdisciplinary, multi-agency working. If creative mental health practice should be truly collaborative we could draw an analogy between the care team and a musical or theatrical group. Sawyer (2012) reminds us that "jazz and theatre performances are created by groups, not by individuals" and group creativity, like music and acting, depends "on the processes

of collaboration among group members" (p. 32), one part of which is the skill of improvisation:

> When groups are performing at their peak, many scholars compare them to improvising jazz groups (...) In both a jazz group and a successful work team, the members play off one another, with each person's contributions inspiring the others to raise the bar and think of new ideas. Together, the improvising team creates a novel, emergent product, both unpredictable and yet more suitable to the problem than what any one team member could have developed alone. (pp. 244–245)

So, learning and developing the skills of improvisation, whether through acting, music or simply through effective, creative teamwork or groupwork, leads to better outcomes. Of course, the "improvising team" as Sawyer (p. 245) describes it, could take many forms. It could be a dyadic, therapeutic relationship (for example, one MHN working with one service user), a clinical team working on solving a problem, one or two clinicians working with a therapeutic group or a family or, indeed, a family or group working without a clinician present.

Musical interventions to promote optimism and reduce burnout (Smyth, 1996), poetry and drama to develop emotional intelligence and empathy (Roberts, 2010; Goldstein & Winner, 2012), improvisation to enhance idea generation and problem-solving (Carson et al., 2003; Sawyer, 2012) – these are just a few examples of how creative arts can be applied in professional development and mental health practice in ways that could benefit service users and practitioners themselves.

A NEW MODEL OF CREATIVE MENTAL HEALTH CARE

Having considered what creative mental health care might look like in practice (see Box 5.1) and having identified the characteristics of a creative mental health practitioner (see Box 5.2) it should now be possible to formulate a more coherent model of creative mental health care (see Fig. 5.1).

This model is informed by all that has been said so far about creativity and mental health practice. It incorporates Finfgeld-Connett's (2007) triad – evidence-based practice, patient-centred (or person-centred) care and creativity – and Le Navenec and Bridges' (2005) triad – creativity, collaboration and caring. The common denominator in both of these is creativity itself. I mentioned earlier that I have made conscious use of the

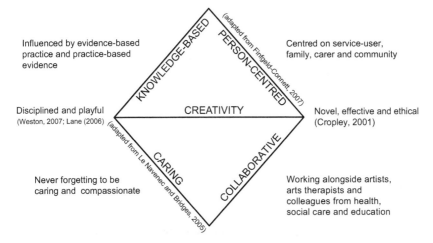

Influenced by evidence-based practice and practice-based evidence

Centred on service-user, family, carer and community

Disciplined and playful (Weston, 2007; Lane (2006)

CREATIVITY

Novel, effective and ethical (Cropley, 2001)

Never forgetting to be caring and compassionate

Working alongside artists, arts therapists and colleagues from health, social care and education

Fig. 5.1 A model of creative mental health care

principle of combination in blending together different ideas about both creativity and mental health practice. In this spirit of combination I have tried to visualise the triads of Finfgeld-Connett and Le Navenec and Bridges as two triangles juxtaposed and, since the triangles share a common feature – creativity itself – the combination results in a rhombus or diamond shape. I have then added into this the recurring themes (introduced in Chap. 2) of discipline and playfulness (Weston, 2007; Lane, 2006) and novelty, effective and ethicality (Cropley, 2001). Finally, surrounding the rhombus of creative mental health care, I have included a single phrase underlining what is meant by the four domains – knowledge-based, person-centred, caring and collaborative.

In Chap. 2, the idea of creativity as a sociocultural act was presented. Glăveanu (2015) saw creativity as "a form of action by which actors, materially and symbolically, alone and in collaboration with others, move between different positions and, in the process, imaginatively construct new perspectives" (p. 165). In the course of Chap. 5, it could be argued, we have moved between different positions to construct just such a new perspective. Of course, it is for the actors – the service providers and service users of mental health services, acting alone and in collaboration – to determine if this model can offer material and symbolic improvements to mental health care.

CHAPTER SUMMARY

Building on the understanding of creativity and wellbeing developed in preceding chapters this chapter has clarified how creativity can be applied to mental health practice. It has addressed two aspects of the question: how to apply concepts of creativity to one's own discipline and how to incorporate creative arts within practice. Themes of evidence-based practice, person-centred care, collaboration and caring led towards a concept of creative mental health care. The meaning and role of creativity were explored along with risk-taking, improvisation, the characteristics of creative mental health practitioners and barriers to creative practice. Incorporating creative arts within practice was examined, the benefits for practitioners and the role of improvisation in individual work, groupwork and teamwork. Finally, a new model of creative mental health care was outlined. Chapters 6, 7 and 8 provide examples of this model in practice.

NOTE

1. It is interesting to note here the individualist focus on characteristics or qualities of therapists, the acknowledgment of novelty combined with effectiveness, and the exploration of barriers (or *roadblocks*, as Sternberg and Lubart (1999) might have put it) that stopped therapists from being as creative as they would like to be.

REFERENCES

Andreasen, N. C., & Ramchandran, K. (2012). Creativity in art and science: Are there two cultures? *Dialogues in Clinical Neuroscience, 14*(1), 49–54.

Barker, P., & Buchanan-Barker, P. (2005). *The Tidal Model: A guide for mental health professionals*. Hove: Brunner-Routledge.

Berg, A., & Hallberg, I. R. (1999). Effects of systematic clinical supervision on psychiatric nurses' sense of coherence, creativity, work-related strain, job satisfaction and view of the effects from clinical supervision: A pre-post test design. *Journal of Psychiatric and Mental Health Nursing, 6*(5), 371–381.

Bohm, D. (2004). *On creativity*. London: Routledge.

British Association of Social Workers. (2014). *The code of ethics for social work*. Retrieved from https://www.basw.co.uk/codeofethics/

Carson, D. K., Becker, K. W., Vance, K. E., & Forth, N. L. (2003). The role of creativity in marriage and family therapy practice: A national online study. *Contemporary Family Therapy, 25*(1), 89–109.

Cropley, A. J. (2001). *Creativity in education and learning: A guide for teachers.* London: Kogan Page.

Ekvall, G. (1996). Organizational climate for creativity and innovation. *European Journal of Work and Organizational Psychology, 5*(1), 105–123.

Fasnacht, P. H. (2003). Creativity: A refinement of the concept for nursing practice. *Journal of Advanced Nursing, 41*(2), 195–202.

Finfgeld-Connett, D. (2007). Mental health nursing is not fine art. *Journal of Psychosocial Nursing, 45*(3), 8–9.

Glăveanu, V. P. (2015). Creativity as a sociocultural act. *The Journal of Creative Behaviour, 49*(3), 165–180.

Goldstein, T. R., & Winner, E. (2012). Enhancing empathy and theory of mind. *Journal of Cognition and Development, 13*(1), 19–37.

Griffiths, S. (2005). The mental health benefits of arts and creativity for young African and Caribbean Men. *Mental Health Review, 10*(2), 27–31.

Health and Care Professionals Council. (2016). *Standards of conduct, performance and ethics.* Retrieved from http://www.hcpc-uk.org/aboutregistration/standards/standardsofconductperformanceandethics/

Jones, P. (2005). *The arts therapies: A revolution in healthcare.* Hove: Brunner-Routledge.

Kaufman, J. C., & Sternberg, R. J. (2007). Resource review: Creativity. *Change, 39*, 55–58.

Lane, J. (2006). *The Spirit of silence: Making space for creativity.* Totnes: Green Books.

Lane, M. R. (2005). Creativity and spirituality in nursing: Implementing art in healing. *Holistic Nursing Practice, 19*(3), 122–125.

Le Navenec, C.-L., & Bridges, L. (Eds.). (2005). *Creating connections between nursing care and the creative arts therapies: Expanding the concept of holistic care.* Springfield, IL: Charles C Thomas Publisher.

MacCulloch, T. (2009). Clinical supervision and the well-being of the psychiatric nurse. *Issues in Mental Health Nursing, 30*, 589–590.

McGarry, T. J., & Prince, M. (1998). Implementation of groups for creative expression on a psychiatric inpatient unit. *Journal of Psychosocial Nursing and Mental Health Services, 36*(3), 19–24.

Nursing and Midwifery Council. (2015). *The code: Professional standards of practice and behaviour for nurses and midwives.* London: NMC.

Roberts, M. (2010). Emotional intelligence, empathy and the educative power of poetry: A Deleuzo-Guattarian perspective. *Journal of Psychiatric and Mental Health Nursing, 17*(3), 236–241.

Roberts, S., & Bund, A. (1993). *Good medicine: Arts in Health in the West Midlands.* Artservice: Lincoln.

Royal College of Occupational Therapists. (2015). *The code of ethics and professional conduct.* Retrieved from https://www.rcot.co.uk/practice-resources/rcot-publications/downloads/rcot-standards-and-ethics

Sawyer, R. K. (2012). *Explaining creativity: The science of human innovation* (2nd ed.). Oxford: Oxford University Press.

Schmid, T. (Ed.). (2005). *Promoting health through creativity: For professionals in health, arts and education.* London: Whurr Publishers.

Smyth, T. (1996). Reinstating the person in the professional: Reflections on empathy and aesthetic experience. *Journal of Advanced Nursing, 24*(5), 932–937.

Sternberg, R. J., & Lubart, T. I. (1999). The concept of creativity: Prospects and paradigms. In R. J. Sternberg (Ed.), *Handbook of creativity.* New York: Cambridge University Press.

Stickley, T., & Felton, A. (2006). Promoting recovery through therapeutic risk taking. *Mental Health Practice, 9*(8), 26–30.

Weston, A. (2007). *Creativity for critical thinkers.* New York: Oxford University Press.

Music and Mental Health Practice

Abstract This chapter adopts a more personal, reflective approach, exploring the author's own experiences of using music in mental health settings. It begins by tracing the development of music therapy, the role of evidence-based practice in arts activities and value for money versus the so-called 'wow factor'. It outlines the Music Workshop Project as an example of practice-based evidence, discussing the project's organic shift from a 'therapy' model towards a 'community music' model. It compares the community music movement with community mental health care and considers how to get creative projects started. A typical session is described in detail and the chapter concludes by reviewing how the project ended, linking this to the sigmoid curve as a model of the natural rise and decline of projects.

Keywords Music in mental health • Music therapy • Evidence-based practice in arts activities • Value for money • The 'wow factor' • The Music Workshop Project • Practice-based evidence • Community music movement • Community mental health care • The sigmoid curve • Rise and decline of projects

MUSIC IN MENTAL HEALTH

In Chap. 1 we saw how Edward Elgar used his musical gifts to enhance the lives of people with mental health problems at the Worcester Lunatic Asylum. Music and dance were part of the life of Victorian mental hospitals. I also described my own modest attempts, as a student nurse, to share my interest in music with service users at day hospitals in Shropshire. These early efforts – unlike the great Mr Elgar's carefully-crafted compositions and performances – were, by necessity, improvisational in every way. Not only did I encourage service users to improvise music but, having little experience at that time of music therapy or groupwork, I was obliged to improvise how to fulfil the role of a musical group facilitator. Like the family therapists striving for creativity described in Chap. 5 (Carson, Becker, Vance, & Forth, 2003) I quickly learnt about the centrality of taking risks with clients and of improvising.

This chapter is less theoretical than preceding chapters – more personal and reflective – grounded as it is in my own experiences of using music in mental health settings. In the model of creative mental health care presented in Chap. 5 (see Fig. 5.1) I provided a commentary alongside the knowledge-based side of the creativity rhombus suggesting that, within this model, care should be influenced by both evidence-based practice and practice-based evidence. Thus, while previous chapters have provided some evidence on which to base our practice, this chapter (and Chaps. 7 and 8 too) discuss practice examples on which we can perhaps build more evidence.

MUSIC AND MUSIC THERAPY

Music has been extensively used throughout history to heal illness and alleviate distress (Bunt, 1994.) It is only in recent times, however, that music therapy as a specific discipline evolved. In the early twentieth century music was used in hospitals "mainly to boost morale, as a general aid to convalescence and as an entertaining diversion" (p. 3):

> physicians invited musicians to play to large groups of patients on the vague assumption that it might activate metabolic functions and relieve mental stress. Listening to music could provide an aesthetic experience of quality and was regarded by many as a very humane way of occupying patients' time. Anecdotal accounts of music's inherent worth abound in the early literature on music in medicine. There seems to be a general consensus that exposure to music could do nothing but good. (pp. 3–4)

The 1940s saw the development in the USA of music therapy as an emerging profession with its own training courses for musicians wanting to become music therapists and, by the 1950s, there were professional associations of music therapy in both the USA and the UK. By the 1960s the UK also had professional music therapy training courses.

More recently, in tandem with other health and social care professions, there has been a growing awareness of a need for music therapy to become more evidence-based. For example, the British Association for Music Therapy's website states:

> Research is an integral component of music therapy as an evidence-based contemporary profession and discipline. In addition to exploring and demonstrating the impact of music therapy and ensuring high standards of practice, research evidence informs funding and policy making decisions in the field. (BAMT, 2017)

EVIDENCE-BASED PRACTICE, VALUE FOR MONEY AND THE 'WOW FACTOR'

There are parallels between creative arts therapies and other professions (including nursing) which have increasingly recognised the need for an evidence-base to underpin practice. As the BAMT (2017) quote above implies, evidence-based practice is not only about effectiveness but efficiency – about practitioners being seen to provide value for money. There might seem to be a paradox, though, in seeking hard, scientific evidence to support the value of arts and arts therapies. The poet Seamus Heaney wrote that the good of literature and of music is first and foremost in the thing itself and the first principle of both is that which William Wordsworth called "the grand elementary principle of pleasure" (Heaney, 2002). Wordsworth also famously wrote that "we murder to dissect" (1968, p. 106), a romantic notion suggesting that we should not seek to analyse things too closely, for fear of destroying their essential value.

Some music therapy researchers are critical of the application of the evidence-based practice paradigm to music therapy. Aigen (2015), for example, argues against restrictive notions of evidence and sees evidence-based practice as over-reliant on an illness model and on the concept of an intervention, neither of which, he asserts, adequately explain what makes

music therapy work. it could be claimed, in the spirit of Heaney and Wordsworth, that if a session of music-making – or a painting or a poem – evokes a powerful emotional response this may be indication enough that it has inherent worth, but this so-called 'wow factor' is hard to quantify. As Ansdell and Pavlicevic (2001) put it:

> as funders generally become more insistent on 'evidence' that what we do makes a difference, and that it makes economic sense to support our work, it is no longer enough for us just to be practising and presenting our work. The 'Wow!' is over. (p. 243)

The Music Workshop Project

My own project, The Music Workshop Project (MWP), thrived for several years on what Ansdell and Pavlicevic (2001) might have described as pure "wow." Essentially, the project, based in Kidderminster, Worcestershire, encouraged people with mental health problems to make their own music. I describe in a previous book (Gillam, 2002) how the project began as a small group in a day hospital, a collaboration between a social work colleague and myself. When I changed jobs and became a community mental health nurse (CMHN) – and the social worker was no longer able to remain involved – the project could easily have folded. However, with managerial support for my involvement and the enthusiasm of a musically-gifted service user who volunteered to help me continue with the group, we were able to transpose it from the day hospital to a community setting and to develop the group into a project that enjoyed considerable success over a ten year period.

The MWP had two main aims – firstly, to help people with mental health problems by involving them in musical activities, and secondly, to present a more positive image of mental health to the public, in order to reduce fear and stigma. The backbone of the project was a monthly improvisational group session but out of these sessions grew the ambition to produce and release CD albums. To coincide with the release of its first album, *Organised Chaos*, the project also launched its own website. The CD cover design was a piece of computer-generated art produced by a project member while the text on the website was also the work of a project member. Thus, although primarily a music project, it also inspired the production of both writing and visual art by service users.

The project provided regular opportunities for people with a range of mental health conditions to express themselves through music. Along with the therapeutic effects of being creative it aimed to encourage people to develop interpersonal skills through improvisational groupwork. From the start, the project was not intended for competent musicians. It did not set out to teach people to be proficient musicians but to promote an interest in making music and exploring its potential for personal expression and interpersonal communication. Moreover, unlike some other music-related groups offered by mental health services, the project was expressly not for passively listening to music but for actively creating it. It sought to enhance active listening skills through playing in a group, being sensitive to the emotional, psychological and creative needs of other participants.

The MWP was the subject of considerable coverage in the nursing and mental health press (Mason, 1999; Everett, 2000; Gillam, 2002). In 1997, it received a national award from the Mind Millennium Fund and, in 1998, achieved international recognition as the only UK winner of the Lilly Schizophrenia Reintegration Award. The subsequent local, national and international media interest in the project helped to present a positive image of mental illness, and acted as a catalyst, encouraging greater user involvement and participation in the planning and expansion of the project.

Awards and recognition for artistic achievements certainly boost the 'wow factor'. It was often within the simple context of the monthly improvisational workshops, though, that moments of 'pure wow' occurred, when a small group of mental health service users – who did not normally consider themselves musicians – came together to produce moments of breathtaking, inspired creativity.

For all its sheer delight in pure and simple music-making, even the MWP began to succumb to the pressure to provide a modest 'evidence-base' for its existence – an acknowledgment of Ansdell and Pavlicevic's (2001) observation that the "wow factor" is not enough. Accordingly, in 2000, we carried out a small audit surveying the views of project members, service users who were not yet using the project and mental health workers. Results from this audit were of immediate practical help in illuminating how best to use resources to meet the needs and wishes of service users. The findings of the survey suggested that there was a real appetite for further recordings – hence work began on the second CD, *Late in the Morning*. This turned out to be very different to *Organised*

Chaos in that it focused on developing the skills of certain members of the project in songwriting, performing and recording.

In 2001, in response to the many requests for support and advice from others wanting to start similar projects, a one-day conference was held – *Using music in mental health* – which discussed the development of the project as well as covering aspects of group facilitation and the practicalities of recording. It was through organising the conference that I became more fully aware of the vibrant community music movement which has grown up in recent years alongside professional music therapy.

THE EMERGING COMMUNITY MUSIC MOVEMENT

As we saw in Chap. 5, it is important to distinguish between creative arts therapies and arts in health. Arts therapies are used in direct therapeutic work as part of the clinical provision whereas arts in health activities either create access to the arts for the disenfranchised or complement health practice (Jones, 2005). Creative arts therapies and the arts in health movement have developed side by side. So, while music therapy and others arts therapies have become more and more professionalised (with increasingly advanced training courses, professional bodies, journals and bodies of research) there has arisen a parallel movement of community arts. This movement is less about using art forms to *treat* mental health problems and more about user-involvement and empowerment. It involves artists – and sometimes mental health workers who are not professional creative arts therapists – and also involves service users themselves.

The community music movement upholds the belief that everyone should have the opportunity to make music and explore their musical potential. It is concerned with the value of music and the arts, not just to individuals, but to communities. Rather than using music *therapists*, community music initiatives often employ professional musicians (such as drummers, singers, songwriters, composers and music technicians.) These musicians then work with people with any level of musical experience (or none at all) to create and sometimes to perform or record music, in a wide range of settings including schools, youth clubs and day centres as well as more traditional performance venues. Community music organisations act

as initiating and developing agencies for innovative participatory music and work towards improving access to music-making. Often, they work in partnership with both arts organisations and disability organisations.

There are a number of key features in the philosophy of the community music movement. These include:

- a belief in providing opportunities for individuals and communities
- inclusiveness
- forging links with community settings
- promoting innovation and participation
- facilitating access to creativity for people with disabilities
- potentially providing the means for the resulting music to reach a wider audience.

The above list overlaps considerably with Griffiths's (2003) list of the mental health benefits of participation in arts and creative activity outlined in Chap. 3 (see Box 3.1). Some of the aims of the community music movement are also common to music therapy approaches. The MWP is one example of an initiative which, almost organically, grew away from a 'therapy' model and towards a 'community music' model.

THE COMMUNITY ARTS MOVEMENT AND COMMUNITY MENTAL HEALTH CARE

Some comparisons have been made here between music therapy and community music groups which might also inform comparisons between the other creative arts therapies and their corresponding community arts manifestations. Moreover, there is the relationship between the community arts movement and community mental health care. Whether or not community mental health workers wishes to become involved in artistic activities (such as those described here) they may wish to espouse some of the philosophy of the community arts movement. It might be helpful for the reader to reflect on the key features of the community arts movement (listed above) and to imagine how they might be applied to community mental health care, even if removed from their artistic context. Regardless of artistic activity, these would seem to be laudable values for a more creative kind of community mental health care.

An Isle Full of Noises

In Shakespeare's *The Tempest* Caliban describes Ariel's music: "Be not afeard; the isle is full of noises, /Sounds and sweet airs, that give delight, and hurt not. /Sometimes a thousand twangling instruments/Will hum about mine ears…" (3.2.129–133.) The effect may not be too dissimilar to one of our Music Workshop sessions when often it seemed as if "a thousand twangling instruments" were humming about my ears. The comparison is apt, too, because the open group that was the MWP was like a "noisy isle" which must have seemed strange to travellers first alighting there but whose music often gave delight to the participants and seemed, at the very least, to do no harm.

Funding and Getting Started

Clinicians and musicians interested in the MWP – and interested in replicating it in some form in their own areas – often asked how the project was funded. In fact, the project started with no specific funding. As a CMHN employed by the local mental health NHS Trust it was agreed that I could use some of my clinical time facilitating and developing the project. The Trust donated a small sum of money to allow for the purchase of a basic selection of musical instruments. (The instruments chosen were mainly hand percussion because these are relatively inexpensive and simpler to play without musical training.) Later, as charitable grants were donated by local, national and international organisations we were asked to account for spending related to these specific funds. We opened a 'clubs and societies' account with a local building society, as this was felt to be more normalising and less bureaucratic than setting up a small trust fund within the NHS Trust. Some additional funds were later raised from the sale of the project's CDs. However, the running costs of the workshops were minimal since service user support was on a voluntary basis while my input was seen (in the early days of the project) as part of my existing job role. The venue for the workshops was cost-free as it was considered we provided an additional attractive opportunity at the drop-in. The main expenditure was the cost of producing recordings and maintaining and replacing musical instruments and equipment.

In starting up new projects first thoughts often concern funding. As with much work in mental health, though, the main resource implications for our project were human resources, time and energy. The project

demonstrated that lack of initial funding need not be an obstacle to inno-
vation so long as the organisational culture allows flexibility and auton-
omy. As we saw in Chap. 3, organisational creativity requires freedom,
support for new ideas and time to think these through, trust, and a will-
ingness to take risks (Ekvall, 1996) (see Box 3.2).

A Typical Session

In the early days of the project participants were uncertain about what was
expected of them in sessions. In later years some members would be rela-
tively new but others had been attending sessions intermittently for several
years. This meant that later workshops seemed to need very little in the
way of warm-up. Preparation for a typical session was as follows.

We would set out a range of instruments, interspersed with seating in a
rough circle. We would also tune guitars immediately prior to the session
and set up one or two microphones (with amplifiers) which were usually
used by harmonica players or anyone who wanted to play a quieter instru-
ment and still be heard, including the occasional vocalist.

People would arrive more or less on time and would often pick up an
instrument and begin playing immediately. Sometimes, participants would
take a seat, perhaps hugging a mug of tea, tell a joke or two and exchange
pleasantries while the music established itself. The first few bars of music
were usually initiated by myself or my fellow coordinator/facilitator. We
tended to begin the music in a tentative, exploratory way which suggested
we were just *playing around* with music rather than *playing* music. The
atmosphere would be one of experimentation rather than performance.

The uttering of witticisms by service users as part of the warm-up for a
session is noteworthy. It could, of course, be seen as a sign of some anxiety
but was also identified in Chap. 3 as a feature of little-c creativity (Kaufman
& Sternberg, 2007). Likewise, the deliberate attempt to suggest we were
just 'playing around' rather than 'playing' embodies the playfulness/humour
factor of Ekvall's (1996) ten factors affecting organisational creativity. We
aimed to promote a creative climate, to make it acceptable to have fun.

As the music would settle in, the group becoming more certain of itself
and the improvisation, participants would often show greater confidence,
perhaps by establishing a dominant theme or by switching instruments to
find a more fitting sound. A series of improvisations would happen with
people dropping in and out of playing, sometimes walking round the
room with their instrument, sometimes leaving the room and returning a

while later. On rare occasions it would become necessary to reiterate the 'rules' such as they were – for example when participants were playing with a lack of consideration or sensitivity to others (or the equipment) or spectating conspicuously rather than participating (however tentatively.) At these times we might remind people that we would like them to listen to what the rest of the group was playing and to try to fit in with the sound, being aware of loudness, softness and rhythm. We used musical terminology minimally and in a non-threatening way. For example, we might say: "We seem to be in the key of G" – enough to help guitarists and harmonica players to join in without alienating any 'non-musicians'.

The session would end after an hour. Sometimes participants would suggest a closing song. The group might be in the mood for a gentle, relaxing ending or a cathartic 'big finish' – a frantic, percussive crescendo of sound – depending on the mood of the session. Some participants would then thank us, as we would thank them, for taking part, and leave; others would offer to help put equipment away. As people were leaving, I would hand out leaflets with the dates of forthcoming workshops – a reminder for the regular attenders, an invitation back for any newcomers.

The size of the group would vary considerably depending on weather and season. We estimated that twenty to thirty service users would have been involved with the project in some capacity during its history and all were made welcome to take part in any aspect of our work, including the improvisational workshops. A typical workshop would involve six to eight participants, which felt like a comfortably-sized group. For some sessions there would have been as few as three (in which case we may have had a very mellow, 'unplugged' session); at others there would have been as many as twelve (which could become quite uncontrollable in terms of both the group dynamics and the 'wall of sound' produced). With larger groups the facilitators would have to be fairly active in role-modelling attentiveness between group members, encouraging quieter members to participate and discouraging louder members from dominating the group. Unlike purely verbal forms of groupwork, in a music workshop there are non-verbal ways of controlling noise and volume – a hand gesture from the facilitator-as-conductor to indicate lowering the volume or, in extreme circumstances, (when people are amplified) discreetly turning down the volume control on the amplifier.

Workshops tended to be made up predominately of male service users, but we had some notable contributions from female members. One young woman, with a very fine singing voice, was actively involved in recording

songs with the project but seemed more reluctant to join in the workshop sessions. We tried to engage more female service users but the group seemed to become something of a sanctuary for a disenfranchised subsection of young to middle-aged men, many of whom rarely engaged in other group activities offered by local mental health services.

ALL THINGS MUST PASS

The CDs, website, conference workshops, local radio interviews and magazine articles generated considerable interest and we received a large number of requests for advice from people – mental health workers, musicians, music therapy students among them – keen to emulate the project and replicate it in some form in their own areas. Along with questions of funding and the practicalities of setting up and facilitating sessions these enquiries often focused on sustainability: how had we managed to go from a small beginning to a large, award-winning project and how had we kept this going for so long? I have suggested that we were fortunate to have a group of highly engaged and engaging service users – and one service user volunteer in particular who had a combination of musical and organisational abilities, willing to collaborate with me in coordinating the project and facilitating the sessions. I have also suggested that I had the good fortune to work in a creative organisational climate that provided freedom, support for new ideas, time to think these through, trust, and a willingness to take risks. However, for a variety of reasons, after ten successful years, the project came to an end.

In January 2005 we wrote to project members, professional colleagues and potential referrers explaining, sadly, the MWP had brought its activities to a close. The reasons for this were partly financial and partly practical. Our existing funds had almost run out and our several attempts at securing new funding had all been unsuccessful. We had continued to suffer the long-standing problem that charitable funds tended either to support arts activities or mental health, not both. Moreover, there seemed to an obsession among funding bodies of supporting only new projects, not continuing to fund established ones. These were the financial reasons. Another practical difficulty was that I had changed posts again and my new job (as clinical manager) made it more difficult for me to devote time to the project.

The out-of-hours drop-in which had acted as our host organisation had lost its contract with the local authority to continue providing out-of-hours

services and, with this, we lost the venue for our activities. Despite negotiations, the new out-of-hours service to be provided by a different non-statutory organisation felt unable to accommodate our activities. The project's website remained 'live' for a short time and continued to receive enquiries from musicians, therapists, service users and providers from all over the world. As project coordinators we continued providing support and encouragement to like-minded projects and initiatives, aware of the challenges but convinced of the value of using music in mental health. The MWP, though, had come to an end.

CHARLES HANDY AND THE SIGMOID CURVE

With hindsight it might be said we had failed to plan for sustainability. We had certainly done little in the way of succession planning. However, it could also be said that the project had run its course. Shortly after the end of the project, I came across the work of Charles Handy, the author of several influential books about organisational culture. Handy's book *The Empty Raincoat* (1994) contains a description of the phenomenon of the *sigmoid curve*, and this resonated with me as an alternative explanation for the end of the MWP.

The sigmoid curve is the S-shaped curve seen in many different contexts – (for instance, sound waves are sigmoid in shape.) Handy claims that the shape of a sigmoid curve reflects the progress of any type of project, (empires, companies, relationships and careers, for example.) With any project there are three phases. First, there is an initial period of experimentation where often we get more things wrong than right. (For the MWP this was perhaps the stage where we were running the group in a day hospital setting without a high level of service user involvement). After this initial, experimental period, performance improves until a peak is reached (perhaps corresponding to the time when sessions were well-attended, we were winning national and international awards and able to invest in more equipment and recordings). After this second phase – the peak – comes an inevitable decline. (For the MWP, this was signalled by our lack of success at finding sustainable funding, changes in the host organisation and my change of job.)

The sigmoid curve may seem a depressing analysis with its three phases implying that everything is doomed to ultimate decline. Handy suggests, however, that there is a way of progressing beyond the sigmoid curve. The key is to start a second curve when the first project is at its peak. This means that the initial period of turbulence in the experimental phase,

where most mistakes will be made, is then accommodated within the success of the first curve.

Organisations or project leaders are much more likely to try to initiate change when there are signs of trouble but Handy would argue the time to start a new 'curve' is just before the previous project reaches its peak. However, he suggests:

> The second curve, be it a new product, a new way of operating, a new strategy or a new culture, is going to be noticeably different from the old. It has to be. The people also have to be different. Those who lead the second curve are not going to be those who led the first curve. (p 52)

If this is the case, we can conclude that the MWP had, within ten years, moved from its experimentation phase, through its peak to its decline and that something new and different, led by other people, would follow. By this token, the idea of sustaining a project seems misguided. All things must pass. For my part, I moved on to other creative projects, taking with me all I had learnt from the MWP and the memory of a thousand twangling instruments humming about my ears.

Chapter Summary

This chapter adopted a more personal, reflective approach, exploring my own experiences of using music in mental health settings. It began by tracing the development of music therapy, the role of evidence-based practice in arts activities and value for money versus the so-called 'wow factor'. It then outlined the Music Workshop Project as an example of practice-based evidence, discussing the project's organic shift from a 'therapy' model towards a 'community music' model. It compared the community music movement with community mental health care and considered how to get creative projects started. A typical session was described in detail and the chapter concluded by reviewing how the project ended, linking this to the sigmoid curve as a model of the natural rise and decline of projects.

References

Aigen, K. (2015). A critique of evidence-based practice in music therapy. *Music Therapy Perspectives, 33*(1), 12–24.

Ansdell, G., & Pavlicevic, M. (2001). *Beginning research in the arts therapies: A practical guide*. London: Jessica Kingsley Publishers.

British Association for Music Therapy. (2017). *Research*. Retrieved from http://www.bamt.org/british-association-for-music-therapy-resources/research.html

Bunt, L. (1994). *Music therapy: An art beyond words*. London: Routledge.

Carson, D. K., Becker, K. W., Vance, K. E., & Forth, N. L. (2003). The role of creativity in marriage and family therapy practice: A national online study. *Contemporary Family Therapy, 25*(1), 89–109.

Ekvall, G. (1996). Organizational climate for creativity and innovation. *European Journal of Work and Organizational Psychology, 5*(1), 105–123.

Everett, M. (2000). Organised chaos. *Mental Health Care, 3*(5), 154–155.

Gillam, T. (2002). *Reflections on community psychiatric nursing*. London: Routledge.

Griffiths, S. (2003). Arts and creativity: A mental health promotion tool for young African and Caribbean men. *Mental Health Review Journal, 8*(3), 26–30.

Handy, C. (1994). *The empty raincoat: Making sense of the future*. London: Arrow Books.

Heaney, S. (2002). *Finders keepers: Selected prose 1971–2001*. London: Faber & Faber.

Jones, P. (2005). *The arts therapies: a revolution in healthcare*. Hove: Brunner-Routledge.

Kaufman, J. C., & Sternberg, R. J. (2007). Resource review: Creativity. *Change, 39*, 55–58.

Mason, P. (1999). Charting success. *Mental Health Nursing, 19*(1), 30–31.

Shakespeare, W. (1978). The Tempest. In P. Alexander (Ed.), *William Shakespeare: The complete works*. London: Collins.

Wordsworth, W. (1968). The tables turned. In R. L. Brett & A. R. Jones (Eds.), *Wordsworth and Coleridge lyrical ballads*. London: Methuen.

Creative Writing, Literature, Storytelling and Mental Health Practice

Abstract This chapter draws on the author's own experience of writing and of facilitating a creative writing group for service users. It provides an overview of therapeutic uses of creative writing, including Pennebaker's work on expressive writing. It reviews evidence for the use of literature, creative writing and poetry in mental health care, exploring bibliotherapy, therapeutic writing and poetry therapy as well as narrative biography. Creative writing is examined as a tool for promoting both the recovery of service users and the professional development of mental health practitioners, including a discussion of the value of storytelling in mental health nursing. The chapter concludes by considering the role of journaling and blogging and the overlapping areas of therapeutic writing, literary writing, autobiography and writing for publication.

Keywords Writing • Facilitating creative writing groups • Therapeutic uses of creative writing • Pennebaker and expressive writing • Literature, creative writing and poetry in mental health • Bibliotherapy • Therapeutic writing • Poetry therapy • Narrative biography • Recovery • Professional development • Storytelling in mental health nursing • Journaling • Blogging • Autobiography • Writing for publication

Speaking Without Being Interrupted

The French writer Jules Renard is credited with the aphorism that writing is a way of speaking without being interrupted.[1] I suspect my own urge to write stems in part from being the youngest of four siblings who grew up in a noisy family. I began writing stories and songs and, later, articles and books to be able to make myself heard, and this is still true today. At work, and in the wider world, you cannot always *say* exactly what you want ... but you can *write* it.

In the late 1980s I helped facilitate a creative writing group in a day hospital. This involved the occupational therapist who led the group selecting a word at random from the dictionary shortly before the session began. The group would assemble in a room normally used for art therapy. The randomly-selected word would be given as a prompt for an exercise in which participants were asked to write a short piece of prose or poetry based on the 'Word of the Day'. Group members were then invited in turn to read their piece aloud, after which other members of the group were invited to comment.

If the group had any stated aims these would have been to promote confidence and to provide a supportive environment where people could share thoughts and experiences without fear of being judged. I have no recollection of us ever formally evaluating the group's outcomes but I suppose I considered it to be broadly therapeutic, without over-analysing how or why, rather in the spirit of the poet Seamus Heaney's (2002) comment (quoted in Chap. 6) that the good of literature (and of music) is first and foremost in the thing itself. Certainly, like the Music Workshop Project described in Chap. 6, the creative writing group seemed to offer many, if not all, of Irvin Yalom's often-cited eleven therapeutic factors of groupwork (Yalom & Leszcz, 2008) (see Box 7.1).

Box 7.1 Yalom's Eleven Therapeutic Factors of Groupwork

1. Instillation of hope (encouragement that recovery is possible)
2. Universality (others have similar problems; the feeling we are not alone)
3. Imparting information (sharing learning about problems and recovery)
4. Altruism (helping and supporting others)

(continued)

Box 7.1 (continued)

5. Corrective recapitulation of the primary family group (identifying and changing unhelpful patterns or roles)
6. Development of socialising techniques (building upon skills to communicate feelings, observations and concerns)
7. Imitative behaviour (modelling the behaviour and recovery skills of others)
8. Interpersonal learning (making discoveries about oneself and others)
9. Group cohesiveness (feeling of belonging to and valuing the group)
10. Catharsis (the release of emotional tension)
11. Existential factors (recognising and facing the realities of life and death)

– Adapted from Yalom and Leszcz (2008)

THERAPEUTIC USES OF CREATIVE WRITING

A cursory glance through the literature on creative writing will show that it has been used in a surprisingly wide range of settings with an equally diverse range of client groups. With older adults it has been used in care homes and in poetry workshops as a preventative approach to cognitive decline (Saunders, 2006; Swann, 2009). In California, creative writing has helped women prisoners cope with incarceration and prepare for re-entry to society (Sparks, 2008) while in Australia it has been used as a means of fostering the wellbeing of GPs (Smith, 2008). In dual diagnosis residential treatment programmes it has been deployed as an intervention for those with alcohol problems, depression and impulse control disorders (Gillispie, 2003) while those working with disadvantaged adolescents have seen it as a means of enhancing young people's self-esteem and self-efficacy (Chandler, 1999).

This brief overview shows that creative writing activity in mental health and wellbeing is widespread. Its uses span across the whole age range from children to older adults and multifarious settings, from community groups to care homes and prisons. It is seen as a means of

- treating a variety of existing mental health problems
- potentially preventing the development of difficulties
- promoting positive mental health and wellbeing in service users, as well as those who work with them.

According to Lepore and Smyth (2002) writing for therapy emerged out of the psychotherapeutic tradition of using expressive therapies for conditions associated with traumatic experiences. They suggest a range of psychological therapies apply techniques that help people identify, explore and express stress-related thoughts and feelings and they note a dramatic rise in interest over recent years in the therapeutic effects of writing among researchers, the public and clinicians. This burgeoning interest they attribute to three factors:

- the growing evidence base
- the cost effectiveness of the intervention
- the ability of writing to provide an appropriate means of self-expression.

Writing can, Lepore and Smyth assert, "provide a method for expressing stress-related thoughts and feelings nearly anywhere and without social repercussions" (p. 6). The phrase "without social repercussions" chimes with my earlier observation that a creative writing group can provide a safe, supportive environment where people can share thoughts and experiences without fear of being judged.

EXPRESSIVE WRITING

James Pennebaker, one of the pioneers of creative writing therapy, used a method called *expressive writing*. Participants were asked to write about personally upsetting experiences for twenty to thirty minutes each day for several days. In randomised controlled trials the expressive writing intervention was found to produce positive effects on a wide range of physical and mental health aspects (Pennebaker, 2002). These included reductions in:

- health centre visits
- self-reported illness
- depressive symptoms
- rheumatoid arthritis symptoms.

Pennebaker's studies also showed improvements in:

- the immune system
- lung functioning in asthma patients
- social relationships
- role functioning.

In an attempt to pinpoint the 'essence' of the writing technique, Pennebaker focused on how "it forces people to stop what they're doing and briefly reflect on their lives" (p. 283). He observed:

> It is one of the few times that people are given permission to see where they have been and where they are going without having to please anyone. They are able to prioritise their goals, find meaning in their past and future, and think about who they are at this point in life (p. 283).

Pennebaker acknowledged that any attempt to pinpoint the essence of the technique is inherently vague but some of the aspects he felt were important were associated with:

- self-regulation
- the search for meaning
- the creation of coherent stories about one's life
- habituation
- emotional awareness and expression.

LITERATURE, CREATIVE WRITING AND POETRY IN MENTAL HEALTH CARE

In 2004, within the broader context of Arts Council England's development of a national strategy for arts and health, a review of the medical literature on arts in health was completed (Staricoff, 2004) that concluded there was "strong evidence of the influence of the arts and humanities in achieving effective approaches to patient management and to the education and training of health practitioners" (pp. 9–10). The review helpfully separated out the relative contribution of different art forms and thus provided useful evidence for the benefits of creative writing, as distinct from the arts in general. It identified specific positive consequences from using literature, creative writing and poetry in mental health services, for both service users and care providers.

Staricoff found evidence that "in mental health, the use of writing as a means of expressing feelings and thoughts can have therapeutic value" (p. 26). There is some confusion in the review between the use of literature which is read (what might be termed *bibliotherapy*) and the active creation of new writing (*creative writing*) and this is explored further below. Notwithstanding this confusion, the review concurs with the findings of earlier studies, concluding that:

- Creative writing can enable service users to increase their mental wellbeing by regaining control over their own inner world (Jensen & Blair, 1997);
- Developing the narrative of their own mental illness helps not only service users but also their families and caregivers (McGihon, 1996);
- Reflective narratives are important in helping nurses think about the service user as a whole person (Graham, 1999);
- The introduction of arts and humanities into the training and education of medical and nursing staff is essential for their understanding of the cultural, social, ethnic and economic factors influencing service users' behaviour (Burr & Chapman, 1998).

BIBLIOTHERAPY, THERAPEUTIC WRITING AND POETRY THERAPY

In a review of the expressive and therapeutic uses of literature two nurse researchers, McArdle and Byrt (2001), found positive outcomes had been reported, with particular evidence of clinical effectiveness for bibliotherapy, poetry therapy and therapeutic writing. The meaning of these three different but overlapping areas of therapeutic uses of literature need further clarification here.

Bibliotherapy is "the therapeutic use of literature with guidance or intervention from a therapist" (Cohen, 1994, p. 40). It involves enhancing the service user's knowledge and insight with literature related to illness or other difficulties, as well as fiction or poetry, as an adjunct to other interventions.

Poetry therapy is less well-defined but involves the intentional use of poetry for healing and personal growth. Some definitions suggest it is synonymous (or almost synonymous) with bibliotherapy. For example, the National Association for Poetry Therapy describe it as "a specific and powerful form of bibliotherapy, unique in its use of metaphor, imagery, rhythm, and other poetic devices" (NAPT, 2017). Still more confusingly, others suggest the term "is used inclusively to refer not only to the use of published and original poems but also to the interactive use of literature (bibliotherapy) and therapeutic writing (journal therapy)" (LifeSpeaks Poetry Therapy, 2017). This seems to imply that poetry therapy is on the one hand a form of bibliotherapy (when it involves the use of the published poetry of others) and, on the other hand, a form of therapeutic writing (when it involves the act of writing original poetry.)

McArdle and Byrt (2001) define expressive writing as "the use of writing to enable people with mental health problems to enjoy and express themselves, develop creativity and empowerment, affirm identify and give voice to views and experiences" (p. 517). This definition would elegantly describe the creative writing group which I referred to at the beginning of this chapter. It would even describe the Music Workshop Project outlined in Chap. 6 if the word *writing* was substituted with *music*, and if we interpreted *giving voice to views and experiences* as including non-verbal expression through music. Whether by means of music or creative writing the aim was to provide a safe, supportive environment where people could share thoughts and experiences without fear of being judged. However, there are significant differences between a group where people can safely enjoy self-expression and the kind of expressive writing Pennebaker (2002) examined.

Like Pennebaker (2002), McArdle and Byrt (2001) emphasise the expression of personal experience in order to create a narrative that affirms identity. However, enjoyment does not necessarily accompany the expression of important personal experiences. Indeed Pennebaker and Segal (1999) note that, in the hours after writing, the participants in their study who wrote about traumatic life events tended to feel – perhaps unsurprisingly – more unhappy and distressed. Participants' emotional state after writing depended on how they were feeling prior to writing. Pennebaker and Segal observe, "the better they feel before writing, the worse they feel afterwards and vice versa" (p. 1246).

If writing can have a short-term negative effect on mood one might hesitate to recommend expressive writing as a way of promoting positive mental health. Pennebaker and Segal, though, found the longer-term benefits of improved physical and mental health were discerned only in the group who had written about their thoughts and feelings. The control group (who had written about trivial, non-emotional topics) did not benefit significantly. Confronting traumatic experiences through writing, they concluded, had a salutary effect on health. They also suggest that, notwithstanding the value placed on self-expression by dance, music and art therapists, there is little evidence that simple catharsis or the venting of emotions in the absence of cognitive processing would achieve the same health benefits (Lewis & Bucher, 1992).

According to Pennebaker and Segal, it is in the act of constructing a story – creating a narrative that helps organise the emotional effects of experiences – that the therapeutic effects emerge. For this reason they postulate that expressive writing would probably be a useful adjunct to

other interventions in clinical populations, underlining the fact that the participants in their study were students (predominantly from upper-middle class backgrounds) and not mental health service users. Indeed, they cite evidence that people with certain types of mental health difficulties (disordered cognitive processing, relatively severe depression or post-traumatic stress disorder) may not benefit from expressive writing.

Learning, Creativity and Narrative Biography

McArdle and Byrt's (2001) definition of expressive writing – as something that enables people with mental health problems to enjoy and express themselves and to develop creativity and empowerment – differs from Pennebaker's (2002) in that it associates its use with disempowered mental health service users (as contrasted with the healthy, relatively privileged population of Pennebaker's study.) An interesting case study by Sagan (2007) describes one example of a mental health service user in the context of a doubly-disenfranchised group, (adults with mental illness and low levels of education). Sagan shows how a basic literacy/creative writing course was able to provide opportunities for enjoyment, expression, creativity and empowerment. She suggests the creative act of writing in this case "was the resilient, reparative process of coming to terms with a new identity and a new self narrative" (p. 311). A reparative process, new identity, new self narratives – all of this concurs with Pennebaker and Segal's (1999) argument that mental and physical health improvements relate to the act of constructing stories. Constructed stories – new narratives – are seen as "a type of knowledge that helps to organise the emotional effects of an experience as well as the experience itself" (p. 1249). For the disempowered, long-term mentally ill participants of Sagan's (2007) study:

> Their concept of learning and writing was more tied to notions of day to day survival and the development and/or maintenance of a bearable personal narrative. Opportunities for social interaction were deemed important in breaking the isolation of mental illness, and the *concreteness* of writing ... was highly valued. (p. 312)

McArdle and Byrt (2001) highlight the need for further research to determine the clinical effectiveness of using literature with mental health service users. They acknowledge that expressive writing and reading can be enjoyable and beneficial and provide examples where "light-hearted

self-expression" (p. 518) was the aim. While this is far from Pennebaker and Segal's idea of expressive writing (involving confronting and cognitively processing trauma), "light-hearted self-expression" fits well with the model of creative mental health care put forward in Chap. 5 (see Fig. 5.1). Within this model, discipline and playfulness are held in balance. Also in tune with the model's emphasis on collaboration is McArdle and Byrt's (2001) recommendation that mental health nurses (MHNs) should collaborate with other practitioners and gather and disseminate supporting evidence to help obtain resources for such projects.

CREATIVE WRITING FOR RECOVERY

King, Neilsen and White (2012) consider the role creative writing could play in the recovery of service users with severe mental illness. They review a variety of theoretical models in an attempt to explain how creative writing might help recovery. Like Pennebaker and Segal (1999) and Sagan (2007) they emphasise the importance of language, narrative and storytelling, citing Roe and Davidson (2005) who argue that the process of re-authoring one's life story is an integral part of the recovery process. King et al. also suggest writing can be a form of cognitive remediation – a systematic training in processes such as attention, concentration and response to stimuli used to compensate for cognitive impairment (which can result from schizophrenia.) Creative writing can, they propose, make similar cognitive demands to cognitive remediation programmes and this, coupled with the benefits arising from its narrative, re-authoring aspects, would make writing a multifaceted tool for promoting recovery from severe mental illness.

Just as Pennebaker and Segal argued that self-expression or catharsis alone is insufficient without cognitive reprocessing, King et al. (2012) propose that creative writing may be more therapeutic if there is a focus on processes and techniques: "When a person develops skill in writing process, and technique builds," they assert, "it is likely to enhance the capacity to develop and sustain a coherent narrative" (p. 450). Thus, they recommend that writing workshops might be better provided by professional writers, focusing on improving participants' writing process and technique, rather than by mental health professionals.

This is interesting in a number of ways. First, with both the Music Workshop Project and the creative writing group I co-facilitated, we always emphasised the groups were not about becoming more technically

skilled (although, if people wanted to improve their playing or writing, this might occur incidentally.) We were at pains to avoid the impression that a level of accomplishment in the art form was needed so as not to exclude those who thought they were unmusical or could not write well. We aimed to be inclusive and, if artistic skills developed along the way, that would be, as it were, a positive side effect.

The second point arising from King et al.'s recommendations concerns the suggestion that professional artists – writers, in this case – should provide workshops. This fits well with the model of creative mental health care set out in Chap. 5, which called for collaboration between artists, arts therapists, and colleagues from health, social care and education. However, within this model, the emphasis is on mental health professionals and artists working alongside one another. King et al. point to the advantages of having a trained writer as facilitator, one who can work in collaboration with healthcare professionals and who "represents literary, rather than clinical authority" (p. 448). The suggestion is that the writing produced will be more crafted and disciplined. We have seen in Chap. 5, how craft has an important part to play in creative mental health care (Barker & Buchanan-Barker, 2005) although this was in terms of the mental health worker rather than the productions of the service user. Again, the model incorporates the discipline required to practice a craft but balances this with playfulness. The model also stresses person-centredness and, while some service users may want to build upon their artistic technique (as did those members of the Music Workshop Project who went on to compose and record their own music) some may be intimidated by the prospect of learning artistic skills from a professional artist and, indeed, some may want less discipline and more playfulness – more "light-hearted self-expression" (McArdle & Byrt, 2001, p. 518).

CREATIVE WRITING FOR MENTAL HEALTH PROFESSIONALS

Earlier in this chapter it was suggested that reflective narratives could help nurses and other mental health workers to think about the service user as a whole person (Graham, 1999), that introducing arts and humanities into staff training and education could promote understanding of the cultural, social, ethnic and economic factors influencing service users' behaviour (Burr & Chapman, 1998) and that creative writing can foster the wellbeing of GPs (Smith, 2008). Certainly there is some evidence that healthcare professionals can benefit from creative writing, both in terms of

their own wellbeing and their clinical skills. Apart from these examples creative writing – coupled with dialogue with professional colleagues – has been seen as a way of promoting the skill of intuition. Thus, Greenhalgh (2002) suggests that "the experienced practitioner should generate and follow clinical 'hunches' as well as (not instead of) applying the deductive principles of evidence-based medicine" (p. 235). She argues it is time "to revive and celebrate clinical storytelling as a method for professional education and development" (p. 235) and points to creative writing as a way of improving intuitive powers and clinical judgement.

Storytelling in Mental Health Nursing

We have already seen how language, narrative and storytelling are important to service users and how the process of re-authoring one's life story is central to the recovery process (Roe & Davidson, 2005). The same could be said for service providers as they recount stories of the care they offer and the kind of practitioner they are. In Chap. 4 we touched on the theme of the psychosocial wellbeing of MHNs and student MHNs. These themes are revisited in Chap. 9 but, here, it is relevant to highlight the work of Treloar, McMillan and Stone (2016) who investigated how storytelling prepares MHNs for practice.

Treloar et al. found that student MHNs are commonly anxious about their early clinical placements and the process of becoming qualified. Nurses tell each other accounts of clinical experiences which are often crystallised as memorable stories, useful in nurse education for triggering discussion and reflection on professional and ethical issues. Stories can generate an excitement about the challenges of mental health nursing "because they come from actual clinical situations which the teller has experienced personally" (p. 2). As our model of creative mental health care suggests, our knowledge is influenced by both evidence-based practice and practice-based evidence. "Using stories in teaching," Treloar et al. argue, "can illustrate 'nursing in an imperfect world', where not everything is orderly and predicable and where there is no textbook solution for every possible situation encountered in mental health nursing" (p. 2).

In their study, Treloar et al. found not only the everyday accounts of MHNs' work, which might have been expected, but insights into mental health nursing's history, understanding and communication at a deep level and examples of how MHNs used humour in difficult situations. This

links to the importance of playfulness within our model, but also to Ekvall's (1996) work, where playfulness/humour was a factor affecting organisational creativity (see Box 3.2). Storytelling, according to Treloar et al., can encourage critical thinking and is able to change the attitudes, values and behaviour of student MHNs: "Stories might be the only way," they suggest, "to capture and preserve some of this wealth of nursing work, and also the only way to show this intensely personal, highly emotional and often brutal world which student nurses enter" (p. 6). They conclude that the telling and discussion of stories from clinical practice can help student MHNs understand there is often no single or perfect way to manage the situations they will encounter in practice.

JOURNALS AND BLOGS

Whether the storyteller is a service user or a nurse, telling stories and/or writing about challenging situations, stressful life events and associated trauma is nothing new. Indeed, poets, novelists and dramatists have always drawn on their personal life experience for inspiration and many writers might say they find the experience of writing therapeutic. Even in the world of therapy, expressive writing techniques are not a new idea. The American psychotherapist Ira Progoff popularised a method using 'journaling' in the 1960s – a technique involving a series of writing exercises using loose-leaf notebook paper in a ring binder, divided into various sections (Progoff, 1977).

Progoff's method has inspired many other forms of creative writing therapies in therapeutic settings, sometimes as an adjunct to other forms of psychotherapy or counselling, sometimes by writers as an aid to creativity or autobiography. The keeping of a personal journal is often recommended for creative writing students and budding novelists as a way of honing writing skills, recording ideas for future use and preventing writer's block. Similarly, since the 1960s, the use of personal-professional journal writing has been encouraged as an aid to the professional development of those in the helping professions, in particular as a means of developing reflective practice (Smith, 2013). Smith notes that the linking of journal keeping with personal growth has led to "a significant 'journaling industry' with a range of books, websites, training programmes and retreats, and even specialist software" (p. 3). More recently, the phenomenon of 'blogging' could be seen as a contemporary manifestation of journaling. Personal 'blogs' (or 'web-logs') blur the boundaries between reflective diaries, writers' notebooks and interactive journalism.[2]

Therapeutic Writing, Literary Writing, Autobiography and Publication

The line between therapeutic writing and literary writing is not always clear. Buslau (2004) argues there are points of contact between therapeutic and literary writing – especially since therapeutic writing can lead to literary writing. One example of this is the writing of Suzy Johnston who published three autobiographical books documenting her experience of bipolar disorder: *The Naked Bird Watcher* (2003), *The Snow Globe Journals* (2009) and *When Do I Get My Shoelaces Back?* (2010). This process began with Johnston writing about her experiences as a service user to support the learning of student MHNs. Her third book, *When Do I Get My Shoelaces Back?*, is an edited version of the diary Johnston kept for seven months whilst recovering in an inpatient ward and, as such, is perhaps an example of the dual use of journaling as both a therapeutic tool and a tool for literary writing. As a contemporaneous expression of acute mental illness it gives general readers an unusually authentic insight into the experience of psychosis and is also an invaluable reflective tool for MHNs, since it illustrates a service user's view of the nursing interventions that supported recovery.

Another example of a blurring between therapeutic writing and writing for publication is the work of Andrew Fusek Peters. Peters has written an account of his recovery from depression with the help of wild swimming called *Dip* (2015), and has co-written a children's book with his wife Polly Peters about parental depression from the child's point of view, *The Colour Thief* (2014). This could be said to be at once a piece of therapeutic writing, a book written for publication and one that can be used as bibliotherapy for children and families affected by parental mental health difficulties.

Finally, it is worth noting that Blakeman and Ford (2012) suggested MHNs should be encouraged to write for publication as a way of sharing knowledge. Other benefits of this for practitioners may include some of the health and wellbeing improvements associated with expressive writing as well as enhanced collegial support (see Chap. 9.)

Chapter Summary

Whether it is part of a therapeutic process or intended for publication – or perhaps both – I have argued that writing offers us a way of speaking without being interrupted. This chapter has drawn to some extent on my own feelings about writing and my experiences of facilitating a creative writing

group for service users. It has provided an overview of therapeutic uses of creative writing, including Pennebaker's (2002) work on expressive writing. It has reviewed evidence for the use of literature, creative writing and poetry in mental health care, exploring bibliotherapy, therapeutic writing and poetry therapy as well as narrative biography. Creative writing has been examined as a tool for promoting both the recovery of service users and the professional development of mental health practitioners, and the value of storytelling in mental health nursing was discussed. The chapter also considered the role of journaling and blogging and concluded by considering the blurring between therapeutic writing, literary writing, autobiography and writing for publication.

Notes

1. "Écrire, c'est une façon de parler sans être interrompu." (Jules Renard, 1895.)
2. I have created a blog – to be found at https://tonygillam.blogspot.co.uk/ – to publish material supplementary to this book and which, I hope, will offer an ongoing forum for those interested in creativity, wellbeing and mental health practice.

References

Barker, P., & Buchanan-Barker, P. (2005). *The Tidal Model: A guide for mental health professionals.* Hove: Brunner-Routledge.

Blakeman, P., & Ford, L. (2012). Working in the real world: A review of sociological concepts of health and well-being and their relation to modern mental health nursing. *Journal of Psychiatric and Mental Health Nursing, 19*(6), 482–491.

Burr, J. A., & Chapman, T. (1998). Some reflections on cultural and social considerations in mental health nursing. *Journal of Psychiatric and Mental Health Nursing, 5*(6), 431–437.

Buslau, O. (2004). Story telling and analysis: Creative writing in therapy and literature. *Musik-, Tanz- und Kunsttherapie, 15*(1), 1–4.

Chandler, G. E. (1999). A creative writing program to enhance self-esteem a self-efficacy in adolescents. *Journal of Child & Adolescent Psychiatric Nursing, 12*(2), 70–78.

Cohen, L. J. (1994). Bibliotherapy: A valid treatment modality. *Journal of Psychosocial Nursing and Mental Health Services, 32*(9), 40–44.

Ekvall, G. (1996). Organizational climate for creativity and innovation. *European Journal of Work and Organizational Psychology, 5*(1), 105–123.



Gillispie, C. (2003). A case report illustrating the use of creative writing as a therapeutic recreation intervention in a dual-diagnosis residential treatment center. *Therapeutic Recreation Journal, 37*(4), 339–348.

Graham, I. W. (1999). Reflective narrative and dementia care. *Journal of Clinical Nursing, 8,* 675–683.

Greenhalgh, T. (2002). Intuition and evidence-uneasy bedfellows? *British Journal of General Practice, 52,* 395–400.

Heaney, S. (2002). *Finders keepers: Selected prose 1971–2001.* London: Faber & Faber.

Jensen, C. M., & Blair, S. E. E. (1997). Rhyme and reason: The relationship between creative writing and mental well being. *British Journal of Occupational Therapy, 60*(12), 525–530.

Johnston, S. (2003). *The naked bird watcher.* Helensburgh: The Cairn.

Johnston, S. (2009). *The snow globe journals.* Helensburgh: The Cairn.

Johnston, S. (2010). *When do I get my shoelaces back?* Helensburgh: The Cairn.

King, R., Neilsen, P., & White, E. (2012). Creative writing in recovery from severe mental illness. *International Journal of Mental Health Nursing, 22,* 444–452.

Lepore, S. J., & Smyth, J. M. (Eds.). (2002). *The writing cure: How expressive writing promotes health and emotional well-being.* Washington: American Psychological Association.

Lewis, W. A., & Bucher, A. M. (1992). Anger, catharsis, the reformulated frustration-aggression hypothesis, and health consequences. *Psychotherapy, 29,* 385–392.

LifeSpeaks Poetry Therapy. (2017). *What is poetry therapy?* Retrieved from http://www.lifespeakspoetrytherapy.com/poetry-therapy/

McArdle, S., & Byrt, R. (2001). Fiction, poetry and mental health: Expressive and therapeutic uses of literature. *Journal of Psychiatric and Mental Health Nursing, 8,* 517–524.

McGihon, N. N. (1996). Writing as a therapeutic modality. *Journal of Psychosocial Nursing and Mental Health Services, 34*(6), 31–35.

National Association for Poetry Therapy. (2017). *History of NAPT.* Retrieved from http://poetrytherapy.org/index.php/about-napt/history-of-napt/

Pennebaker, J. W. (2002). Writing, social processes and psychotherapy: From past to future. In S. J. Lepore & J. M. Smyth (Eds.), *The writing cure: How expressive writing promotes health and emotional well-being.* Washington: American Psychological Association.

Pennebaker, J. W., & Segal, J. D. (1999). Forming a story: The health benefits of narrative. *Journal of Clinical Psychology, 55*(10), 1243–1254.

Peters, A. F. (2015). *Dip: Wild swims from the borderlands.* London: Rider.

Peters, A. F., & Peters, P. (2014). *The colour thief.* London: Wayland.

Progoff, I. (1977). *At a journal workshop: The basic text and guide for using the intensive journal process.* New York: Dialogue H.

Roe, D., & Davidson, L. (2005). Self and narrative in schizophrenia: Time to author a new story. *Medical Humanities, 31*, 89–94.

Sagan, O. (2007). An interplay of learning, creativity and narrative biography in a mental health setting: Bertie's story. *Journal of Social Work Practice, 21*(3), 311–321.

Saunders, P. (2006). *Silent no more: Older adults as poets. Creative writing as a preventative approach to cognitive decline of the elderly.* Ann Arbor, MI: UMI Dissertation Services.

Smith, M. (2013). *Writing and keeping journals. A guide for educators and social practitioners.* Retrieved from http://infed.org/mobi/writing-and-keeping-journals-a-guide-for-educators-and-social-practitioners/

Smith, S. B. (2008). This sylvan game: Creative writing and GP wellbeing. *Australian Family Physician, 37*(6), 461–462.

Sparks, L. P. (2008). *The creative writing process as a means for a woman inmate to cope with her incarceration, rehabilitate herself within the prison setting, and prepare for her re-entry into society.* (Doctoral dissertation, University of Arkansas, Fayetteville).

Staricoff, R. (2004). *Arts in health: A review of the literature.* London: Arts Council England.

Swann, J. (2009). Creative writing in care homes: Getting started. *Nursing and Residential Care, 11*(6), 306–309.

Treloar, A., McMillan, M., & Stone, T. (2016). Nursing in an imperfect world: Storytelling as preparation for mental health nursing practice. *International Journal of Mental Health Nursing, 26*(3), 293–300.

Yalom, I. D., & Leszcz, M. (2008). *The theory and practice of group psychotherapy* (5th ed.). New York: Basic Books.

CHAPTER 8

Creative Approaches to Learning and Leadership

Abstract Learning and leadership are closely related and so, in this chapter, the author considers how creativity might be applied to these two important areas of mental health practice. Beginning with a series of reflections, the chapter examines the nature of leadership, seen as a complex interaction between the leader and the social and organisational environment. It examines resilient leadership and the unhelpful confusion between management development and leadership development. Different leadership styles are considered with a particular focus on transformational leadership. The concept of servant leadership is explored as well as Beghetto's description of creative leadership. The chapter concludes by suggesting transformational and servant leadership have much in common with creative leadership, which involves both role-modelling everyday creativity and establishing a creative organisational climate.

Keywords Learning and leadership • Nature of leadership • Social and organisational environment • Resilient leadership • Management development and leadership development • Leadership styles • Transformational leadership • Servant leadership • Beghetto and creative leadership • Role-modelling • Everyday creativity • Creative organisational climate

Before becoming a senior lecturer in mental health nursing, I was a clinical manager of an Early Intervention Service. This post combined many different roles: service manager, nurse, therapist, supervisor and mentor. In addition, I had a role within the organisation helping to provide family therapy training. Alongside this 'day job' I also did some freelance writing, training and lecturing. The common factor of these various roles could be regarded as *leading learning*. Learning and leadership are, in my view, closely related and so, in this chapter, I have chosen to reflect on these two important areas of mental health practice and to consider how creativity might be applied to learning and leadership. The chapter includes several examples of creative nonfiction because – as we saw in Chap. 7 – storytelling is important in mental health nursing (Greenhalgh, 2002; Treloar, McMillan, & Stone, 2016).

THE LESSON OF *THE DESERT RATS*

I was studying for my Master's degree and had spent several hours reading about leadership. Needing a break, I turned on the TV and soon became engrossed in a classic war film from 1953, *The Desert Rats*. The film tells the story of the siege of Tobruk in April 1941. I must have seen this film a few times on rainy Sunday afternoons in my childhood but, at that time, was probably only vaguely aware of the fact that my Uncle George had fought in the Africa campaign and may therefore himself have been part of the British 7th Armoured Division who were dubbed 'The Desert Rats'. The film contains several historical inaccuracies, no doubt forgivable in the name of dramatic storytelling, but I found myself reflecting on what it tells us about leadership.

The central character, an English Captain called 'Tammy' MacRoberts, (played by Richard Burton) is put in charge of a company of disorderly and inexperienced Australian troops. In the film's climax, MacFarlane and the men he leads are asked to take control of a key position for three days to enable a relief column through. Relentlessly bombarded by German artillery, three days turn into nine. Throughout the film, MacRoberts has been shown to be a brave and fair leader but, in the dramatic ending, he and his men are exhausted and he can see no alternative but to order a retreat. What follows could either be seen as a complete failure of leadership or the ultimate mark of successful leadership. Having given the order to retreat, MacRoberts emerges from his bunker only to find all of his men holding their positions. After one final bombardment, the sound of

bagpipes can be heard, heralding the arrival of the relief column. The mission has been a success despite – or perhaps because of – the leader's decision to retreat being unanimously disobeyed.

Leadership can be seen as "a set of processes concerned with influencing people and achieving goals and outcomes" (Hartley & Hinksman, 2003, p. 12). In the *Desert Rats* example it might be said that success has only been achieved through the followers demonstrating insubordination to the leader. The message could be that, sometimes, it is acceptable or even necessary to ignore the leader's orders. But, rather than see this as the failure of leadership, the scene could be interpreted as an example of the successful adoption of *self-leadership* by the followers. Day (2001) describes how, traditionally, leadership has been seen as an individual-level skill but he argues that leadership can equally be viewed as "a complex interaction between the designated leader and the social and organisational environment" (p. 583). He elaborates:

> In addition to building leaders by training a set of skills or abilities, and assuming that leadership will result, a complementary perspective approaches leadership as a social process that engages everyone in the community (...) In this way, each person is considered a leader, and leadership is conceptualized as an effect rather than a cause (...) Leadership is therefore an emergent property of effective systems design (and) leadership development from this perspective consists of using social (i.e. relational systems) to help build commitments among members of a community of practice. (p. 583)

Thus, in *The Desert Rats* scenario, far from leadership having failed or broken down, since the troops are leading themselves and one another, MacRoberts has succeeded in building commitment in the group and leadership has *emerged*. This can only be judged as a *failure* of leadership if we believe that leadership is about the individual leader always being seen to be 'leading from the front'.

The idea of a person who 'leads from the front' borrows from Victorian philosopher Thomas Carlyle's 'great man' theory of history according to which only men (or exceptional women) with great intellect, powers of persuasion and decision-making abilities can lead effectively (Carlyle, 1841). The notion that leaders are born rather than shaped by their societies was challenged even in Carlyle's lifetime, yet Alimo-Metcalfe and Lawler (2001) found a worryingly large number of organisations rely on the 'great man' theory and engage in leadership development based

implicitly on these assumptions. One example of this type of leadership development was a programme I undertook a few years ago which aimed to promote *resilient leadership* (Gillam, 2012).

THE PROBLEM WITH RESILIENT LEADERSHIP TRAINING

The resilient leadership course was a strange blend of what could be called 'soft' techniques to help participants manage stress (such as relaxation and visualisation techniques) and the 'hard' science of the use and interpretation of a psychological tool known (somewhat ominously, I thought) as MTQ48. This stands for 'Mental Toughness Questionnaire 48' and aims to measure "total mental toughness, as well as its subcomponents" (Marchant et al., 2009, p. 429), the latter being: Control, Commitment, Challenge and Confidence.

It seemed to me there was something to be said for the idea of building the resilience of healthcare staff to enable them to provide better care and better leadership. However, I found this programme disconcerting because the assumption that resilience was analogous to mental toughness seemed counter-intuitive. The humanistic teaching style of the trainer also seemed at odds with the language of mental toughness and several of us were uncomfortable with the implicit message that a low score in the MTQ48 could be taken to mean that the person was not tough enough to be an effective leader. Raising awareness of one's lack of mental toughness is perhaps more likely to lower self-confidence than to increase participants' resilience.

With the passage of time and further reflection, I came to recognise the reasons why I found the resilient leadership training so dissonant. The first is to do with my inclination towards a more behavioural and evidence-based approach to teaching and learning; this meant I found myself constantly questioning the aims of the programme and the evidence underpinning it and feeling frustrated that the trainer, with her more humanistic approach, was apparently unable to provide me with a satisfactory rationale for the content. I suspect my gentle challenging was an irritation to her. The second problem I had with the programme was that, diverting as it was, it failed to satisfy my learning needs as a piece of leadership development, perhaps because it was actually what Hartley and Hinksman (2003) call "management development repackaged as leadership development" (p. 47).

Alimo-Metcalfe and Lawler (2001) note that the concept of leadership is often ill-defined and nebulous and, frequently, in the literature no distinction is made between management and leadership (Rost, 1998). A helpful differentiation is provided by Day (2001) who argues that leadership may or may not come with formal authority, while the focus of management is on performance. Moreover, "leadership processes (...) enable groups of people to work together in meaningful ways whereas management processes are considered to be position- and organization-specific" (p. 582). As a *manager* I had a formal managerial role that was position- and organisation-specific, but this interested me less than my leadership role. As a *leader*, I was keen to enable groups of people to work and learn together in meaningful ways (whether these groups were the teams I managed, the students I taught, the colleagues I trained, fellow students in an enquiry-based learning situation or families in family therapy sessions.)

SALVAGING RESILIENCE: BEND WITHOUT BREAKING

Following the resilient leadership training programme some of us continued to meet to discuss how we could make use of any learning from it; there was an idea that we might be able to take the more useful elements of it and implement these as part of either team leader development programmes or staff wellbeing initiatives. I had no formal authority in these discussions, just an interest in wellbeing and learning. After a few meetings, I became aware that there was no expectation that those who had undergone the programme should cascade or share their learning so, instead, I began to consider ways in which the idea of resilience could be shared not with colleagues so much as with service users.

Serendipitously, I had received a review copy of a manual for *Building Happiness, Resilience and Motivation in Adolescents* (MacConville & Rae, 2012) and, inspired by this, I initiated discussions with my occupational therapy colleagues in the Early Intervention (EI) Service about how we could adapt this positive psychology curriculum designed for wellbeing in schools into a psychoeducational group for our EI service users in the community. The programme (see Box 8.1) would have a clear structure and be soundly based on evidence in the field of positive psychology, drawing on the work of Peterson and Seligman (2004). It would include sessions on resilience but also cover areas like persistence, creativity and 'love of learning'.

Box 8.1 Bend Without Breaking: A Wellbeing Programme for Service Users

Bend Without Breaking was a modular educational programme focusing on wellbeing and resilience, provided by Worcestershire Early Intervention Service from 2013–2016. Developed in collaboration with occupational therapy and mental health nursing colleagues, and adapted from MacConville and Rae's (2012) *Positive psychology curriculum for well-being in adolescents*, the programme proved successful in promoting the wellbeing of service users. It also encouraged greater engagement with social and educational community resources since the venue used for the sessions was a bookable room at Worcester city's public library, The Hive, which is also part of the University of Worcester.

The curriculum followed Peterson and Seligman's (2004) work on the 24 *signature strengths* which are organised into six *virtues*. Thus, there were sessions on all 24 strengths, (including, for example, sessions on creativity, love of learning, persistence etc). As well as sharing useful content in a non-threatening environment the sessions provided the benefits of the therapeutic factors of groupwork (see Box 7.1).

The project was an example of the model of creative mental health care in practice (see Fig. 5.1) in that it was collaborative (with colleagues of different disciplines working side by side), centred on both the service user and the community and was both knowledge-based and caring. Some of the feedback received reflected the incidental learning from the programme (e.g. re-establishing a regular routine of activity, feeling more confident using public transport to get to and from the venue). One participant noted, "The biggest part of the battle is turning up!" Another was inspired to create a witty catchphrase to describe the project: "Not stigmatised, realized!"

As manager of the EI service, I knew that we ought to be providing evidence-based, therapeutic group opportunities for our service users that would promote positive mental health. In creating what I called the *Bend Without Breaking* Programme, though, I was acting not so much as a

manager (setting out tasks for staff to implement) but as a leader (enabling groups of people to work together in meaningful ways) and, moreover, as a role model.

In a study of leadership for learning in clinical practice, Allan, Smith and Lorentzon (2008) describe how workforce changes in clinical settings have restricted opportunities for trained nurses to role-model caring activities for student nurses.[1] I was therefore in a privileged position in being able to take on a role as a leader of learning in a therapeutic group situation and to be able to model this kind of work, along with colleagues, to students of nursing and other disciplines. Similarly, I not only trained and supervised staff to practice family therapy but I still personally practiced it, sometimes as a co-worker with my colleagues. As such, I aspired to be a positive role model who could be emulated. Acting as a role model in this way is a characteristic of *transformational leadership* (Burns, 1978; Avolio & Bass, 2002).

RECOGNISING DIFFERENT LEADERSHIP STYLES

At the suggestion of the course leader of my Masters programme, I accessed the website of the Foundation of Nursing Leadership (2015) and carried out one of the self-assessments to be found there, namely *What is your leadership style?* This tool is designed to indicate which of three commonly identified leadership styles the participant favours: *transactional, laissez-faire* and *transformational*.

Transactional leaders monitor team members and provide rewards to them contingent upon adequate performance and the achievement of goals whereas laissez-faire leaders exercise little control, leaving team members to sort out their own roles and work objectives unless obliged to intervene when a problem occurs (Foundation of Nursing Leadership, 2015). The results of my own assessment confirmed that my style was predominantly transformational. Transformational leadership is a style characterised by the four elements of idealised influence, inspirational motivation, intellectual stimulation and individualised consideration (Burns, 1978) (See Table 8.1).

For all the simplicity of the Foundation of Nursing Leadership's tool, it seemed surprisingly accurate to characterise my style as predominately transformational, to a lesser extent transactional and to a much lesser extent laissez-faire. However, an unexpected meeting with some pre-registration nursing students in the university café led me to reflect further.

Table 8.1 Elements of transformational leadership

Idealised influence	The leader acts as a role model, engendering trust through doing the right thing
Inspirational motivation	The leader provides meaning and challenge to arouse the team's enthusiasm to achieve goals
Intellectual stimulation	The leader questions assumptions, reframing problems and challenging old ways of thinking
Individualised consideration	The leader acting as a mentor or coach to help each team member develop and learn

Adapted from Avolio and Bass (2002)

The Students Who Wanted to Film Themselves

I had arrived early at the university for one of the enquiry-based learning days on my Masters course. I was reading in the café when I was approached by three students who had recently been at a teaching session I had given on Behavioural Family Therapy. The students were so taken with the approach they had decided to video-record a role-play of themselves using the intervention, as part of their assessed learning. I was able to share with them not only my experiences of the therapy, but also of being filmed role-playing the therapy. A few weeks later, I came across these students on placement in a clinical area and they told me how beneficial our chance conversation had been and how they had been given top marks for their efforts.

It appeared this was an example of idealised influence and individualised consideration in practice (see Table 8.1). I could have asked the students to leave me alone with my book and my coffee – I was neither their lecturer nor their manager, after all, – but I was happy to be of service and this experience led me to consider the concept of *servant leadership*.

Transformational Versus Servant Leadership

Servant leadership emphasises serving and meeting the needs of others, with the role of the leader being a servant (Greenleaf, 1977). The concept was first articulated by Robert K Greenleaf, a writer and researcher in management, development and communication, who took his inspiration from a short novel by Hermann Hesse (1972) *The Journey to the East*.[2] The central character of the novel is a servant called Leo, making a journey with a group of travellers. When Leo disappears the group can no longer

function and they abandon their journey. Greenleaf takes this idea as the source of his concept of servant leadership: Leo is a great leader because he is first and foremost a servant. The leader assumes the position of servant in relation to fellow team members and is motivated not by self-interest but by the needs of others.

Russell and Stone (2002) reviewed servant leader attributes in an attempt to develop a researchable model of the concept. They found the literature on servant leadership to be philosophical and systematically undefined, but acknowledged it as "an intuitively attractive concept" (p. 145). Spears (1998) identified ten characteristics of servant leaders:

- listening
- empathy
- healing
- awareness
- persuasion
- conceptualisation
- foresight
- stewardship
- growth
- building community.

There are clearly some similarities with transformational leadership. This relationship was explored by Stone, Russell and Patterson (2004) who found that, superficially, the concepts are rather similar, if not almost the same. They argued that the primary difference is in the *focus* of the leader: in transformational leadership the leader's focus is directed towards the organisation and the aim is to build follower commitment to organisational objectives whereas the servant leader focuses on the followers, with the organisational objectives being subordinate. If we accept this distinction then, again reflecting on the earlier examples, in my role as clinical manager I was unable to ignore organisational objectives (and so may have been more transformational in style) whereas in my role as a visiting lecturer I could afford to be more of a servant leader.

Transformational leadership and servant leadership may have much to teach us in terms of a creative approach to learning and leading. Stone et al. (2004) conclude that both of these types of leadership offer a conceptual framework for dynamic leadership but, while transformational leadership has been well-researched, servant leadership theory requires

further support. They argue both types can bring about real organisational change and, when leaders genuinely follow the ideals of servant leadership, team members are more likely to themselves become servants, leading to the greater success and stability of the organisation.

THE MICROMOMENTS OF LEADERSHIP

In Chap. 2, we discussed the difference between Big-C and little-c creativity, Big-C referring to the rare kind of genius-like creativity and little-c being the ordinary, everyday kind that all human beings possess (Andreasen & Ramchandran, 2012). Beghetto (2015) considers what form *creative leadership* might take and suggests that, rather than being associated with outstanding accomplishments, creative leadership is more likely to manifest itself in "the micromoments of everyday leadership" (p. 72). In other words, creative leadership is little-c rather than Big-C.

Beghetto defines creative leadership as "the ability to respond to the everyday challenges and opportunities of leadership in new and meaningful ways" (p. 72). He identifies what he calls three corollaries, derived from his assertion that creative leaders stand out from other leaders by the way they respond to these micromoments:

- Knowing when to be creative – Creative leaders judge whether the time and place are appropriate for taking the risk of being creative. Creative leadership is called for when routine ways of doing things are no longer effective or need to be improved;
- Moments, not monuments – Moments when leaders face unusual, unforeseen situations are defining moments which require creative thought and action;
- Democratising opportunities for creative leadership – everyone in the organisation can use creativity and the creative leader is a role model who also establishes a creative climate.

The third of these corollaries is particularly interesting because it fits well with the concept of transformational leadership (see Table 8.1). A creative leader is both a role model, leading the way through their actions, and also a leader who establishes a creative climate. We discussed in Chap. 3, Ekvall's (1996) work on organisational climate and factors affecting organisational creativity (see Box 3.2). Although, Beghetto (2015) believes in micromoments rather than monuments, perhaps this last aspect – establishing a cre-

ative climate – is less momentary and needs to be built and nurtured over time. Equally, if we accept the reality of the sigmoid curve phenomenon described at the end of Chap. 6 then, while it may take time and effort to establish creative organisational climates, perhaps they are more transitory, more easily dissolved, than we would care to believe.

CHAPTER SUMMARY

Learning and leadership are closely related and so, in this chapter, we have considered how creativity might be applied to these two important areas of mental health practice. Beginning with a series of reflections, the chapter examined the nature of leadership, which is seen as a complex interaction between the leader and the social and organisational environment. It examined resilient leadership and the unhelpful confusion between management development and leadership development. Different leadership styles were considered with a particular focus on transformational leadership. The concept of servant leadership was explored as well as Beghetto's description of creative leadership. It is clear that transformational and servant leadership have much in common with creative leadership, which involves both role-modelling everyday creativity and establishing a creative organisational climate.

NOTES

1. In their study, Allan et al. (2008) focused on general nursing in in-patient settings so this may be less true of mental health community settings. Nevertheless, it is increasingly the case that senior nurses in mental health tend to have more managerial and fewer clinical responsibilities and therefore the opportunities for them to act as clinical role models are diminished.
2. Greenleaf's theory arose as a result of reading a novel – an illustration of the importance of literature (and the humanities generally) as a positive influence on healthcare, as discussed in Chaps. 3 and 7.

REFERENCES

Alimo-Metcalfe, B., & Lawler, J. (2001). Leadership development in UK companies at the beginning of the twenty-first century: Lessons for the NHS? *Journal of Management in Medicine, 15*, 387–404.

Allan, H. T., Smith, P. A., & Lorentzon, M. (2008). Leadership for learning: A literature study of leadership for learning in clinical practice. *Journal of Nursing Management, 16*, 545–555.

Andreasen, N. C., & Ramchandran, K. (2012). Creativity in art and science: Are there two cultures? *Dialogues in Clinical Neuroscience, 14*(1), 49–54.

Avolio, B. J., & Bass, B. M. (2002). *Developing potential across a full range of leadership: Cases on transactional and transformational leadership*. Mahwah, NJ: Lawrence Erlbaum Associates.

Beghetto, R. A. (2015). Creative leaders define themselves in the micromoments of leadership. *Journal of Leadership Studies, 9*(3), 72–74.

Burns, J. M. (1978). *Transformational leadership*. New York: Harper and Row.

Carlyle, T. (1841). *On heroes, hero-worship, and the heroic in history*. London: James Fraser.

Day, D. (2001). Leadership development: A review in context. *Leadership Quarterly, 11*, 581–613.

Ekvall, G. (1996). Organizational climate for creativity and innovation. *European Journal of Work and Organizational Psychology, 5*(1), 105–123.

Foundation of Nursing Leadership. (2015). *What is your leadership style?* Retrieved from http://www.nursingleadership.org.uk/test1.php

Gillam, T. (2012). The brilliance of resilience. *British Journal of Mental Health Nursing, 1*(4), 266.

Greenhalgh, T. (2002). Intuition and evidence – uneasy bedfellows? *British Journal of General Practice, 52*, 395–400.

Greenleaf, R. K. (1977). *Servant leadership: A journey into the nature of legitimate power and greatness*. New York: Paulist Press.

Hartley, J., & Hinksman, B. (2003). *Leadership development: A systematic review of the literature*. London: NHS Leadership Centre.

Hesse, H. (1972). *The journey to the East*. London: Panther Books.

MacConville, R., & Rae, T. (2012). *Building happiness, resilience and motivation in adolescents: A positive psychology curriculum for well-being*. London: Jessica Kingsley Publishers.

Marchant, D. C., Polman, R. C. J., Clough, P. J., Jackson, J. G., Levy, A. R., & Nicholls, A. R. (2009). Mental toughness: Managerial and age differences. *Journal of Managerial Psychology, 24*(5), 428–437.

Peterson, C., & Seligman, M. E. P. (2004). *Character strengths and virtues: A handbook and classification*. Washington, DC: APA Press and Oxford University Press.

Rost, J. (1998). Leadership and management. In G. Hickman (Ed.), *Leading organizations: Perspectives for a new era*. Thousand Oaks: Sage.

Russell, R. F., & Stone, A. G. (2002). A review of servant leadership attributes: Developing a practical model. *Leadership and Organization Development Journal, 23*(3), 145–157.

Spears, L. C. (1998). *Tracing the growing impact of servant leadership.* In L. C. Spears (Ed.), *Insights on leadership: Service, stewardship, spirit, and servant-leadership.* New York: John Wiley and Sons.

Stone, A. G., Russell, R. F., & Patterson, K. (2004). Transformational versus servant leadership: A difference in leader focus. *Leadership and Organization Development Journal, 25*(4), 349–361.

Treloar, A., McMillan, M., & Stone, T. (2016). Nursing in an imperfect world: Storytelling as preparation for mental health nursing practice. *International Journal of Mental Health Nursing, 26*(3), 293–300.

Wellbeing and Mental Health Nursing: Implications for Practice

Abstract This chapter revisits the themes of the systematic review, introduced in Chap. 4, which explored the question: *what is wellbeing and how is it relevant to mental health nursing?* The five main themes identified are discussed: wellbeing as a nebulous, multifaceted notion, physical wellbeing as a legitimate concern for nurses, psychosocial wellbeing *for* nurses, psychosocial wellbeing *of* nurses, and nurses as spiritual allies. The chapter examines how we can facilitate flourishing, the centrality of relatives, carers and family life, the connections between general health and psychological wellbeing, occupational stress and satisfying professional practice and the interaction between individual and organisational wellbeing. The author makes links and draws conclusions from the findings which lead to a series of eight recommendations for translating these findings into practice.

Keywords Wellbeing and mental health nursing • Wellbeing as a nebulous, multifaceted notion • Physical wellbeing • Psychosocial wellbeing • Nurses as spiritual allies • Facilitating flourishing • Centrality of relatives, carers and family life • Health, psychological wellbeing, occupational stress and satisfying professional practice • Individual and organisational wellbeing • Recommendations for practice

© The Author(s) 2018
T. Gillam, *Creativity, Wellbeing and Mental Health Practice*,
Palgrave Studies in Creativity and Culture,
https://doi.org/10.1007/978-3-319-74884-9_9

In Chap. 4 we introduced wellbeing theory and outlined the findings of a systematic review I conducted that explored the question: *what is wellbeing and how is it relevant to mental health nursing?* In this chapter, we revisit and discuss the findings of that review before making recommendations based upon this discussion.

The Nebulous, Multifaceted Notion

Of the five main themes emerging in my systematic review it is unsurprising that the first was *wellbeing as a nebulous, multifaceted notion*. Eleven different types of wellbeing were identified along with numerous attempts by researchers to list what might be its components. All this supports McNaught's (2011) assertion that wellbeing is "a complex, confusing and contested field (with) competing and contradictory definitions (and) it is sometimes unclear if it is something profound or just a linguistic flourish" (p. 7–8). This is a salutary forewarning when examining the literature and some papers were rejected in my review (Bonham, 2010; Jones & Jones, 2008) because, despite using the word in the title, the subject was actually health rather than wellbeing.

McNaught (2011) attributes this overuse (or misuse) of the term to the historical coupling of the words 'health and wellbeing', stemming from the WHO definition of health as not merely the absence of diseases but a state of wellbeing (WHO, 1946). This, he suggests, led to a tradition of health being associated with objectivity and biomedical science while wellbeing was viewed as a more psychological, subjective construct. Psychologists like Seligman (2011) and Huppert (2008) have subsequently striven to establish a robust evidence base for wellbeing to the point where it cannot be dismissed as mere "happiology" (Seligman, 2011, p. 14).

Of the plethora of 'wellbeings', it was interesting to note the weight given to different types within the literature reviewed. Useful findings were gleaned relating to both physical and spiritual wellbeing but the overwhelming focus was on psychosocial wellbeing. It might have been predicted that literature pertaining specifically to mental health nursing would be more concerned with psychological, emotional and social aspects but the relative inattention paid to physical wellbeing was surprising given the increasing emphasis on monitoring and promoting physical health, especially in service users with serious or severe mental illness. Spiritual wellbeing emerged as having almost equal weighting with physical wellbeing and,

while psychosocial aspects were by far the most salient, it was noteworthy that the psychosocial wellbeing of mental health nurses (MHNs) themselves was as great a preoccupation as the psychosocial wellbeing of service users.

Physical Wellbeing as a Legitimate Concern

The second theme points towards some conclusions about wellbeing's relevance for MHNs. The relative paucity of papers concerned with physical wellbeing may reflect a historic neglect of this aspect in MHNs' practice in favour of the psychosocial. Nash (2014) attests that the physical health of mental health service users, long neglected, has now become a major area of concern in mental healthcare. He argues MHNs cannot claim to be providing holistic care if they continue to overlook physical health and his textbook aims to provide MHNs with the knowledge needed to address this. (It may also represent a prime example of the use of wellbeing as a linguistic flourish, since it predominantly deals with health.)

There is certainly a compelling argument for MHNs to concern themselves with physical wellbeing, and the findings suggested several practical ways in which MHNs could approach this. Foremost among these is the monitoring and promoting of physical health – especially in severely mentally ill patients – as part of a holistic assessment (Stodart, 2014). Beyond individual physical assessment, monitoring and health promotion is the involvement of some MHNs in wellbeing support programmes and healthy lifestyle groups (Jones, 2004). While it might be expected that MHNs should certainly assess physical health status (particularly in people with serious mental illness), and monitor and promote physical wellbeing in their service users, involvement in healthy lifestyle groups or programmes could also be a worthwhile extension of the MHN's role, (albeit one that might take them into territory more usually associated with occupational therapists, dieticians or sports therapists.) However deployed, the key conclusion to be drawn here is that physical wellbeing should be a concern for MHNs.

Psychosocial Wellbeing for MHNs

The third theme includes several subthemes which, again, suggest new roles or new interpretations of the role of the MHN. These subthemes are:

- facilitating flourishing
- the importance of relatives, carers and family life
- general health and psychological wellbeing
- recovery and wellbeing.

The findings strongly suggested that MHNs need to move beyond focusing on symptom reduction or amelioration towards positively promoting resilience. This requires an appreciation of the impact of poverty, social exclusion and inequality, skills in supporting the welfare of children and families, greater use of solution-focused approaches and self-management resources and an ability to identify and mobilise strengths in the community to bolster resilience (Blakeman & Ford, 2012; Ruddick, 2013). Some of these attributes are more traditionally associated with social work than with nursing, and Blakeman and Ford seem to call, not only for a more social approach to nursing, but for a political dimension. They urge MHNs to promote social inclusion both in their interventions and by engaging politically through public health campaigns, writing for publication and sharing knowledge via support, supervision and educational groups. The encouragement of writing for publication fits well with all that was said in Chap. 7 regarding the importance of creative writing and storytelling in mental health practice while the emphasis on support, supervision and educational groups underlines how, as we saw in Chap. 3, supervision and support promote both creativity and wellbeing.

Facilitating flourishing, then, seems to demand that MHNs become more socially and politically engaged, working not only with individuals but with families and communities. While Ruddick (2013) called for MHNs to have skills in supporting children and families, the importance of relatives, carers and family life emerged as a subtheme in itself. Several authors stressed the value of assessing the wellbeing of families and carers and developing therapeutic relationships with the relatives of service users (Jormfeldt, 2014; Saarijarvi et al., 1998; Minardi, Heath, & Neno, 2007; McGuinness & McGuinness, 2014).

Within the subtheme of general health and psychological wellbeing Hamdan-Mansour and Marmash (2007) concluded MHNs should screen for physical symptoms as well as assessing psychological wellbeing. This is effectively approaching the subtheme of physical wellbeing as a legitimate concern from the other end of the telescope, as it were, and so 'loops back' neatly to the earlier theme.

Moving beyond symptom reduction would be understood by many MHNs as shifting from the biomedical illness model to the recovery

model. Shepherd, Boardman, and Slade (2008), for example, contrast recovery-oriented services with traditional, 'treatment-and-cure' services, the latter focusing on symptom relief and relapse prevention, the former stressing the importance of quality of life as judged by the individual service user. Within this framework, services can be considered as more or less traditional or more or less modern and recovery-orientated.

Papadopoulos, Fox, and Herriott (2013) try to contextualise the concept of recovery within a wider wellbeing framework, suggesting the road to recovery can lead ultimately to wellbeing. This appears, at first, a promising approach, but the framework is over-complicated and flawed in assuming the service user enjoyed wellbeing *before* they became unwell and, through the recovery process, will *recover* wellbeing. This seems to overlook the impact of factors like social exclusion, poverty, stigma and marginalisation. There is a sense in Papadopoulos et al.'s paper that wellbeing keeps slipping away; the discussion keeps reverting to talk of recovery rather than wellbeing. While there is a section on implications for nursing practice this appears almost as an afterthought to the body of the argument, suggesting the co-authors (two psychologists and a nurse) developed a psychological model that might, in the end, have implications for MHNs. Perhaps the problem is that it is not radical enough; wellbeing may be not so much a destination at the end of the road to recovery as a different road altogether, one that stems not from illness but from strengths. The recommendations (that MHNs use tools like Wellness Recovery Action Plans[1]) seems insufficiently bold; a more radical conclusion would be that MHNs might work within a wellbeing model *rather than* a recovery model. This is what Seligman (2011) called for when he suggested psychologists should supplement their "venerable goal of relieving misery and uprooting the disabling conditions of life" (p. 1) with the aim of "building the enabling conditions of a life worth living" (pp. 1–2). MHNs could address not so much illness – not even *recovery* from illness – but wellbeing.

PSYCHOSOCIAL WELLBEING OF MHNs

If MHNs are to address effectively the psychosocial wellbeing of service users they may need to attend to their own psychosocial wellbeing – the subject of the fourth theme to emerge. Within this, three subthemes were identified:

- occupational stress and satisfying professional practice
- individual and organisational wellbeing
- what can be learnt from the wellbeing of student MHNs.

Much of the literature explored the quest for satisfying professional practice in the face of considerable occupational stress. Several papers highlighted evidence that MHNs experience higher levels of stress and burnout compared with both other nursing specialties and other mental health disciplines. Also highlighted was the impact on wellbeing of high psychological demand, low job control and low support at work plus the worsening effect of isolation, which can occur in inpatient settings but is a much greater risk for community mental health nurses (CMHNs) (Leka, Hassard, & Yanagida, 2012; Tyson, Lambert, & Beattie, 2002). Cole, Scott, and Skelton-Robinson (2000) found organisational factors a greater source of stress than service user-related factors. Stressful organisational factors identified were:

- lack of role definition
- lack of support
- lack of knowledge of procedures.

In fact, the CMHNs in Rose and Glass's (2006) study recounted, without irony, how visiting service users was sometimes used as a coping strategy to provide respite from dealing with workplace stress. Though their qualitative study involved only five CMHNs it provides some rich, deep insights into how CMHNs need organisational support to be able to speak out and to practice autonomously, particularly given the triple stress identified by MacCulloch (2009) of carrying the burden of

- complex risk
- patient and family distress
- potential criticism from wider society.

Several studies concur that clinical supervision is essential to provide a trusting relationship that demonstrates organisational support for MHNs' emotional wellbeing and help them retain a sense of meaning in their work (Leka et al., 2012; Rose & Glass, 2006; MacCulloch, 2009).

Linked with occupational stress and satisfying professional practice is the subtheme of individual and organisational wellbeing. One cross-cultural study, which used an impressive sample of 1016 MHNs, provides

valuable data about the relationship between autonomy and wellbeing (Thomsen, Arnetz, Nolan, Soares, & Dallender, 1999). Thomsen et al.'s study supports Rose and Glass's finding that autonomy is only helpful insofar as the organisation supports MHNs to practice it. Autonomy may not always enhance wellbeing if nurses feel they lack the knowledge, skills or status to exercise it. This chimes with Cole et al.'s (2000) finding that lack of role definition, support or knowledge is stressful. There is a difference, evidently, between having the skills, knowledge and support to work autonomously and simply being left to get on with it.

Thomsen et al.'s (1999) Swedish/English comparative study is particularly interesting in light of other evidence that Scandinavian countries generally enjoy higher levels of wellbeing (Huppert & So, 2009). English MHNs were found to be at increased risk of poor mental health; working with severely mentally ill service users was stressful and political and organisational factors (including management style) impact most on job satisfaction. While organisational culture doubtless makes a difference personality factors play a part and Thomsen et al. concluded English MHNs would enjoy levels of personal wellbeing equivalent to Swedish MHNs if they had comparably high levels of self-esteem. Much more than their Swedish counterparts, English MHNs felt other disciplines had taken over parts of their role, requiring them to forge new roles for themselves and work in new team configurations for which they felt ill-equipped. This insecurity coupled with the higher professional status Swedish MHNs enjoy (as a result of a powerful union) were suggested as a cause of English MHNs' lower personal wellbeing. This may support the argument made by Blakeman and Ford (2012) for greater politicisation of MHNs while the perceived need to create new roles may be met by some of the recommendations at the end of this chapter.

Morrissette (2004) finds evidence of vicarious trauma in student MHNs who may be traumatised by concern by the intense clinical situations they confront and their own perceived inability to alleviate distress. He recommends strategies to anticipate and manage this. Since Leka et al. (2012) noted younger MHNs are more prone to emotional exhaustion it seems likely these strategies hold good for qualified nurses as much as for students, particularly in the early years of their careers. What Morrissette calls for can be translated as simply giving MHNs the same kinds of support it is hoped they would offer service users and carers – a safe, respectful atmosphere in general and a trusting relationship in particular (the latter, for nurses, in the form of clinical supervision.) Morrissette also recommends participation in support networks and professional organisations, something Blakeman and Ford (2012) suggested when they encouraged MHNs

to write for publication and share knowledge through support, supervision and educational groups. These vehicles of collegial support could enhance MHNs' wellbeing as well as benefiting those for whom they care. All are excellent ways of connecting, being active, taking notice, learning and giving (Aked, Marks, Cordon, & Thompson, 2008).

Spiritual Allies: MHNs and Spiritual Wellbeing

The final main theme relates to MHNs and spiritual wellbeing (SWB). Dunn, Handley and Shelton's (2007) study found low levels of SWB correlated with high levels of depression and anxiety and Coleman (2004) found a similar correlation between high SWB and low depression scores. Since depression and anxiety are the most common of mental health disorders, it is reasonable to view SWB, like physical wellbeing, as a legitimate (if hitherto neglected) concern of MHNs and Dunn et al. recommend the inclusion of spiritual assessment skills in nurse education.

The richest findings relating to SWB come from Hood Morris (1996) who provides a SWB model and proposes MHNs act as *spiritual allies*,[2] a role involving using warmth, respect and empathy to help service users resolve pain and despair. She also strongly advocates groupwork (an intervention in which MHNs in the UK have arguably become deskilled with the widespread closure of day hospitals and day centres.) The development (or rediscovery) of groupwork skills could be one of the roles MHNs need to (re)claim. Based on Thomsen et al.'s (1999) findings, it seems likely adopting new roles could improve MHNs' security, self-esteem and personal wellbeing. The role of becoming a spiritual ally could have the same effect. Therapeutic groups, facilitated by MHNs, could address spiritual, psychosocial or physical wellbeing, as in the healthy lifestyle groups discussed in Jones (2004). Groups like the Music Workshop Project (see Chap. 6), creative writing groups (see Chap. 7) and the Bend Without Breaking programme (see Chap. 8) also have the potential to address all aspects of wellbeing, as well as offering those therapeutic factors identified by Yalom and Leszcz (2008) (see Box 7.1).

Conclusions of the Findings

The first, perhaps self-evident, theme emerging from the findings of this review was that wellbeing is a nebulous, multifaceted notion. Trying to understand the concept might have seemed a fruitless exercise had the

thematic analysis not yielded other themes which, together, provide a framework of the kind McNaught (2011) called for, to help us make sense of wellbeing. Within this framework, psychosocial wellbeing emerges as paramount in its relevance, both in terms of the ways in which MHNs can support the psychosocial wellbeing of service users and how organisations can support the psychosocial wellbeing of MHNs. Appreciating the importance of all three aspects (psychosocial, physical and spiritual wellbeing) and making use of this understanding in practice, could provide mental health nursing with greater clarity, meaning and purpose, and new roles which can enhance the wellbeing of MHNs and service users.

Recommendations for Practice

The following eight recommendations are made by way of translating the above findings into practice:

1. MHNs should have a key role (and the necessary skills and knowledge) to be able to assess, monitor and promote physical health, as part of a holistic assessment, especially in service users with serious mental illness. This role could be further extended through involvement in healthy lifestyle groups or programmes.
2. MHNs should have an appreciation of the impact of poverty, social exclusion and inequality, and skills in supporting the welfare of children and families, greater use of solution-focused and self-management resources and an ability to identify and mobilise strengths in the community to bolster resilience and facilitate flourishing. They should promote greater social inclusion through interventions and engage politically through public health campaigns, writing for publication and sharing knowledge through support, supervision and educational groups.
3. MHNs should consider wellbeing not merely as an extension of the recovery approach but as a positive approach in its own right that facilitates flourishing. MHNs could address not so much illness – not even *recovery* from illness – but wellbeing.
4. MHNs should have the necessary skills and knowledge to be able to assess the wellbeing of families and carers and to develop therapeutic relationships with the relatives of service users. They should be mindful of how stigma and marginalisation negatively impact on the psychosocial wellbeing of families.

5. MHNs should participate in regular clinical supervision. This should provide a trusting relationship that demonstrates organisational support for MHNs' emotional wellbeing and help them retain a sense of meaning in their work. Organisational support is needed to practice autonomously, (particularly for CMHNs), if they are to maintain emotional wellbeing and satisfying professional practice.

6. For student MHNs and those in the early stages of their career, nurse educators and mentors should anticipate the impact of caregiving and help colleagues maintain personal awareness through feedback and clinical supervision. They should provide a safe, respectful atmosphere and encourage participation in support networks and professional organisations, the setting of realistic, achievable clinical goals and, if required, mental health consultation in one's own right.

7. Like physical wellbeing, spiritual wellbeing is a legitimate (if hitherto neglected) concern of MHNs. Spiritual assessment skills should be included in nurse education and MHNs should have an awareness of spiritual wellbeing so they can act as spiritual allies, using warmth, respect and empathy to help service users resolve pain and despair.

8. MHNs should further develop their skills in groupwork so they are able to facilitate therapeutic groups to help address psychosocial, physical and spiritual wellbeing. Groupwork is valuable because it provides opportunities for social inclusion, connection, creativity and care.

One of the questions at the heart of this book is whether there can be a genuine synergy between contemporary mental health practice and wellbeing. The systematic review that forms the basis of this chapter suggests that, with a better knowledge of the complex concept of wellbeing and a framework to demonstrate its relevance, MHNs can adopt fresh perspectives and roles that can enrich mental health practice and its contribution to society's wellbeing. Ultimately, the conditions for wellbeing are the same, whether we are the cared-for or those who care.

Chapter Summary

This chapter revisited the themes of the systematic review, introduced in Chap. 4, which explored the question: *what is wellbeing and how is it relevant to mental health nursing?* The five main themes identified were discussed: wellbeing as a nebulous, multifaceted notion, physical wellbeing as

a legitimate concern for nurses, psychosocial wellbeing *for* nurses, psychosocial wellbeing *of* nurses, and nurses as spiritual allies. The chapter examined how we can facilitate flourishing, the centrality of relatives, carers and family life, the connections between general health and psychological wellbeing, occupational stress and satisfying professional practice and the interaction between individual and organisational wellbeing. I have made links and drawn conclusions from the findings which led to a series of eight recommendations (see above) for translating these findings into practice.

NOTES

1. The Wellness Recovery Action Plan (WRAP) is a self-management resource used with service users with severe mental illness, first developed by Copeland (2000).
2. Hood Morris (1996) provides a reference for an earlier use of the phrase "spiritual ally" (Colliton, 1981).

REFERENCES

Aked, J., Marks, N., Cordon, C., & Thompson, S. (2008). *Five ways to wellbeing: The evidence*. London: New Economics Foundation.

Blakeman, P., & Ford, L. (2012). Working in the real world: A review of sociological concepts of health and well-being and their relation to modern mental health nursing. *Journal of Psychiatric and Mental Health Nursing, 19*(6), 482–491.

Bonham, E. (2010). Approaches for mental health well-being in children and adolescents. *Journal of Child and Adolescent Psychiatric Nursing., 23*(4), 242.

Cole, R. P., Scott, S., & Skelton-Robinson, M. (2000). The effect of challenging behaviour, and staff support, on the psychological wellbeing of staff working with older adults. *Aging and Mental Health, 4*(4), 359–365.

Coleman, C. L. (2004). The contribution of religious and existential well-being to depression among African American heterosexuals with HIV infection. *Issues in Mental Health Nursing, 25*(1), 103–104.

Colliton, M. A. (1981). The spiritual dimension of nursing. In V. Carson (Ed.), *Spiritual dimensions of nursing practice*. Toronto: W.B. Saunders.

Copeland, M. E. (2000). *Wellness recovery action plan*. Dummerston, VT: Peach Press.

Dunn, L. L., Handley, M. C., & Shelton, M. M. (2007). Spiritual well-being, anxiety, and depression in antepartal women on bedrest. *Issues in Mental Health Nursing, 28*, 1235–1246.

Hamdan-Mansour, A. M., & Marmash, L. R. (2007). Psychological well-being and general health of Jordanian university students. *Journal of Psychosocial Nursing, 45*(10), 31–39.

Hood Morris, L. E. (1996). A spiritual well-being model: Use with older women who experience depression. *Issues in Mental Health Nursing, 17*, 439–455.

Huppert, F. (2008). *Psychological well-being: evidence regarding its causes and its consequences.* London: Foresight Mental Capital and Wellbeing Project.

Huppert, F., & So, T. (2009). *What percentage of people in Europe are flourishing and what characterizes them?* Cambridge: The Wellbeing Institute, Cambridge University.

Jones, A. (2004). Matter over mind: Physical wellbeing for people with severe mental illness. *Mental Health Practice, 7*(10), 36–38.

Jones, M., & Jones, A. (2008). Choice as an intervention to promote well-being: The role of the nurse prescriber. *Journal of Psychiatric and Mental Health Nursing, 15*, 75–81.

Jormfeldt, H. (2014). Perspectives on health and well-being in nursing. *International Journal of Qualitative Studies on Health and Well-being, 9*, 10.

Leka, S., Hassard, J., & Yanagida, A. (2012). Investigating the impact of psychosocial risks and occupational stress on psychiatric hospital nurses' mental well-being in Japan. *Journal of Psychiatric and Mental Health Nursing, 19*(2), 123–131.

MacCulloch, T. (2009). Clinical supervision and the well-being of the psychiatric nurse. *Issues in Mental Health Nursing, 30*, 589–590.

McGuinness, T. M., & McGuinness, J. P. (2014). The well-being of children from military families. *Journal of Psychosocial Nursing, 52*(4), 27–30.

McNaught, A. (2011). Defining wellbeing. In A. Knight & A. McNaught (Eds.), *Understanding wellbeing: An introduction for students and practitioners of health and social care.* Banbury: Lantern Publishing Limited.

Minardi, H., Heath, H., & Neno, R. (2007). Mental health and well-being for older people in the future: The nursing contribution. In R. Neno, B. Aveyard, & H. Heath (Eds.), *Older people and mental health nursing: A handbook of care.* Oxford: Wiley-Blackwell.

Morrissette, P. J. (2004). Promoting psychiatric student nurse well-being. *Journal of Psychiatric and Mental Health Nursing, 11*(5), 534–540.

Nash, M. (2014). *Physical health and well-being in mental health nursing: Clinical skills for practice* (2nd ed.). Maidenhead: Open University Press.

Papadopoulos, A., Fox, A., & Herriott, M. (2013). Recovering wellbeing: An integrative framework. *British Journal of Mental Health Nursing, 2*(3), 145–154.

Rose, J., & Glass, N. (2006). Community mental health nurses speak out: The critical relationship between emotional wellbeing and satisfying professional practice. *Collegian, 13*(4), 27–32.

Ruddick, F. (2013). Promoting mental health and wellbeing. *Nursing Standard*, *27*(24), 35–39.

Saarijarvi, S., Taiminen, T., Syvalahti, E., Niemi, H., Ahola, V., Lehto, H., & Salokangas, R. K. R. (1998). Relatives' participation in a clinical drug trial of schizophrenic outpatients improves their psychologic well-being. *Nordic Journal of Psychiatry, 52*(5), 389–393. Saarijarvi and colleagues use the rare word 'psychologic' (sic) rather than the usual 'psychological'.

Seligman, M. E. P. (2011). *Flourish: A new understanding of happiness and wellbeing – and how to achieve them*. London: Nicholas Brealey Publishing.

Shepherd, G., Boardman, J., & Slade, M. (2008). *Making recovery a reality*. London: Sainsbury Centre for Mental Health.

Stodart, K. (2014). Breaking through the barriers to well-being. *Kai Tiaki Nursing New Zealand, 20*(3), 16–17.

Thomsen, S., Arnetz, B., Nolan, P., Soares, J., & Dallender, J. (1999). Individual and organizational well-being in psychiatric nursing: A cross-cultural study. *Journal of Advanced Nursing, 30*(3), 749–757.

Tyson, G. A., Lambert, G., & Beattie, L. (2002). The impact of ward design on the behaviour, occupational satisfaction and well-being of psychiatric nurses. *International Journal of Mental Health Nursing, 11*(2), 94–102.

Yalom, I. D., & Leszcz, M. (2008). *The theory and practice of group psychotherapy* (5th ed.). New York: Basic Books.

World Health Organisation (WHO). (1946). *Constitution*. Geneva: WHO. Retrieved from http://apps.who.int/gb/bd/PDF/bd47/EN/constitution-en.pdf?ua=1

CHAPTER 10

Conclusions

Abstract This final chapter summarises the book's main arguments. The author asserts that some aspects of contemporary mental health practice have become mechanical, joyless and uninspiring, leading to a loss of creativity and wellbeing; enjoying a high level of wellbeing is essential to mental health and the practice of mental health care, and creativity is at the heart of this. Key areas are revisited and both the model of creative mental health care (from Chap. 5) and the eight wellbeing recommendations (from Chap. 9) are reviewed. The chapter concludes with the hope that all those associated with mental health practice will support and implement the wellbeing recommendations and make use of the model of creative mental health care in order to promote greater creativity and wellbeing.

Keywords Contemporary mental health practice • Loss of creativity and wellbeing • Model of creative mental health care • Wellbeing recommendations

© The Author(s) 2018 145
T. Gillam, *Creativity, Wellbeing and Mental Health Practice*,
Palgrave Studies in Creativity and Culture,
https://doi.org/10.1007/978-3-319-74884-9_10

The View from the Top

If you stand on the Old Hills between Malvern and Worcester, with your back to the Malvern Hills, you can see Worcester Cathedral and, in the near distance, the site of the former Powick Hospital which, like Shelton Hospital in Shrewsbury (where I first trained as a mental health nurse), is now mainly housing. As I explained in Chap. 1, it was at Powick that the young Edward Elgar led the asylum orchestra.

This book began with Elgar and Housman – a great composer and a celebrated poet – and their connections with mental hospitals and with my own journey working in mental health. Like the asylums, both Elgar and Housman were products of the Victorian age and both created art characterised by a nostalgic yearning for a lost past and a disappearing landscape, a "land of lost content" (Housman, 1975, p. 57). Elgar's music evokes his walks on the Malvern Hills; Housman's poetry celebrates Shropshire's hill country and rural life before the Industrial revolution. If Elgar's compositions still enjoy popularity, Housman's poetry now seems out-of-fashion and it is easy to forget how influential it once was (Kirsch, 2017).

In the creative arts, styles and genres go in and out of fashion and shape future trends just as, in mental health practice, changing attitudes and approaches come and go. In *Creativity, wellbeing and mental health practice* I have reflected on the past and on current ways of working. I have reviewed the evidence relating to creativity and wellbeing and described examples of contemporary practice. If there is a hint of nostalgia in my book, it is not because I wish continually to hark back to the days of the asylums or to return to a system of institutionalised custodial care. Far from it. It is because some aspects of contemporary mental health practice have become rather mechanical, joyless and uninspiring. This loss of creativity has led to a reduced sense of wellbeing for practitioners and the result is a missed opportunity for promoting greater wellbeing in our society. As Ordoña (2005) wrote:

> It saddened me (…) to think how dangerously ill-equipped and unhealthy most of us working in the mental health field are (…) We are expected to lead patients who are lost into the promised land of well-being when most of us are so unwell and so lost. (p. 1399)

Don't Lose Yourself

There is a song by American singer-songwriter Laura Veirs called *Don't lose yourself*. I would suggest this is a good motto for mental health nurses (MHNs) and other practitioners like us. We should not lose ourselves while caring for others. Rather, we should enjoy a good level of health and wellbeing and be able to act as reliable fellow travellers on the journey of recovery. Rapp and Goscha (2012) argue the role of a mental health worker should be more like that of a travelling *companion* than that of a travel *agent*. Rather than arranging care packages and sending service users off on their travels we should, instead, accompany people, enjoy the time spent travelling together and learn from one another. If we are to be reliable travelling companions it is important not to lose ourselves.

Several metaphors have recurred through the course of this book. These include metaphors of resilience (bending without breaking), journeying (the journey of recovery, the journey of mental health professionals through their careers,) and the need to remain well-orientated, rather than becoming disorientated, on our shared journeys. Along with supervision and collegiate support we have seen that creative leadership and the fostering of a creative organisational climate can promote the wellbeing of mental health workers. It is interesting to note that Greenleaf's (1977) theory of servant leadership (discussed in Chap. 8) arose as a result of his reading a novel – Hesse's (1972) *Journey to the East*. Here again is the image of a journey, but it also illustrates the point made earlier that literature (and the humanities generally) are a positive influence on healthcare, providing new insights and improvements.

Hesse's enigmatic novel is not just about servant leadership but also about spirituality. We have seen (in Chap. 9) how spiritual wellbeing is, like physical wellbeing, an often neglected area of mental health care and how practitioners could promote wellbeing by acting as spiritual allies – a role involving the use of warmth, respect and empathy to help resolve pain and despair (Hood Morris, 1996). Such supportive alliances can be between practitioner and service user, but they can also be between one practitioner and another.

Journey to the East is also about the struggle to create, the struggle for self-expression, the poet disappearing in the process of creating art, "the

creations of poetry being," as Hesse puts it, "more vivid and real than the poets themselves" (p. 108). The creative urge is seen as a spiritual journey wherein the artist risks becoming lost. This reminds us of Jung's (1984) idea (discussed in Chap. 3) of "the divine frenzy of the artist (that) comes perilously close to a pathological state" (p. 78). However, as we have seen, this 'divine frenzy' – like its close relative 'strong imagination' – while romantic and attractive in some ways, is not supported by evidence. We need to be well to be creative, and being creative enhances our wellbeing.

THE BUSINESS OF LIVING HAPPILY

In 1892, just a few years after Elgar composed his dances for Worcester asylum, the poet Housman gave his introductory professorial lecture at University College, London. In this, he declared: "Our business here is not to live, but to live happily" (Housman, 1961, p. 7). Our business in this book has been to examine how living happily – enjoying a high level of wellbeing – is essential to mental health and to the practice of mental health care. Creativity is at the heart of this for, as the painter, author and educator John Lane (2006) wrote: "to create presupposes delight ... To live the self-expressive life, the creative life, is to tread a path towards the deepest personal fulfilment" (pp. 74–75).

In this book, we have covered a lot of ground so let us retrace our steps a little, recalling some highlights and drawing some conclusions from what we have learnt on our journey.

Over the preceding nine chapters we have explored what is understood by creativity and wellbeing and how these concepts relate to mental health. We have seen that creativity is indeed applicable to mental health practice and is not only desirable but necessary. Notwithstanding a persistent romantic association between creativity and 'madness' we have also seen how people are more likely to be creative when they are mentally well-balanced. Creativity thrives on mental wellbeing rather than on mental illness and, moreover, creativity *promotes* wellbeing. In the workplace, a creative climate, rather than a risk-averse one, helps reduce stress for mental health practitioners, leading to greater autonomy and empowerment for the workforce and for service users.

Despite being a nebulous, multifaceted notion, wellbeing has been shown to be an important and useful concept. Physical wellbeing is a legitimate concern for MHNs, while understanding the psychosocial wellbeing

of MHNs is as crucial as knowing how MHNs can enhance the psychosocial wellbeing of service users, carers and wider society. Spiritual wellbeing, too, should not be overlooked and MHNs have a valuable role to play as 'spiritual allies'.

THE MODEL OF CREATIVE MENTAL HEALTH CARE REVISITED

In Chap. 5, a new model of creative mental health care (see Figure 5.1) was outlined, informed by the findings from the preceding chapters about creativity and mental health practice. It incorporated Finfgeld-Connett's (2007) triad – evidence-based practice, patient-centred (or person-centred) care and creativity – and Le Navenec and Bridges' (2005) triad – creativity, collaboration and caring. The common denominator in both of these was creativity itself. Conscious use was made of the principle of combination in blending together different ideas about both creativity and mental health practice. Thus, the triads of Finfgeld-Connett and Le Navenec and Bridges were visualised as two triangles juxtaposed and, since the triangles shared a common feature – creativity itself – the combination resulted in a rhombus or diamond shape. Added to this were the recurring themes (introduced in Chap. 2) of discipline and playfulness (Weston, 2007; Lane, 2006) and novelty, effectiveness and ethicality (Cropley, 2001). Finally, surrounding the rhombus of creative mental health care, I included a single phrase underlining what was meant by the four domains – knowledge-based, person-centred, caring and collaborative:

- Influenced by evidence-based practice and practice-based evidence
- Centred on service-user, family, carer and community
- Never forgetting to be caring and compassionate
- Working alongside artists, arts therapists and colleagues from health, social care and education.

I hope practitioners will find the model of creative mental health useful and that it will encourage greater creativity in practice. I also hope the examples given in this book for applying the model – including the use of music, creative writing, literature and storytelling with individuals and in groups – will inspire innovations elsewhere. Creative arts activities are powerful tools for promoting the recovery of service users and the professional development of mental health practitioners. They can provide a

means of self-expression and social inclusion along with the therapeutic benefits of being part of a group.

As for learning and leadership, we saw that transformational and servant leadership have much in common with creative leadership, which involves both role-modelling everyday creativity and establishing a creative organisational climate that can lead to reduced stress and greater success for the organisation. The model of creative mental health care applies as much to leaders, managers and educators in mental health as it does to practitioners.

THE EIGHT WELLBEING RECOMMENDATIONS REVISITED

In Chap. 9 I introduced eight wellbeing recommendations, based on the findings from the preceding chapters on wellbeing and mental health practice. These recommendations can be seen as each addressing important aspects of skills, knowledge, awareness and approach which can be combined to promote wellbeing and creativity alongside the model of creative mental health care. I reiterate the recommendations here, highlighting the area each one addresses. While they were designed as recommendations for MHNs specifically, professionals from other disciplines may wish to reflect on their applicability to their own practice.

1. **Physical health and wellbeing** – MHNs should assess, monitor and promote physical health, especially in service users with serious mental illness.
2. **Social and political** – MHNs should be aware of social factors and be able to mobilise the community to bolster resilience and facilitate flourishing, engaging politically and collegially through public health campaigns, writing for publication and sharing knowledge through support, supervision and educational groups.
3. **Philosophical** – Wellbeing is not merely an extension of the recovery approach but a positive approach in its own right that facilitates flourishing. MHNs could address not so much illness – not even *recovery* from illness – but wellbeing.
4. **Families** – MHNs should have the skills and knowledge to be able to work therapeutically with the families of service users and understand how stigma and marginalisation impact on the psychosocial wellbeing of families and carers.

5. **Supervision and support** – Regular clinical supervision should provide a trusting relationship demonstrating organisational support for MHNs' emotional wellbeing, to foster meaningful autonomy, emotional wellbeing and satisfying professional practice.
6. **Supportive nurse education** – Nurse educators and mentors should anticipate the impact of caregiving, provide a safe, respectful atmosphere and encourage participation in support networks and professional organisations.
7. **Spiritual wellbeing** – MHNs should have an awareness of spiritual wellbeing so they can act as spiritual allies, using warmth, respect and empathy to help service users resolve pain and despair.
8. **Groupwork** – MHNs need skills in groupwork to be able to facilitate therapeutic groups. Groupwork is valuable because it provides opportunities for social inclusion, connection, creativity and care.

CONCLUSION

I do not underestimate how complex and challenging it is to work in mental health care and I hope practitioners will not think I have been too unrealistic or idealistic in what I propose in this book. I know it is not always easy to transform services, to enjoy satisfying professional practice or even to maintain a good level of wellbeing in one's own right. My intention is that this book, rather than having increased any sense of frustration, will have given some solace, some affirmation, some ideas and perhaps some inspiration to foster good practice and improve the wellbeing of service users, carers and service providers.

I hope practitioners, managers, leaders, educators and supervisors will feel able to support and implement the eight wellbeing recommendations proposed in this book and make use of the model of creative mental health care. Bohm (2004) described a feeling of unsatisfying narrowness and mechanicalness which is antithetical to creativity. We need to break free of these constraints, to develop a creative state of mind as individuals and to establish a creative culture within our organisations. This would mean flourishing rather than languishing, not only living but living happily, so that mental health practice can be about more than treating illness, more than enabling recovery. It can be about promoting creativity and wellbeing for all.

REFERENCES

Bohm, D. (2004). *On creativity.* London: Routledge.

Cropley, A. J. (2001). *Creativity in education and learning: A guide for teachers.* London: Kogan Page.

Finfgeld-Connett, D. (2007). Mental health nursing is not fine art. *Journal of Psychosocial Nursing, 45*(3), 8–9.

Greenleaf, R. K. (1977). *Servant leadership: A journey into the nature of legitimate power and greatness.* New York: Paulist Press.

Hesse, H. (1972). *The Journey to the East.* London: Panther Books Ltd..

Hood Morris, L. E. (1996). A spiritual well-being model: Use with older women who experience depression. *Issues in Mental Health Nursing, 17,* 439–455.

Housman, A. E. (1961). *Selected prose.* Cambridge: Cambridge University Press.

Housman, A. E. (1975). *A Shropshire lad.* London: The Garnstone Press Ltd..

Jung, C. G. (1984). *The spirit in man, art and literature.* London: Routledge.

Kirsch, A. (2017). *A poet for the age of Brexit: Revisiting the work of A. E. Housman.* Retrieved from https://www.theatlantic.com/magazine/archive/2017/10/the-poet-laureate-of-englishness/537864/

Lane, J. (2006). *The Spirit of silence: Making space for creativity.* Totnes: Green Books.

Le Navenec, C.-L., & Bridges, L. (Eds.). (2005). *Creating connections between nursing care and the creative arts therapies: Expanding the concept of holistic care.* Springfield, IL: Charles C Thomas Publisher.

Ordoña, T. T. (2005). Review of the book *Feeling good: The science of well-being,* by C. Robert Cloninger. *American Journal of Psychiatry, 162*(7), 1399.

Rapp, C. A., & Goscha, R. J. (2012). *The strengths model: A recovery-oriented approach to mental health services.* Oxford: Oxford University Press.

Weston, A. (2007). *Creativity for critical thinkers.* New York: Oxford University Press.

Index[1]

[1] Note: Page number followed by 'n' refer to notes.

© The Author(s) 2018
T. Gillam, *Creativity, Wellbeing and Mental Health Practice*,
Palgrave Studies in Creativity and Culture,
https://doi.org/10.1007/978-3-319-74884-9

Performance targets, 7
Performing arts, 6, 37
 See also Dance; Drama; Music;
 Theatre
Person-centred care, 73, 82–84, 149
Peters, Andrew Fusek, 113, 121, 122
Photography, 6, 37, 38
Plath, Sylvia, 35
Plato, 32
Playfulness, 10, 20, 29, 40, 41, 76, 77,
 83, 95, 109, 110, 112, 149
Poetry, 11, 13n1, 81, 82, 102, 103,
 106–108, 114, 146, 148
 therapy, 11, 106–108, 114
Poverty, 57, 58, 134, 135, 139
Practice-based evidence, 9, 11, 111, 149
Problem-solving, 17, 18, 76, 82
Productivity, 17, 23, 24, 53
Progoff, Ira, 112
 See also Writing, journaling
Psychiatric nursing, *see* Mental health,
 nursing
Psychiatry, 33
Psychology
 behavioural, 58, 61
 cognitive, 16, 25, 58
 evolutionary, 27, 28, 34
 humanistic, 21
 positive, 7, 10, 48, 50, 55, 56, 66,
 121, 122
Psychosis, 10, 32, 34, 43, 113
Psychoticism, 35
 See also Psychosis
Public health, 27, 58, 61, 134,
 139, 150

R
Recovery, 11, 41–43, 54–56, 60, 76,
 102, 103, 109–111, 113, 114,
 134, 135, 139, 147, 149–151
Reflection/reflective practice, 4, 12,
 111, 112, 120, 127

Renard, Jules, 102, 114n1
Resilience, 53, 56–58, 61, 63,
 120–123, 134, 139, 147, 150
Risk
 assessment, 41
 management, 41, 137
Risk-aversion, 75, 76
Risk-taking, 11, 40, 41, 75–78, 84,
 88, 126
Role definition, 62, 136, 137
Role-modelling, 12, 96, 127, 150
Rothenberg, Albert, 21, 27, 32, 33,
 35, 39, 43n1

S
Satisfying professional practice, 5, 12,
 55, 61–63, 136, 140, 141, 151
Sawyer, R. Keith, 16–21, 25, 27,
 32–35, 39, 74, 75, 81, 82
Schizophrenia, 35, 57, 59, 67n3
 See also Psychosis
Schizotypy, 35
 See also Schizophrenia
Self-esteem, 24, 36–38, 53, 58, 63,
 103, 137, 138
Self-expression, 37–38, 104, 107, 109,
 110, 147, 150
Self-management, 58, 139, 141n1
Seligman, Martin, 7, 10, 48–52, 66,
 121, 122, 132, 135
Service users, 3, 7–11, 28, 34, 38,
 41–43, 55, 57, 60, 62, 75, 77,
 80, 82, 83, 88, 90–92, 94–98,
 103, 105, 106, 108–114,
 121, 122, 132–140, 141n1,
 147–151
 user-involvement, 91, 92, 98,
 133, 139
Sexuality, 56
Shakespeare, William, 32, 94
Sigmoid curve, 11, 98, 99, 127
 See also Handy, Charles

CPSIA information can be obtained
at www.ICGtesting.com
Printed in the USA
LVHW081540190419
614846LV00010B/166/P

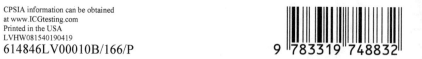

9 783319 748832